# THE CROSSING POINT

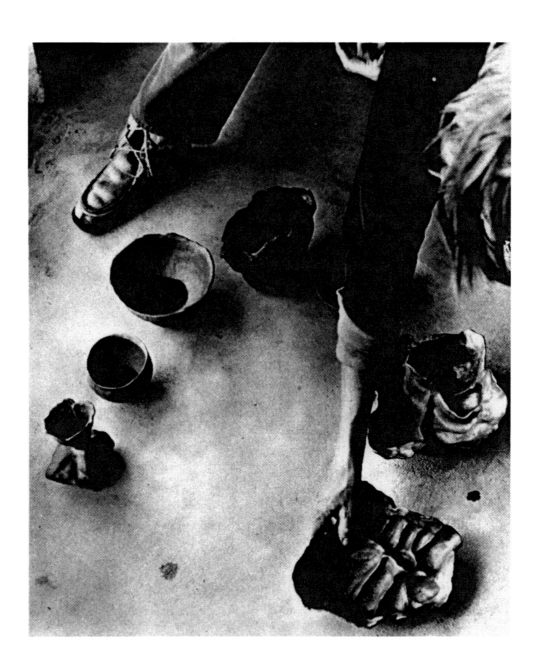

# THE CROSSING POINT

## Selected Talks and Writings

### by

### MARY CAROLINE RICHARDS

*Wesleyan University Press*
Published by University Press of New England
Hanover and London

WESLEYAN UNIVERSITY PRESS
Published by University Press of New England
Hanover, NH 03755

Some of these papers have previously been published elsewhere, as detailed in their respective headnotes. The author is grateful for permission to reprint and for assignment of copyright.

"New Resources" was first printed in *Ideas* No. 5, published and copyright © 1968 in Great Britain by University of London Goldsmiths' College.

"Pilot Course Seven: New Resources for Learning" was included in *Curriculum & Resources*, published and copyright © 1969 in Great Britain by University of London Goldsmiths' College.

"Triune," by Alfred Barnes, is reprinted by permission of the author from *Goetheanum News* (Dornach, Switzerland), Vol. 38, No. 2, March–April 1970.

"Hunger," by Elizabeth Hamlin, is reprinted by permission of the author from her book *Poems* (Stinehour Press, 1968), copyright © 1968 by Elizabeth Hamlin.

"Blue Girls," by John Crowe Ransom, is reprinted by permission of Alfred A. Knopf, Inc., from *Selected Poems of John Crowe Ransom*, third edition, revised and enlarged, copyright © 1969 by Alfred A. Knopf, Inc.

"A Ritual to Read to Each Other," by William Stafford, is reprinted by permission of the author from his book *West of Your City* (The Talisman Press, 1960), copyright © 1960 by William Stafford.

"The force that through the green fuse drives the flower," by Dylan Thomas, is reprinted by permission of New Directions Publishing Corporation from *The Poems of Dylan Thomas*, copyright © 1939 by New Directions Publishing Corporation; reprinted also by permission of J. M. Dent & Sons Ltd. and the Trustees for the Copyrights of the late Dylan Thomas from *Collected Poems of Dylan Thomas*.

Library of Congress Cataloging in Publication Data
Richards, Mary Caroline.
    The crossing point.
    1. Education—Philosophy—Addresses, essays, lectures.
2. Self-realization—Addresses, essays, lectures. 3. Conduct
of life—Addresses, essays, lectures. I. Title.
LB885.R5313    370.1    73–6010
ISBN 0–8195–4060–9
ISBN 0–8195–6029–4 (pbk.)

# Contents

# Illustrations

# Who We Are

THIS book is published in response to an expressed wish that certain talks I have given in recent years should be available under one cover.

These are real talks for real occasions with real people in them. The question I immediately faced was whether to preserve the context of the talks, and the persons who were part of them.

I have given a lot of thought to this question, and I have decided to tell it the way it was.

It matters who we are. Not one of these talks would have been composed had it not been for a specific human being who invited me, a specific human context to which I was responding, and real human relationships. Three of the pieces are articles which were written for publication rather than to be spoken, and they too were inspired by real individuals and real situations. Repetitions are inevitable in a book of this kind, made up of individual pieces written for separate occasions, and not written as a continuity. I beg the reader's patience. Decisions to allow repeated material to stay have come always from a feeling for the form of the original occasion.

Each piece will be introduced by a headnote, which will give information about when and where, why and wherefore, mood and human setting. They will also carry the over-all narrative of this seven-year period, which represents a cycle in my life and work.

For you can find a kind of story line through the years from 1964–1971, which these talks span. The first one was given in the summer of 1964, just before my book

*Centering* was published. Then and during the months to come, I went through a personal crisis which tested me and my book to our core. As a result of it, I left my home in Stony Point, New York, where I had lived for ten years, my community there, my pottery studio, my garden, all the patterns of my emotional dependency as well as the life I had helped to build. Previously it had not seemed imaginable that I should live without them, and survive as the person I was. During the traumas, I held a little funeral for our former selves, picked a flower, lit a candle, sang a wailing chant, cast myself into the unknown future of my own becoming. I resolved to suffer through that part of life of which I felt most fearful, and to seek a sense of worth not so exclusively dependent upon partner and community — to bring myself, if possible, into a better balance. I began to live in a quite different way than I ever had done, to trust the shadow side of life, and to let new courage slowly grow. I mention this personal experience here because it changed my life and influenced all the public work I was to do. After these years, I am at another point on the unfolding spiral, experiencing differently the dynamics of separating and connecting, and more consciously in touch with the ground of our being.

*Centering* was commissioned at a time when I had taken a leave of absence from teaching English at City College in New York. I did not return to conventional steady employment, but chose to be free lance, responding to invitations and setting new projects in motion. No matter what materials I work with, my subject seems to be the human person and wholeness in living and learning.

I wish I knew how to make clear the nature of the trust I put in personal witness. For there is a way of experiencing ourselves, which sees human being as objective truth. There is, I believe, a growing insight now that human beings may be their own laboratories, and may study themselves as representing conditions of their times. Certainly in my own life I sense very strongly a reflection of movements which are culturally shared: for example, separating from orthodox academic institutions and searching for other ways; integrating the masculine and the feminine in oneself; integrating religious life and public life. The life-works of such scientists as C. G. Jung and Rudolf Steiner have importantly explored this truth for our time: that there is a new science of man being born out of individual spiritual activity and self-observation. Also I choose to follow Hamlet's humorous advice: "We must speak by the card, or equivocation will undo us." Of course, speaking by the card as honestly as we can may undo us too, but differently.

Like poems, our lives are more than particular. The whole may be felt in every part. The mystery of human identity holds community in trust. Every day we experi-

ence practically how the welfare of others is involved in our own welfare: the telephone operators at work so that we may make a call, the grocer on hand so that I can buy my cheese, the bus driver okay so that I can make my trip. And within ourselves, we are sustained by the "you in me" or "me in you": our souls are in each other's charge.

When we say our honor is at stake, we mean that we will keep the faith both with that inner connectedness with other people and with the trusting person in ourselves. The trusting child, its hand in ours. Keeping the faith, keeping the circle, present even in its absence — when we are separated from each other, still the circle-center holds.

Early this century the poet Yeats wrote "the center does not hold." We bring good news: the center *is* holding, and we whose honor is at stake are holding it, with the power that is in our connectedness and our need for each other's warmth, our willingness to be shone on, and to shine, even here where it is dark, dark figures standing in the shine, like wicks in candle light, standing in blue ovals of living flame.

It is hard to keep one's nerve for what one feels to be true. It tends to seem too simple, or presumptuous, or just plain tiring to maintain. One of the truths of our time (truths evolve like other beings) is this hunger deep in people all over the planet for coming into relationship with each other, in living and working. And equally they hunger for self-worth and for their own space.

The image of "The Crossing Point" comes from studies of projective geometry and plant growth. I could put it most simply this way: in the plant there is a layer — sometimes only one cell wide — between the tissue of the root and the shoot. It is a crossing point between earth and sun. Below, the root hairs grow out of the dense core — think of a beet or a dandelion — the gesture of the form radiates from a mid-point outward. Above, the foliage arises out of a hollow, drawn by the sun from the periphery. The movement resembles the figure-of-eight, or Moebus strip, where what is enclosed and digging down turns into what is open and lifting up. And vice versa. The two realms are an organic breathing continuum. The geometric form is the lemniscate.

The crossing point, like the image of centering clay on the potter's wheel, is archetypal, and lights up in other intersections. Inward to the self. Outward to the self. We find our aloneness and our connectedness and affirm them, helping to stir up possibilities, working the body of our mind, the mind of our body, to make the big vessel of living water we all need to drink, and we all need to help to make so that it will be big enough to hold us all.

The making of the vessel is part of the potter's craft. As is the art of the fire by which the vessel reaches maturity in the potter's kiln. An Art of Fire is the image of

transformation used by medieval alchemists. By its means, physical materials achieve a condition which is called "pure gold." Each of the elements to be transformed is also a feeling. Sulphur for example is passion, and mercury is liveliness, and salt is relatedness, and lead is melancholy. Feelings are experienced as objective elements, which can change in the fire and by a complex process contribute to the birth of a new person. The art of the alchemists requires that they pay close and sustained attention to what is happening in "the vessel," that is to say in "heart consciousness." I think there is something to all this, and I have been trying to learn how to govern the fire, in pottery kilns, and in my own development as a person. I look in the human heart for the foundation stone of a new social impulse. One of the reasons I work in the arts is that they reach toward this heart-vessel and nourish it. I might have titled this book *The Vessel and the Fire*.

Hop Bottom, Pennsylvania                                                      M. C. R.
February, 1973

## THREE WISDOMS

"Go slow," said the snail.
"Hop! Hop!" said the hare.
"Pace yourself," said the cheetah, "it's a long run."

<div align="right">MCR</div>

# I

This talk was given at Haystack Mountain School of Crafts on Deer Isle in Maine, in August of 1964. It is low key, and expresses, I think, a tenacious respect for feeling, even at wit's end — and the need to be nourished by Haystack's supportive environment. Thus, Feeling, and Community — and the intimacy of its tone. It was an informal occasion, for a group of sixty to eighty people who were there during the summer to participate in various handcrafts. Hal Riegger, David Van Dommeln, Fred Mitchell, whom I mention, were craft masters in pottery, stitchery, and graphics. For the talk, I had surrounded myself with some of my own works in clay. These were handled and discussed at the end.

I first taught pottery at Haystack in 1961, and have been on the Board of Trustees ever since. It is an environment in which my own efforts to integrate poetry, pottery, inner development, community, education, have been encouraged. The natural setting on the coast of Maine is the ground under our feet. The architecture of the school, a continuum of ramps and porches and studios and stairs leading to the sea, designed by Edward Barnes, made the project I proposed in this talk seem not only feasible but enchanting and serious — like a MAKING TOGETHER of US IN THIS PLACE, an imaginative documentary, a revelation of WHO WE ARE, multileveled, multimedia. One doorway. The Portal did not come into being. But the image of A Door, A Doorway, A Threshold, A Crossing Point, which haunts this book, makes its invisible appearance here.

# Karma and Craftsmanship: Feeling and Form

I'D like to introduce myself. I've brought a few of my pots, and a few sculptures, which I hope will create a kind of image of the way I work and the kind of forms that seem to be extensions of the tips of my fingers, of somebody who lives inside.

Tonight I want to talk about a project we could do together, about feeling, and about karma and craftsmanship.

Here at Haystack Mountain School of Crafts we have a very special opportunity to relate to each other personally and to relate to the various media of the studios. Hal Riegger and David Van Dommeln and Fred Mitchell and I got together last night, and found ourselves talking quite spontaneously in the direction of a common project — something we could all do together — preferably during this week, although quite possibly extending beyond. It is the idea of a DOOR. We would create a PORTAL where there is now only a wooden slab: a portal, a threshold, a closing, an opening — a secret — an open secret — a sliding door turned into an open secret. This appeals to me, this idea of polarities, that something can be both open and secret; the fusing of opposites is at the very heart of the spirit of poetry. And the fusing of elements: earth, air, water, fire, is at the very heart of alchemy, a spiritual science, the art of nature and man.

Francis Merritt, the director here and my friend, told me last winter that I am full of hot air. I thought a long time about what he might mean! I knew it wasn't a totally negative insult because after all he was inviting me to come here. I pondered on the image, and decided that it wasn't a bad thing to be full of — heat and air, warmth and air — they are in some sense the basis of life. But you see, this is just what he meant, I think. I take some simple little idea and pretty soon it's the basis of life!

And this is true: this is a truth I sense everywhere: that every little idea contains within it a microcosm of a big idea. I feel this way about people, every little one contains a big one. Just as every cell of the body enacts the life processes of the whole: digestion, circulation, metabolism, reproduction, etc. The ONE, the WHOLE BODY, is enacted in all the parts. If we listen to the little words, we will learn a lot about the big ones. Musicans are very attentive to silence and to soft sounds.

And so I find the potter's craft of centering the clay enacted in all realms of life: a bringing into center of all the elements of experience and the creating of forms out of that centered condition. And I find poetry also expressed by the media of craftsmen. This will be the subject of my next talk: Poetry and Craftsmanship. And I find the religious impulse also expressed in all realms of life. I'm not officially religious; I'm not institutionally religious. But I take my cue from the word *religio, religere*. It's a Latin word, and it means "to bind together, to bind together again, to be concerned."

Now it's not so easy to do this in a natural and sincere way — not just sort of pasting and nailing and soldering things together in a huge collage effort in which separate elements are all somehow forced to hang together by some great commercial adhesive. As a friend of mine said recently, "It is not enough to *bring* them together, they must *come* together."

4

And so for our common project of creating a doorway for Haystack, which will celebrate its spirit, our spirit, we shall need to move gently together, sensing the center, sensing each other, sensing relatedness of materials — creating out of a common dedication to a common center — letting ourselves flow into that and out, breathing, in and out, inspiration-expression, reading-writing, uniting-separating-uniting-separating-uniting: the moods of a single organism made up of many souls.

We will work on one of the sliding doors — probably the one on the weave shop because of the way light lives in that area; or the graphics shop, visible from the dining hall. We will use fibers, yarns, all the materials of weaving; canvas, paper, color, the materials of graphics; clay; wood; metal; words.

Let's make a start. Fred Mitchell has some canvas he will size for outdoor use. Barbara has some rice paper. Hal has made some hanging slabs. David is weaving on shingles. Let's begin to gather our materials and to compose together. The image will grow, it will invite participation. Let's enter the mystery, let's work with the known, and use everything we know to equip us for the effort.

And this brings me to another aspect of my subject — what I want to say while I am here, and why I have brought these pots with me as part of what I have to say.

I want to talk about Feeling as a mode of knowledge. I want to talk about Feeling and Forms — and Community and Art. They are all linked together in my experience and in my imagination.

I want to talk about Feeling in the sense that we mean it when we say that we have the Feel of a thing — we have the Feel of a moment — we have a Feeling for material. This Feeling is a kind of relationship. It's not love, exactly, though I am sure it is akin to it. It is not even very personal. Actually it seems to be physical and intuitive. It is a point where we *enter into* an object or a situation outside ourselves, we flow with it, we *know* it. We somehow know it in our organisms, we have the *Feel* of it. To have the Feel of a thing is to identify with its truth.

Those of you who have read Bernard Leach's book *Potter in Japan* will remember that he talks a lot in that book about Truth of Being. He is trying to point to a very special quality that he finds in pots. He says they may contain a truth of being. This sounds abstract. It is hard to do anything with if we try to translate it into other words. But I think we know what he means when we think about what we mean by saying that we have a Feeling for something. And how it is that it isn't exactly personal, it isn't exactly that we like it or don't like it. It's that somehow we are involved with the truth of its being. We know it — we know what it is.

5

It's not an intellectual experience. It's something between ourselves and another person, between ourselves and an object, something in each wakes to the other. A claim of life wakes to the life in the other.

The capacity for this kind of feeling is related to an ability to live *in* forms. To enter into forms with our spirit — to catch on. To be with it. The formative potential in matter, its ability to take form constantly, begins to be a constant flow in our own conscious experience. We open to it. We help to create it. We are more than spectators, passive and responsive and sensitive. We also create and impress our spirit upon matter. Constantly. We are continually creating nature.

Now what is this but an artistic process? Creating forms. Living in forms, with our feeling. And what is community but the experience of living in the forms of our relatedness — not withholding ourselves, but flowing in the forms of our relatedness at all levels and creating, by our participation, new forms? What is this but an artistic process?

We behold the world of men and nature as a vast artistic process to which we belong. The specific craft we practice is part of that vast process.

The artist may see himself as the most responsible citizen, holding in trust a vision and a skill — seeking freedom in his perception, freedom in his initiative, freedom in his participation. He may be impelled by a commitment to inner quality, and to making his dreams come true. Giving shape to his dreams.

Our world is in trouble, and we are tempted by discouragement, confusion, rivalry, loneliness, cynicism — all the temptations of ignorance and weakness. And our society is jeopardized by forces of ignorance and weakness. We make a few beautiful pots or poems or pictures or fabrics or windows or sculptures or ornaments, and appease our conscience, which is raising questions about justice and survival and freedom and decency. I know this because I attended the First World Craft Congress, as did others here, and we know that when craftsmen discuss crafts they discuss as well business, politics, religion, philosophy, esthetics, scientific research, inner growth, communication, education, and all the other arts. In other words, craftsmen are people living the richly varied lives that people do, and their craftsmanship is involved with everything else, whether they are conscious of it or not.

It became clear at that conference of fifty-three nations that certain craftsmen may not be allowed to join the Congress because of the politics of their countries. Certain craftsmen will turn to other pursuits because they cannot come to a reasonable economic solution. The Mexican craftsman, representing millions of indigent peasants,

6

quarreled with the studio artist of the American affluent society. The sophisticated American angrily justified himself and wished to quit the Congress. And vice versa. Mutual accusations flew, there as on any warring front: "bunch of rich female hobbyists, unrealistic, spoiled . . ."; "political hotheads, arrogant, self-seeking . . ."

To be able to live in the different forms imaginatively — to feel the form of the other man, the other place, the other necessity. To flow together as the many persons of the one god. To initiate new forms, bearing upon all life's necessities — to be artists — is this not our task?

It seems to me that all our craft is apprenticeship — a preparation, an unfolding of powers; that we have been blessed with an opportunity to see the possibilities of forms in existence and to develop our powers of enjoyment. These may lead us far in our growth and in the contribution we make by our example. The spirit of the artist-craftsman's community may be offered to the world in our smallest daily deeds. As I began by saying, in the small deeds and thoughts live the highest power and meaning and blessing.

Within the microcosm of our being, the powers of our feelings and our thoughts and our willing take on certain shapes: because we live in a certain kind of body, because we have certain parents, certain childhoods, certain educations — we live in a certain place, we belong to a certain race, and so on.

We know our Feeling life mostly as a stream of likes and dislikes. We like this, we don't like that. We think of Love as personal attachment. And these likes and dislikes, upon examination, turn out to be largely the consequences of our past experience and training. They are not *free* — they are attached to past influences, usually in very unconscious ways. They are, as I would put it, karmic.

The law of karma is not talked about in the Western world as much as it is in the Orient, but it is no less operative. It is the law of reaping what we sow, of receiving the consequences of past action. And, in most of the world, these past actions are frankly traced far back into past lives — into our past lives.

The life of Feeling concerns me particularly, because Feeling is related to the ability to *live in* forms — whether we are creating them, beholding them, or moving within them. "The characteristic of really living Feeling is the capacity for living in forms." This important insight was stated by Rudolf Steiner in his book *Toward a New Style in Architecture.*

As artist-craftsmen here together, we are working every day in forms — forms in clay, in fiber, in metal and glass, in paper and ink and pigment, and the impulse of our

7

study and practice and growth is all toward an ability to live in forms. Isn't this so? It seems to me that our fullest life of form then is our fullest life of Feeling, in the sense in which I introduced it: not as likes and dislikes, but as contact with that primal, macrocosmic spirit realm.

How can we develop our capacity for this freedom of Feeling? I have a few ideas which I have tested out in my own experience, and these I share with you:

First, we must be mindful of the nature of our prejudices and our preferences. We must learn to let them float by, at just a little distance, no longer identified with us — we watch them float by. We are able to imagine ourselves without them.

Second, we learn to meditate on the sources of our feelings about things. Where do they come from? Are we really satisfied with them? We learn to recognize our feeling patterns, and to develop a sense of karma.

Third, we may seek a path which will change our karma. We seek the path of liberation. Above all, artist-craftsmen may seek this path, for it is the path of feeling and it lives through forms.

And this brings me to the other question which I want to ask you to consider: it's another face of the same question. And it's this: Where does our art come from?

Where does our art come from? Surely it does not come from the clay nor from the wool. It comes as an impulse from another realm: as a vision, as an unconscious coordination, a conscious study, it comes onto our canvas from *somewhere else*. This is what Plato was referring to when he said that Art is Imitation, and when he pointed out the dangers in this fact. It is dangerous for poets and painters and sculptors and musicians to think that their image, their composition, is the source of value — instead of the reflection of value, the making conscious of an experience of value otherwise derived. The paint peels and cracks, the pot breaks, but the realm out of which it comes continues to reveal itself in more works of art and craft.

My interest is in the fact that Life is the realm of art — and that the true source of our images, the original face as it were, moves within life itself. There, if we can but behold it, is the vision, is the form. There are the forms which our feeling, purified, prepares us to live within.

This all seems to me terribly important. I don't know if it does to you.

I have spent a great deal of my life in the academic world. I took my Ph.D. in English at the University of California, and I became a teacher and taught across the country. I was a good student and believed what I read and what my teachers taught me. It was a terrible blow to me to discover that it didn't seem to make much practical

difference, that the life of an academic community is not that much superior to other moral slums.

I puzzled about this for years. How was it that I could teach *Paradise Lost* around the clock, but I couldn't get along with my husband and was impatient with children?

I taught at an experimental college, Black Mountain College, for several years. Terribly experimental, terribly far out. Historic! The whole thing died — deteriorated and died. How could that be? A group of distinguished people, gifted people, artists all: artist-scholars, philosophers, professors of ethics, poets, physicists, economists.

Higher education? What do we learn in "higher" education?

I took all there was. I went until they said, "Go! Go! You're finished. You're through." And they gave me the hat with a gold tassel.

I feel the same way about artists and craftsmen. I feel that there's a connection we ought to make between what we "profess" as creatures sensitive to form, and the forms we practice in community. Should we not learn to extend our ability to live in forms and to feel the authenticity of forms *other than those of our likes and dislikes* if we are to get on with the tasks of our humanity?

There has been a lot of attention given to the descent of man. I would like to call attention to an *ascent* of man. How shall we apply our skills on behalf of our dreams — not for a glaze formula, for heaven's sake, or an esthetic effect, or a prize at Syracuse! — but our dreams for the future of our species and the destiny of outer space. For our personal health and the health of the great mystical body. If I labor this point about Feeling, the capacity for Feeling in forms, it is on behalf of this concern.

As craftsmen, deliberating upon materials and forms and use and ceremony and nonanalytic values and responses, we have the advantage of approaching life at the outset from an artistic point of view. We have the opportunity to bring Dream into Reality, to bring our dreaming into the waking world.

The artist is estranged from society? Society does not love the craftsman? Ah, let us be fair. The artist and craftsman withdraw their love also, they withdraw their feeling. "I have no feeling for all that," they say.

We must not be unfaithful to love and to feeling in the social body. We must not be, like timid lovers, "afraid of rejection," "looking for approval," looking for someone else to support us, to justify us.

We must be vessels of true feeling for life and its forms. The freer we become in making our offering, the freer will society become in her response.

To be faithful to the spirit of love, we have to go through the ordeals of the hum-

bling of pride, the chastening of desire, the strengthening of inner resolve. We have to apply certain disciplines of devotion to our inner lives, like craftsmen.

We need a fellowship in order to awake and nurture in each other the spirit of love. Our thinking is transformed as it is infused with warmth, our feeling is transformed as it grows strong enough to separate itself from our egotism, our behavior is transformed as we learn how to be still, how to listen, how to behold — and then how to move gracefully, firmly, naturally, tenderly.

So much of what stands between us and our work is our own zeal to get on with it.

You know how it is to lie still in the sun, to feel it working all its wonders everywhere — the sun — to feel its great working, much vaster than just upon ourselves, but we feel its power upon us and we know its vast power everywhere. We lie out here on the decks and it works upon us. I think there is a truth here. How we come to life and good works as warmth, as the spirit of the sun, shines upon us.

As you can see, I am trying to speak about something very vast, that lies at the source of our being and our craftsmanship. It is a truth of being in which our lives are at stake, our future, the future of others, our society and our world, the universe — and all the forms of our art.

The revelations of our crafts teach us how to live. If we behave like expert craft machines, we will be as dangerous as other machines. But our life here at Haystack and our relation to our materials tell us how we may awake to the world around us. We sense what can happen, what wants to happen. It becomes one of our disciplines, as craftsmen, to be true to that spirit wherever we are.

Before we adjourn to court the Muse and to prepare offerings for the Haystack Doorway, I would like to read five prayers. They are called "Holy Poems: Prayers." Then I will be glad to speak about any of these pots if anybody wants to know anything about them: my use of glass, my use of raw shards, my use of plants . . . Now all the pots here are mine except this one. This is an ancient Egyptian potsherd, which is probably the most beautiful thing in the room. . . . An ancient Egyptian potsherd fragment . . .

HOLY POEMS
PRAYERS

*Prayer One*
All that I hate and am
against

be exorcised. Be spent
as day is; was.
Gladly to do, I hereby
stamp and spit thrice and
mew in
            spite. All
gone, I want it to be
all gone. And everyone's
                    as well.
Calumnia, all hail! farewell!
I'll practice dying every night,
breathe first each A.M. and
no more turn aside to brood on
fate or scope or sum.
Creator spirit, be with me now
as unattended I
persist.

*Prayer Two*
Litchfield
            loony-bin
holds me dear. I
swear, wall-eyes
can hear. Make it so,
make it so — I would be
near to thee, crazed boy
and girl, be near to
vandal life and limb.
Strike my heart dumb to
falsify, seal my lips sweet
to kiss.
Creator spirit, be with me now
to down the draught
of ill.

*Prayer Three*
I would give a million bucks
    to be free of the past.

Another million, to levitate.
Three, to get going.
Double the bet, to be nowhere and
    love it.
Giving odds on all practices
    perfect and imperfect.
I would sell out to the species,
    to space, to
the sport of it.
Creator spirit, my money's down.

*Prayer Four*
Put some sense into my head, lord,
and I'll get after it.
Fallow, my hello lies for your ring.
Tattle, lord, on the void's high halo
and hunch is, I'll be tuned; and
timed to the split. Cut through, father,
my blood runs in circles. And
Wichita's my state. All plums I'll heap
and cattails piled in feathers, all
sticky buns and pornographic pleasures I'll
be sure. Lord, take my hand and place it
on the prick of thou that I may
sow and hallow.

*Prayer Five*
Magnify thy works, lord, and I'll
be seeing you: wherever the salsify roots
and the ground's ground underfoot.
Tenderfeet, shut eye, will follow thy gleam
as big as life and twice as visible. Oh why not,
why not pick the pocket of tares and
holly thorns — red berries of blood
that never runs cold, red summer's
treat, blind with the
splendid brand. Magnify those works of
yourn and my squint will stare

well, to the loveless
ever-leafing void. Of hope and the five
wants. Hoarfrost, Indian pipes, and greenswards.
For heaven's sake, god o' th'heart,
who thou art, to be at quits with.

# II

In the summer of 1965 at Haystack School of Crafts I offered for the first time a workshop called "Writing as a Handcraft." It came out of my feeling for starting at the beginning again, from real inner sources: in this case from the gestures of writing/drawing the alphabet, which had been awakened through my study of Rudolf Steiner's educational and artistic insights. I had the intuition that *all* the things we do are language, and that Writing is as much a tangible form in our environment as are other artistic "objects," all of which carry spirit into the world. Since then I have become highly motivated to reconnect writers with the materials of their craft: with what were previously known as Arts of the Scribe: papermaking, western calligraphy, the use of color in the illumination of the page, the making of inks pens brushes and gums, bookbinding, unbinding.

I talked at Colby College to craftsmen that summer, about Caring. In December, the theme was developed further for the New Jersey Designer-Craftsmen in a talk called "From the Inside . . . Where I have come in my own work." These do not appear in this volume in their original form but were integrated into the piece that follows.

All that winter of 1965, living in a sixth-floor walk-up apartment in New York City, I met with a group of friends, planning a new kind of program which I had agreed to design for Penland School of Crafts in North Carolina. Originally, Bill Brown, its director, had asked me to plan a Writers' Conference. But what I came up with was an interdisciplinary program called "Cross-Over: to a New View of Language, Verbal and Non-Verbal." It developed further the theme "all forms are language" in a collaborative teaching and learning group of about twenty persons, seven of whom I had specifically invited because of their experience in more than one discipline or art.

The following article called "Thoughts on Writing and Handcraft" appeared in *Craft Horizons*, July–August 1966. It was based on the two workshops and the two talks mentioned above. In this longer written piece, I have sacrificed the simplicities of the separate talks to an integration of themes.

# Thoughts on Writing and Handcraft

... Were you thinking that those were the words,
Those upright lines, those curves, angles, dots!
No, those are not the words, the substantial words are in the ground and sea,
They are in the air, they are in you ...
The workmanship of souls is by those inaudible words of the Earth,
The masters know the earth's words and use them more than audible words ...
To her children the words of the eloquent dumb Great Mother never fail ...
Say on, sayers! Sing on, singers!
Delve! Mould! Pile the words of the earth!
Work on, age after age, nothing is to be lost,
It may have to wait long, but it will certainly come in use,
When the materials are all prepared and ready, the architects shall appear.
— WALT WHITMAN, "A Song of the Rolling Earth"

ALL forms are language, and communication flows between all of them, nonverbal and verbal alike. Mathematics is a language, plant growth is a language, gesture is, likewise politics, business, geology — all the arts and sciences are vocabularies alive through man. And the things we do, like pinching a pot, are in some deep sense "words." And the words we speak are, as deeply, movement. And how about the ones that are not speakable. These also shape the world, like great invisible sculptors.

This point of view has grown naturally through a lifetime in various arts and disciplines. It is being explored for three weeks this summer in a program called "Cross-Over" at Penland School of Crafts. The hope is to build bridges to awareness between unique fields, and to enter into activities new to each of us. Leaders of the program think of it as research into deepened interconnections. Movement in space may, for

15

example, be a bridge to making pots, a line of poetry, a dance, painting, sculpture, engineering, theater, geometry . . . astronomy. A biochemist may find metabolism a poetic process, and enzymes as hidden as the muses. A workshop last summer at Haystack Mountain School of Crafts began to extend lines of communication between writing and other arts — with human being always as source. What follows is a summary of what I have been thinking and saying recently on this theme.

The central intersection where all our paths meet is language — language in some sense, not necessarily verbal. Words are one form language takes; this is the starting point. What is it that moves through words to make them language, and how are words connected with the other forms that language takes: forms in space (color, shape, movement, imbued with feeling) or in time (rhythms, sounds, etc.)? How shall we work consciously with the shapes we make when we write? How shall the craftsman sense the shape of his feeling, sense the force and nature of his communication? The writer tends to think that he can do nothing with his hands, though, in fact, he is creating a world of paper and ink, creating physical environment as well as psychological environment. The craftsman tends to think that it is the writer and not he who has the gift of expression, when in fact the shapes and images he is forming carry into the world potent reflections which create environment with a certain "feel" to it.

By our very presence we resound, we "give off" something. Utterance, in this sense of living presence, is common to all men. It is important to face up to the powers that we wield. We may study to approach and thus to hear, through the multiplicity of our expressions, the common human source. Beginning here, communication may become an art which uses all its resources, all its vocabularies of natural materials and human concern, light and shadow and sound and silence and movement and quiet and the surprises that always occur when the human being allows himself to play in the pools at his source. The most ordinary tasks of public meeting, classroom discussion, social gathering, may become alive as artistic possibility. It becomes "fun" then to do one's work, although one may be altogether in pain, because into the tasks of communication come all the resources of our play. There is nothing more seriously connected with our deepest longing than is our play.

So the writer may acknowledge the material aspects of his craft. And the craftsman may acknowledge the soul-force emanating from his objects. The writer then takes into himself the craftsman's feeling of "forming," and the handscraftsman takes into himself the writer's feeling of "uttering."

In the beginning was the Word — how familiar is this opening sentence of St.

John's Gospel. In the beginning was the Word — and the word for *Word* in Greek is *Logos* — in the beginning was the Logos — and the Logos means the forming spirit.

The first "words," then, were beings. And the first writing was the pictures of real things: a man, a bird, a bison, a woman, a child, a slain deer. The man was a word — *we* are the words — the pictures are our names, the alphabet is the spelling of our names. But *we* and *things* and *actions* and *ideas* are the words — the Logos — the living forms of reality, the common language, the meaning.

What a script — what a vocabulary! Think of it for a moment: *the language of the day; the poetry that flows constantly.*

These beads and these bowls are the words. It is no wonder that it is so difficult to translate them into other words; no wonder they are so expressive, so compelling, so self-declared. The living language of the crafts — this is quite different from a view of language as an intellectual or esthetic discipline, verbal in nature. Speech is common to men, and so are objects and sensations and perceptions. We are all both silent and sounding. Crafts are a language, language is a craft. They are not two worlds: they are ONE.

Surely all behavior and objects have their interior source and their outer shape. The materials we use appeal to us because of some inner sense they carry. Colors, textures, shapes; gloss and dryness, glow and shadow, weight, sound — rhythm of movement in time and space — these speak to our hearts. If they didn't, we wouldn't *care* about them. And we do care. We do care. We are warmed and nourished, chilled and disquieted — we are affected. There is an innerness implicit in all sensory and motor experience. We can come into life from the inside and flow in this stream which binds together.

It is part of our self-education to learn to swim in this stream: to awaken in ourselves a perception of inner unity. A living tissue between all of us and all our things. This begins to approach an art of communication.

The handcrafts bear witness to the soul qualities that flow through physical materials and sense perception. It makes a difference what we look at and handle — and how we look at and handle things. When we speak of writing, we say, "It makes a difference how the writer *looks* at things, how he handles his material." Perhaps this is getting closer to it: the way we look at things is a creative work. The way we look at things and handle things is one way we create the world for ourselves and for others.

And now maybe we are coming finally to it. For it is not the hand that we are

really talking about, nor the physical organs of consciousness. A hand may become no different from a machine when it is well trained; just as a brain may become no different from a computer. There is no guarantee that the hand or the brain will make that much difference unless the truly human spirit creates and writes through them. Consciousness and handcraft are not immune from the machine ideal, of beauty and polish and no pain. Neat, polished, smoothly running, efficient, expert, well heated, dependable, turning out one moment after another that is dignified interesting skilled sensitive, faultless instruments as they say, without breath, without death, without blood-warmth, without heart-pulse, without failure. Everything swinging, everything recognizable. The presses roll. The kilns blaze. The chemical baths drink in the recorded images. And what is really happening? What is really being said?

As human craftsmen, we are not after a machine ideal of life without friction, with automatic response and replaceable parts. Peace and love are not machine ideals — they do not eliminate abrasion and conflict. They in fact embrace them. That's their secret. War and hate want to get rid of differences. Peace and love want to be penetrated by them. Differences are the language of beauty and relationship.

When I think about writing as a bodycraft, I think about starting with our first words. Our first words, our first mouthings and lispings, our first reaching out, hitting out, wailing, sucking, demanding; our first tugging and snatching and cuddling, our first smile, our first weariness and our first hope. A person early in the world, so glad and so beset, so speechless with it all that we spend our lives searching for a satisfying language.

So last summer when Francis Merritt asked me whether I would give a writing workshop at Haystack, I had a mixed response. Being both writer and craftsman, I knew it would be special to work with language in a handcraft environment. I wanted to come into the experience of writing in a way new to me, a way I was just beginning to imagine: words as physical experiences of color and shape and size and sound, the page as painting, *not for outer effect but from inner feeling.* To see the page with the artist-craftsman's spirit: volume, negative space, texture, transparency, density — how energy coagulates here, disperses there — build-ups of tension and feeling. We looked at our manuscripts like this, *from the inside:* seeing the intensity in the crossed-out passages, the forms of feeling in quick marginal additions and erasures — drawings and scribbles; the life of the script as it comes from the hand is dynamic. This was an eye-opener. We pay extra for books which contain facsimile pages in the author's own hand!

We went around to the craft workshops to listen to the words, the names of tools and materials, the *verbs*, especially the verbs: to wedge, to swedge, to etch, to oxidize, to reduce, to rasp, to bathe; the nouns, too: sprue, investment, heddle, treadle, turkey work, pumice, pin stem, catch, joint, finial, flange, grog, WOOD. All these mighty words, they made us act foolishly, we would say them and sing them and dance around and feel somehow that we were celebrating a great miracle of doing and being and meaning.

I made a clay book of clustering clay leaves with the sun as title page, and a hanging poem. And a clay study of vowels from which to make print-rubbings. Clark Poling made a clay word from which to print the title of one of his handwritten critiques. Stanley Hazell carved maxims on his wife's platters, wrote his first poems, and composed carefully worded critiques in an earnest hand. Carol Garber made a silk-screen "book of poems." Jonathan Fairbanks combined drawing and calligraphy and poetry and text in a critique of a pot. Linda Tinlin made poems and drawings. Catherine Bailey tested the possibilities of sincerity and relationship. We had group-writing-dialogue-experiments to see what would happen if we spoke and wrote together on the same big sheet of paper out of a real questioning and answering; we wrote with pine cones and brushes and crayons and pen and ink and pencil and magic markers. There was more, but that's enough to say.

We didn't know what we were doing, and we were doing it. We had asked the question and were trying to grow to the answer. How to awaken the writer's hand and eye — how to help him kick the typewriter habit, the black-and-white print habit, the modern book design habit. How to explore ourselves as writer-craftsmen.

For the writer works with his body as the potter works with his; feelings, observations, sensations, ideas, these are all mediated through the body. The feel of the hand, WRITING. The sensation in the eye, LOOKING. The awareness of inner life in the senses. The pressure of the wrist, the jab or lift of the pen, the dim-down of the inner eye that shows in the face — the calligraphy of the face, the lines, the empty spaces, the erasures and blots and cross-outs. It's all such a reading and writing. Or that's one way of looking at it.

Poetry involves breath and ear and physical shape on the page. The poetic approach to life tries not to leave anything out — it does not leave out the prose, the prosaic; it offers a transfer of experience from one person's breast to the breast of another. It is a bodycraft: the gestures of the throat and mouth and lips and tongue in the utterances of vowels and consonants; the gestures of the body and of nature in the shapes

of the letters. We could study writing as a form of dance, or of nature study. A sense of inner volumes and spaces.

Writing that is disconnected from the inner life does not concern us here. It is a matter of the relation of each man's language to himself as source, and to others. What is a natural form of language to one is strange to another. Good. This makes life difficult and therefore interesting, as continuous dialogue and communication. It makes growth possible and it makes relationship possible as, by trying to understand One Another, we make ourselves more complete. And that's the point. As I said in my book *Centering,* "Poets are not the only poets, and if poetry is as deep a matter as I think it is, it is not confined to words."

How do we keep ourselves and our clay plastic and workable into new forms? How do we kick the temptations to congeal, to impress, to "make it," to betray? Because this is it, isn't it? It is a fact, isn't it, that our miseries are not caused by a lack of beautiful designs and handcraft. We are not at war because China and Southeast Asia are insensitive to pottery or textiles or metalwork or jewelry or woodcarving — or religion, philosophy, and poetry. We are not reaching for the moon because we think we'll find some nice stained glass there. Right?

It's something else driving us, driving us. And we'd better find out what it is. What kind of a future are we looking for — really, on the inside, looking for? What kind of peace do we hope we will find? It doesn't make any difference what kind of work we do, how old we are, where we live; there is no person now who can escape these questions; whether he faces them consciously is another question. The impulse to extend ourselves in new ways into new media-relationships is related to this search.

It is essential to enter into these explorations *from the inside,* otherwise they quickly turn into decorative tricks. It is not the *effect* which we must have a care for, but the feeling which precedes the act: the feeling which may turn into speech or form. Life is known by an inner sense; therefore, its way is an inner way. If this is forgotten, we fall instantly into a concern for technical virtuosity and artistic style. It is not a question of putting things together, it is a question of starting at the center where they *are* together and proceeding toward their articulation, like an organism with all its functions. The hope is that we may enter into those parts of ourselves that are yet to be awakened.

I must continue to stress that it is Language which is at stake here, and Communication. It is not pattern which is at stake, it is Living Being: . . . a long tapering throat, rising where the sea meets the land, a pulse visible in it, pulsing in color, a long

throat, like a freesia, opening arched over the harbor and the palisade, connected to the ground, rising out of it and arching over it, light-filled, shadowed, pulsating, I came round the bend on a bus and beheld it over Haverstraw Bay, and it was like being inside music someone was making, and I thought, well, I'll have to remember this, I'll have to be sure to remember that this is really how it is, a long gorgeous delicate indestructible living throat, pulsating, and containing a fountain of sperm and feminine essences and something very like syllables, like sound, like the way you feel on the *inside* when you feel yourself moving rhythmically.

We look for release, for relief, for contact, for creativity: these are inner states. Therefore real change is inner change. If we want to range in new territory, we have to alter our relationship to "home," we have to be able to question, and not invent answers, but *listen* for answers, listen like Columbus on the deep sea for the new way. To be willing to be at sea. To be able to be seasick. You have to believe in the waves and the currents and the shores, you have to believe in law. Artists do not make the laws of revelation, they acknowledge them and work in league with them.

To transform our raw shapes into forms with deeper color and firmer use, we surrender them to the fire. Otherwise, they can be charming, exciting, fun, good — but they (we) cannot be fulfilled as vessels of life without the fire. We know this as a wisdom, but we have to find our way into it as living experience. We have to discover what *fire* is — what *heat* is; if we want to change, we have to undertake it. We have to undergo the unknown. We cannot pull back and say No, I can't, I'm afraid. Of course we are afraid of relinquishing a known value for an uncertain result. As potters we all know the feeling of risk and hope and anxiety when we put a pot in the kiln and never know exactly how it will come out — and we have worked hard on it. Of course we are afraid. But are we not afraid anyway — afraid of war, of the bomb, of death? Is it less fearful to die in a war than go through the ordeals of self-creation?

Yes, of course, it is — it is less fearful to be a passive victim of a stronger force than it is to undergo inner loss and indeed a kind of inner death which precedes the birth of new capacities. Because the tender fragile trusting raw clay shape is gone forever once it is submitted to the fire. We have to be willing to sacrifice it to the next level of its maturity.

It takes a lot of time and a lot of energy. It is slow and painstaking work. It is a full-time job. Leisure time? That's a laugh. Who has any leisure time?

Yet it is difficult to say what we are doing when we are doing this kind of work. We are trying to move into a new relation to The Power Who flows in us. People act as

if nuclear power is all OUT THERE somewhere, stored in big bombs. They don't realize that we are all WALKING STOCKPILES. Every nucleus in our bodies is full of THAT STUFF. NO WONDER WE CAN DO SO MUCH DAMAGE AND SO MUCH GOOD TO EACH OTHER. No wonder we are scared to death most of the time, and for good reason. No wonder we keep our legs crossed, our eyes veiled, and our step measured; we have to let out our line a little at a time, a little at a time, or we'll EXPLODE. Our unconscious inner controls know this, and the guy at the panel lets only as much juice through as he thinks we can handle. A power failure doesn't mean there isn't any power; it means THERE'S TOO MUCH for the available carriers. Now, what we've got to do as writer-craftsmen is have a care for ourselves as carriers of consciousness and the powerlines of interaction. They are the way things are. They are the form and structure of our plight. We can grow in our capacity to contain and handle them humanly. This is what it's all about, as far as I'm concerned. Again, it is not a matter of control and management. It is a matter of *awaking within* The Source.

What is writing, if it is not the countenance of our daily experience: sensuous, contemplative, imaginary, what we see and hear, dream of, how it strikes us, how it comes into us, travels through us, and emerges in some language hopefully useful to others.

DESIGN: what does the word mean? DA-SEIN. *To be there, to be there.* CRAFT: what does it mean? It means *strength, power, ability.* HAND: *manus, manual, manu, mana,* MAN. Play the scale, it's the music of our spheres: *Designer-handcraftsmen.* To be there: a man in his being as a man, his *mana,* his spirit-power, the power of his magic. To be there as humanized power: not nuclear power merely, but humanized power. That is the meaning of our names.

And this brings me to where the intersection between writing and handcraft seems to me really to lie: it is in the quality of CARING. Really what moves me in the craftsman's contribution to society is his *caring.* Caring: about the vessel, the robe, the ornament, the tool, the table, the stool, the emblem, the food, the room. This seems important to the feeling of how writing is a handcraft — because of course writing is very much an expression of caring — of being uncool — of having an impulse to move toward self, toward others, to move in relation to what one thinks and feels and perceives.

We are not talking about passion or personal involvement. We are talking about an ability to respond humanly, which sometimes requires the sacrifice of one personal feeling to another. To act not just as a force, but as a humanized force — not a "sys-

tem" or a "game" or a god or a demon or a gnome, but a human being. Now to come to dwell in oneself consciously as a *human* being, neither brute nor angel, this is a path of inner development.

And the world seems to be arranged in such a way that the inside lies outside. If we want to get the feel of something we may have to *handle* it. Or, as the old saying goes, insight waits upon action.

(This is a helpful reminder when we are about to explore new territory. It is not so hard to learn what is already known. But how to find our way in the dark . . .)

Where does caring come from? What gives it birth? Surely not the head, the brain. It seems to come partly from the natural pleasure in handling materials — working the clay, throwing or building the pot, cutting the wood, planing, tooling, sanding, waxing, staining, fitting, joining. Handling fibers — tasting colors. Textures. Choosing. Participating. Being involved and connected.

An opportunity to respond to an organic material is an opportunity to care. To respond to the life in nature and each other. To be given a chance to say Yes and No, to speak for ourselves, to hear our own voice in the vast mosaic of our culture.

Caring comes from our bodies and their sensations — the pleasures of making and doing.

Caring also comes from the heart: making something for a place, for an occasion, for others. What we and others do enriches our association. Enhances our environment. Infuses it with personal warmth.

Caring also comes from the spirit — from conscience — from the sense of what it means to live as a human being in a world of human beings. When our enjoyment is unsure, we may still care because we know that what we do is useful. It is useful to infuse our lives with the personally created object. In the vast collective mass, to awaken a sense of the unique human being and his individual contribution.

Perhaps most of our caring, as craftsmen, is unconscious and implicit, but I hope that it may become more and more conscious — that the influence of our individual caring may be faithful against the currents of indifference and coldness and heartlessness in our world.

There is this quality available to the craftsman which is of the utmost importance to our personal growth and therefore to the growth of values in society. We must be vigilant to keep our human caring alive.

It is easier, I think, to make a pot or a painting or a weaving or a bracelet or a chair or a poem or a house than it is to create ourselves — and yet it is the creation of

being which is our human craft. The world is changing — but are we changing? And if so, how? If life is the greatest art or craft, then as human craftsmen we seek to know ourselves and to do what we can do to embody the strivings of our souls. In the Orient there is a saying that "Transformation is the aim and purpose of all practice." This is a big order . . . to move slowly toward friendship with what is unfamiliar or shameful in ourselves, as well as toward concern for others.

*Whatever is real must be built again.* Writers have made their page by hand, with care for the color and the look of it, with care for the paper or the skin, for the ink and pigment. The poet has had a care for his instrument and his voice and his song. The man of knowledge has had a care for wisdom, the storyteller for his audience, the dancer for his gods.

Much of what man has done in his history has come about through unconscious natural necessity. The handcrafts arose in such a way — out of need and circumstance. They arose *naturally*. Now the handcrafts are practiced in our society largely by conscious choice. Historically, they are an anachronism in a machine age. Spiritually, they are basic to life, and, I think, prophetic of a reconfirming of human sources. They express the truth of the saying: Whatever is real must be built again. We need not be *victims* of history; we may be *makers* of history. We need not submit mindlessly to the trends and fashions of the times. We can consciously initiate and reinitiate values. We can persevere *in the work of our hands. It makes a difference.* This we all know.

The handcrafts bear witness to the soul qualities that flow through physical materials. It is the craftsman's privilege to choose to live in the world as a person — with human caring and human touch.

Ah touch! — there's the rub! Touch. To have the touch. To be touched. A sure touch. A warm touch. A sensitive touch — shy, delicate, tender to the touch. All of it — let all of it in — the quavering, violent touch. The wild, the passionate touch. That's how you know it's us — it's human. Now we can live. Now we can know each other and live. Earnest, dark, hale and ill, true and false; for better or worse, in sickness and in health, for richer and poorer — the full dish of animate clay.

This doesn't mean that our troubles are over if we surround ourselves with handmade objects, or if we devote ourselves exclusively to handwork. The craft object, like any other, can become a status symbol. And we can be seduced into isolation by the life of imagination and making, as easily as by any other. If all our sensitivity goes into the fine line of our drawing or the sumptuousness of our glaze or the allure of our con-

cepts, we may be as vulnerable to lies and callousness as the next person. What is important is the transformation of our sensitivity into human capacity. We have to keep our eyes on the true goal: the crafts may be the path we walk. The goal is . . . to extend our caring from the center through all the parts. This does not happen of itself. It is a discipline of inner plasticity and shaping. It is a craft without end.

# III

In the spring of 1966 I was asked by Robert Mather, program chairman, if I would speak to the Eastern Pennsylvania Association of Occupational Therapists. I felt equipped, however modestly, by having come into such close fellowship with my own disabilities.

I met Robert Mather at a talk I gave in Wallingford, Pennsylvania, at the Arts Center. This had been arranged by Paulus Berensohn, who was founder and teacher of the Wallingford Potters' Guild, and a special friend and co-worker. Some of his students and members of the Guild were occupational therapists, and I had met them in the pot shop, and some of us — Louise Davis and Mary del Bello — had worked in clay together. At Wallingford I read some poems and showed some work in clay as part of my lecture. Afterwards Robert Mather asked me whether I would speak at a dinner meeting of OTEP at Valley Forge Officers' Club, on May 19, 1966. I said I would, and that I would like to bring some clay things, but that in such a big hall with so many people, maybe they wouldn't be visible. But we decided I should do what I needed to do. People could come up afterwards to look at things and talk about them.

Ever since the catastrophes of summer 1964, my soul seemed to have lost its adaptation for anything that wasn't pretty simple and personally real. Still in 1966 I could not bear to use a typewriter (or potter's wheel), and wrote out my talks in longhand, in colored pencils, on colored paper. I had low tolerance for formalisms and asbtractions. I got immense mileage out of very small things. The slightest contact reverberated like a deep meditation. I wondered if life had moved me into the CROSSWAY, and I was singing out gently for others who wanted to know where I was. So I took along to Valley Forge some things I had made with my hands in order to keep the record straight: that talking is difficult and is only one way we communicate or perceive, and that work in clay and songs could help us to wake in that Threshold Place where communication flows through all its forms, like light through water, moving and implicit.

After the evening, I went home with Ursel Pietzner to Beaver Run Village for Mentally Handicapped Children. I asked her how she liked my talk. She said, "It was *wesentlich*." Since I didn't know what *wesentlich* meant, I wasn't much better off. I asked Carlo Pietzner what it meant. He said, "Oh, it's very *wesentlich* to be *wesentlich*."

# Occupational Therapy

I have a good friend who advised me that when one makes a speech one should be careful to make *just one point*. Be clear! Don't overload! Give something which can be clearly grasped and taken home. . . .

Well — I thought a lot about this in pondering what I would say to you tonight. And I realized gradually that that is not my way. I have not come here to make a point, to give you a solution to your problems. But I *have* come hoping to create a certain mood. A certain spirit I will try to offer: in a picture of occupational therapy which fills both *occupation* and *therapy* with life: as a kind of work *one stands within as a person:* like a wick in a candle flame.

This is something I want to urge you to consider: that we *stand within* our lives, and that what we do is therefore imbued with, afire with, who we are. We then create the substance of our deeds and of our thoughts and decisions out of our *human* substance — our relation to the world a *human personal* relation, acknowledged and not covered over with masks.

Occupational Therapy has a kind of built-in apology for itself, very often — why is that? Have the O.T.'s brought themselves into center (as we say in pottery) as teachers and healers and artists and craftsmen?

There is this temptation these days to belittle man's occupations: as if the life and dignity had died away somehow. I met with a design class at Alfred University recently, and they said they were changing its name to Art because Design didn't seem to attract people! There are these emotional squeezes on words, e.g. "business," "politics," "statesmanship," "poetry," depending on who is speaking, which occupation will be mocked at and abused. Can't we look at a vocation and see what its possibilities are? its *human* possibilities? before we dismiss it?

A new birth of the *occupations* of man!: related to a new spirit within man, a risen sense of who he is.

Robert Mather asked me to come to speak to you. "What do you want me to talk about?" I asked him. "Just say what you know," he answered.

What I know? What do I know? "You know," he said, "it's not the clay we are forming, it's the soul." "Oh yes," I said, "I do know that." (For hadn't I written that in

27

my book *Centering*: "It's not our pots we are forming but ourselves"?)

What else? Oh I know too that therapy may bear within it the artistic impulse of poetry and making; that education may be an art of healing; that to be whole is to be vulnerable and to be normal is to be handicapped.

So I am going to sing you a song tonight — a longish song — and then the clay, which is language too, will sing its part of the song —

and I hope you will see how connected these two impulses are: of song and of clay:

the inner ear and the moving hand.

Who was it spoke of sculpture as "frozen music"?

When Robert Mather invited me to meet with you tonight, I gathered from him that what was hoped for was a kind of engineering: building bridges between diagnostician, physician, psychiatrist, occupational therapist:

relating occupational therapy to the larger medical and therapeutic situation.

We can do that by seeing occupational therapy in a certain light: that precisely here, in an impulse that combines bodily skills, feelings (of interest and pleasure and value), and the uniqueness of the individual — precisely here in the body, the soul, and the spirit — is the center of our concern. To be healed and cared for through one's occupation: is this not a seed-thought worth tending?

I am not an occupational therapist, so how can I speak to this thought? Well, I've done a lot of teaching and living and pondering: teaching in both the verbal arts and in pottery; living both with others and alone; and I have had some modest but very real experience with the mentally handicapped, as well as great gobs of experience with the handicaps of the rest of us — the so-called normal citizens.

The occupational therapist is concerned with human be-ing, and with helping to bring it into activity — the occupational therapist is not devoted to manufacture as such nor to activity as such — but pays his attention to the whole story and its human source.

He helps the person to direct himself to an activity of an artistic nature: painting, ceramics, model building, mosaic, enameling, leatherwork — activities which awaken in the person a meaningful process — directed toward a goal and a value of some kind, however secret and inner: by supplying materials and helpful instruction. Okay. Good. It's probably not possible to generalize much beyond that since each individual's way is

unique, each person's problem and solution are unique. It takes a golden ear to hear the cry of soul written in our silences.

To roll the stone away, and bid the buried life to rise!

The Buried Life!

I would like to read you a poem called "The Buried Life" by Matthew Arnold, an English poet and educator (therapist?) of the last century:

### THE BURIED LIFE

Light flows our war of mocking words, and yet,
Behold, with tears mine eyes are wet!
I feel a nameless sadness o'er me roll.
Yes, yes, we know that we can jest,
We know, we know that we can smile!
But there's a something in this breast
To which thy light words bring no rest,
And thy gay smiles no anodyne.
Give me thy hand, and hush awhile,
And turn these limpid eyes on mine,
And let me read there, love! thy inmost soul.

Alas! is even love too weak
To unlock the heart and let it speak?
Are even lovers powerless to reveal
To one another what indeed they feel?
I knew the mass of men concealed
Their thoughts, for fear that if revealed
They would by other men be met
With blank indifference, or with blame reproved;
I knew they lived and moved
Tricked in disguises, alien to the rest
Of men, and alien to themselves — and yet
The same heart beats in every human breast!
But we, my love! — doth a like spell benumb
Our hearts, our voices? — must we too be dumb?

Ah! well for us, if even we,
Even for a moment, can get free

29

Our heart, and have our lips unchained;
For that which seals them hath been deep-ordained.

Fate, which foresaw
How frivolous a baby man would be —
By what distractions he would be possessed,
How he would pour himself in every strife,
And well-nigh change his own identity —
That it might keep from his capricious play
His genuine self, and force him to obey
Even in his own despite his being's law,
Bade through the deep recesses of our breast
The unregarded river of our life
Pursue with indiscernible flow its way;
And that we should not see
The buried stream, and seem to be
Eddying at large in blind uncertainty,
Though driving on with it eternally.

But often, in the world's most crowded streets,
But often, in the din of strife,
There rises an unspeakable desire
After the knowledge of our buried life;
A thirst to spend our fire and restless force
In tracking out our true, original course;
A longing to inquire
Into the mystery of this heart which beats
So wild, so deep in us — to know
Whence our lives come and where they go.
And many a man in his own breast then delves,
But deep enough, alas! none ever mines.
And we have been on many thousand lines;
And we have shown, on each, spirit and power;
But hardly have we, for one little hour,
Been on our own line, have we been ourselves —
Hardly had skill to utter one of all
The nameless feelings that course through our breast,
But they course on forever unexpressed.

And long we try in vain to speak and act
Our hidden self, and what we say and do
Is eloquent, is well — but 'tis not true!
And then we will no more be racked
With inward striving, and demand
Of all the thousand nothings of the hour
Their stupefying power;
Ah yes, and they benumb us at our call!
Yet still, from time to time, vague and forlorn,
From the soul's subterranean depth upborne
As from an infinitely distant land,
Come airs, and floating echoes, and convey
A melancholy into all our day.

Only — but this is rare —
When a beloved hand is laid in ours,
When, jaded with the rush and glare
Of the interminable hours,
Our eyes can in another's eyes read clear,
When our world-deafened ear
Is by the tones of a loved voice caressed —
A bolt is shot back somewhere in our breast,
And a lost pulse of feeling stirs again.
The eye sinks inward, and the heart beats plain,
And what we mean, we say, and what we would, we know.
A man becomes aware of his life's flow,
And hears its winding murmur; and he sees
The meadows where it glides, the sun, the breeze.

And there arrives a lull in the hot race
Wherein he doth for ever chase
That flying and elusive shadow, rest.
An air of coolness plays upon his face,
And an unwonted calm pervades his breast.
And then he thinks he knows
The hills where his life rose,
And the sea where it goes.

*"A bolt is shot back somewhere in our breast"*
a portal is opened: Who stirs within? — my
    life-line, the current of my being,
    my inner light, my
    spirit
        wakes
Wakes how? wakes to whom?
    to the *presence* of another.
Light wakes to light.

"An act of the self, from me to you. From center to center. We must mean what we say, from our innermost heart to the outermost galaxy. Otherwise we are lost and dizzy in a maze of reflections. We carry light within us. There is no need merely to reflect. Others carry light within them. These lights must wake to each other. My face is real. Yours is. Let us find our way to our initiative." (*Centering*, p. 18)

Not everyone agrees that art should be used in a therapy situation. Some artists, some teachers, some doctors think it is demeaning to the seriousness of art to apply it as a kind of medicine or mending tape.

I think they are wrong. The artistic experience is central to the human being, because it is the affirmation of his inner life: an externalizing of the inner man in ways that are not basically rational though they are coherent and organic. An affirmation of the nonverbal sources of our awareness and our feelings. I have always held that poets are inarticulate — what they want to say strains at the body of the word like a baby in the body of its mother — life seeking to be born into the world out of the WORD.

Artistic experience is central to the human being and where it is sleeping, it should be awakened however modestly — for it is the person who will awake — and be strengthened — and aided in his growth and development.

Growth and development are fostered through art. As with most of us, it may depend upon who teaches us and how much we can do for ourselves. We may be very anxious because it is not so often that we are invited to stand for the free spirit within us. There are certainly many things to consider.

But I know that creativity takes many forms: the inner being working with the materials he has been given, to transform them into further stages of inner growth. When you work with handicapped children, you know there is no greater wonder and joy in creativity than when you see a severely damaged child who has been helpless

begin to feed himself. Just that: to see a little person able to lift his own spoon to his own lips and not spill. You know the difficulties overcome, what inner effort and will — you are awestruck with the mystery and the meaning — with thanksgiving.

> "The creative spirit creates with whatever materials are present. With food, with children, with building blocks, with speech, with thoughts, with pigment, with an umbrella, or a wineglass, or a torch. We are not craftsmen only during studio hours. Any more than a man is wise only in his library. Or devout only in church. The material is not the sign of the creative feeling for life: of the warmth and sympathy and reverence which foster being; techniques are not the sign; 'art' is not the sign. The sign is the light that dwells within the act, whatever its nature or its medium." (*Centering*, p. 12)

From the Rose Valley school, the children of the first grade filed anxiously down the steps, past the chicken house, to the marshy spot in the woods. There lay Petey, the gloriously plumed bantam rooster, dead. The culprit was still hovering around — a German shepherd, with blood on his jowls. The children gathered around, looking and wondering. Every day they had fed Petey and petted him, but now they could do nothing. Helpless, one of the boys suggested that at least "we should take off our hats." "But I don't *have* a hat!" worried one child. "Then take off your coat," another suggested. Relieved, he slipped it off and pressed it to his chest. (Adapted from a news item in *The School in Rose Valley Parents' Bulletin*, May 1966)

*Therapy* is the art of holding one another, caring for, supporting. It comes from a word that means just that: to carry, support. The same root is found in *throne*. But the support is by a person, not by crutches or a stretcher. The quality of caring for others is healing in the deepest and most accurate sense.

As James Baldwin once wrote, "The moment we cease to hold each other, the moment we break faith with one another, the sea engulfs us and the light goes out."

> "There is a wonderful legend in Jewish Hasidism that in the beginning when God poured out his grace, man was not able to stand firm before the fullness and the vessels broke and sparks fell out of them into all things. And shells formed around them. This is the *shekinah*, the world of forms. By our hallowing, we may help to free these sparks. They lie everywhere, in our tools, in our food, in our clothes. . . . A kind of radiance in things, a Being, an emanation, a freedom, something that fills our hearts with joy and gratitude no matter how it may strike our judgment! There is a Being within man who seeks this joy. Who knows this joy. Joy is different from happiness. I am not talking

33

about happiness. I am talking about joy. How, when the mind stops its circling, we say yes, yes to what we behold." (*Centering*, p. 13)

What do we behold? And what are we doing when we are beholding?

We are beholding what is revealed — *the child holding his coat to his breast in honor of a dead chicken* — what is shining out with its own light — what is therefore beautiful. For that is *beautiful* which reveals itself — which shines forth, *schön*. It has not to do with prettiness or unattractiveness. What is revealed may be horrible indeed, horrible and heartbreaking, cruel and tragic: Iphigenia may have to be sacrificed for the winds to be freed for her father Agamemnon's troopships; Persephone may be carried off to Pluto's kingdom, and the earth waste in grieving; the young princes may be murdered in the tower; we may grow old or fat or witless or corrupt; our trust may be betrayed. Yet when we are able to behold the leper and warm him between our breasts, as did St. Julian in Flaubert's story, ah then we behold the mysterious workings of the Gods.

It all tumbles up out of the center like the fountain of life out of the center of a rose — tumbling and speaking in tongues of flame like the petals of the rose —

How the artist is a see-er: one who beholds — not with the eyes alone, indeed he may be blind like Homer or Milton, deaf like Beethoven — a seer: one who sees beauty, that is, one who sees the light which shines from within. One who sees it: cares for it, attends it, supports it

is therefore THERAPIST.

How freely we may live then, we human beings:

sufferers:

Artists: beholding each other and offering our caring:

Therapists:

The *therapeutae* were young ascetics of both sexes nearby ancient Alexandria, who were devoted to contemplation and meditation.

*Meditation:* and what has that to do with medicine and therapy and doctoring?

Oh my dear friends, the beautiful flow of languages and meanings in our lives: like an organism, a living being, growing and changing and connected, always connected.

One world: One tongue.

Look! Listen! Take the word *physician*. Where does it come from? What does it mean? Ah that is as precious a question as it is when we ask of one another where we have come from and how we are to be understood.

34

We may feel our way into an understanding like poets, feeling all around the edge of a word, testing its ring, studying its gloss or dryness, handling it, feeling our sense of meaning begin to flicker and then glow, we know it by its warmth, a sense of something living, something sharing a quality that feels like our most intimate and spontaneous and personal consciousness, like when we first wake in the morning into ourselves and say Yes, this is I. And we feel the warmth of our bodies and the presence of the dream that has been the occupation of our soul during the night. What a small delicious daily thing, what an actuality, the sense of life and meaning and identity, felt from the inside.

It is like that, reaching into the inner life of words, their sleep, their dreaming, what lives in them more than meets the eye, what secret beings they are till we begin to wake to each other: the words and we in whom they resound.

*Physician* comes from the Greek word for nature, *physis*. The stem of this word, *bhu*, means *to grow, to produce*. From the same stem come *to be* and *being*. The physician then was a student of nature — he was a philosopher of being: his province was the wholeness of life: there was no part of nature that was not living being.*

*Doctor* comes from the same word as *educate* and *teach*. The men who were called the Doctors of the Church were the great philosophers and theologians who taught. The only physicians entitled to the calling of Doctor in the medieval medical schools were those who taught. To be able to teach is to be able to show others. *To show* comes back again to *schauen*, to behold. We show others what we ourselves behold. We are doctors when we are artists and teachers.

*Medicine* and *medical* are terribly interesting words: what a rich inner life they have! Suffice it to say that they come from a Latin word meaning *to care (mederi)* which is sister to the word for meditation *(meditari)*. These are both rooted in an ancient Iranian word for a grain measure!

*Care* then is related to *medicine* and to *meditation*: just as *care* and *contemplation* are related to *therapy*. It is interesting that the emotional qualities of loving care and concern for others are primary — as are the powers to behold, to grow, and to be.

There are two more words that I want to draw your attention to for the wisdom to be found in them. The first Greek word for physician is *iatros*. "The origin of *iatros* is dubious," writes Hillman, "but there is authoritative opinion saying that it means 'he who rewarms'; the *iatros* is the one who stirs up and reanimates. . . . *Iatros* is said to be akin to *ira*, the Latin concept of anger, aggression, the spirit of will, of power, tem-

---

* In this "matter of words," I am indebted to a chapter in James Hillman's *Suicide and the Soul*, which added to my own research.

per, wrath, irascibility. *'Psychiatrist' thus would mean animator or inspirer of the psyche.* He brings back warmth and temper by stimulation and excitement."

The therapist "has recourse to his own spirit and soul (*anima*) in order to bring warmth and life to the patient." The white coat, the medical atmosphere, should not prevent this emotional involvement. "If we can judge from this root *iatros*, it is the task of the healer to inspire, animate, and kindle emotion."

The other word is *pathology*, which means literally the study of suffering. The ancient source of that word is the same as for *patient* and *patience*, and means *long-drawn-out*, as the tension of a bowstring. The patience to endure suffering is part of the health of the soul. Health does not exclude illness, for illness is part of our wholeness.

Whole, heal, health, hale, holy — here is another family of sounds that breathe their undulations of meaning like a shell to which we put our ear.

SOUND — didn't I say we might try tonight to come like poets into our thinking and our feeling and our understanding?

And this is one of the most joyful mysteries to me: that a word for Sound in German, TON, means both tone

and

CLAY.

And this, I hope, may drive you quite out of your heads and into your ears and your imaginations, that the common quality of TONE and CLAY is their *stretch,* their *stretching,* their *drawn-out-ness,* their plasticity.

Their ancient root is TA: to stretch. We hear it not only in *tone,* but in *tendon, tension.* The Latin word *tono* means to resound, and *tonens* is thunder, the thunderer, the thunderer-God Jupiter! And here we are

back with the Gods
who thunder
and whose thunderous tones
dwell in the plasticity
of our clay.

Need we ask ourselves what we are doing, ladies and gentlemen, when we are doing occupational therapy? If we need to ask, there is plenty to answer from within.

Shall we say that we are affirming individual being

shall we say we are healing by increasing the ability to live in pain

shall we say that we are teaching

shall we say that we are supporting and attending and caring

shall we say that we are concentrating on the souls in our charge, seeking to wake to their wounds and their light, to hear their wounds speak, to be led by their light to that part of us who stands in darkness.

Actually we are all patients and therapists at the same time: just as we are both teaching and learning at the same time, teachers and pupils.

"In antiquity the physician healed through his own suffering, as Christ healed through his.

"The wound that would not heal was a well of cures." It is from our wounds that our compassion flows. One cannot claim compassion and feel no pain. The capacity to be wounded, to be vulnerable: this is part of what equips us in our caring. "The wound, as poetry often tells us, is a mouth and the therapist need only listen." If we are to be healthy patients and patient therapists, we must unseal our mouths and let them weep afresh.

Suffering is part of our health because it means we are *in life*, willing *to undergo*. That's what *to suffer* means, it means to undergo, to be involved, not to "cop out." To avoid the sufferings of our woe and guilt, to eliminate the bruises and the defects and the obstacles, endangers our wholeness and our health. Who was the sage who said that symptom is part of cure?

I long ago learned that the bonds between us are the bonds of our need for each other. It is not our strengths (in the popular sense of big muscles and status-success, or The Cool) that bind us together in mutual caring, but our weaknesses and our needs. This truth was dramatically acted out by millions of people the night of the Blackout, the night in November 1965 when the power went off all over the Northeast. When the power went off, people began to care for one another. Tenderness and generosity and resourcefulness were in the air, a willingness to show concern for others and personal feeling. These did not remain. When the power went on again, so did the masks.

Our so-called weaknesses are indeed the sinew of our humanity if we are able to ask for the help we need. These make the bonds, these create the relationships — this is our plasticity — these the bridges between us — our speaking mouths — where we can extend our selves like tones, like clay, stretching across.

What is sometimes called the *web* of life, the *fabric* of life, its *composition* and *interweaving*: how finely wrought it is . . . how exquisite is the timing of our ordeals and our overcoming.

To live like clay, *in tension*, this is part of life's wisdom: to live with our fibers outstretched and played by the breath: all the songs of mankind.

37

This is why I say in my book *Centering:* "I do not know if I am a philosopher, but if philosophy is the love of wisdom, then I am a philosopher, because I love wisdom and that is why I love the crafts, because they are wise."

The occupational therapist's caring regard for the things made by the souls in his charge would, I should think, be unflinching — faithful and constant — as, I should think, would be the regard of anyone who teaches and heals. Contempt and disdain, however disguised, are further wounds to the soul, particularly virulent when directed upon oneself.

An individual who is feeling his way into deeds, into deeds of his body, into living will, is a vision to be held in trust.

It is not the pots we are forming but ourselves.

I do not know if I have been of any help to you tonight but my hope has been to strengthen your inspiration and your good faith.

I cannot tell you anything about your profession, it would be presumptuous of me to think so —

You are the hosts giving aid to those in need — I am the pilgrim who sings your deeds.

> Sing of the terror
>> Sing dismemberment
> Sing rage and folly
> Sing of childlike innocence
>> and its rape
> Sing of chosen innocence
>> and its goodness
> Sing of the cramp
>> the withdrawal
> of loving
> Sing of love betrayed
>> of starvation
> Sing the mouthful
>> of wonder
> Sing tightlips
>> and torture
> Sing damnation
> Sing the singer's
>> commitment
>> to song.

38

Sing the terrors
    Sing the decline
Sing devastation
    and ruin
Sing the epileptic and mongol
    the hydrocephalic and autistic
Sing illness suffering
    abandonment
    Sing death
    Sing handicaps
    and trials

SING SPIRIT AND AWAKENING

Sing
    consciousness in the body
    awakeness in the soul
Sing warmth in the
    heart
and radiance in the
    mind
Sing the inner light in
    the membrane
    and tissue
that lights up to welcome
    the clay and its
    plasticity
the plasticity in the tissue
    that is awakened
    by the clay
the sculptor sleeping in
    the hand
    the sculptress
    stroked tenderly
into waking and wonder
    and the piece,
    that has been made
Piece-makers
Peace-makers

The occupational therapists work with all the ages and afflictions of man: the aged, the crippled, the retarded, the diseased, the recovering.

They start with an artistic feeling, an artistic intuition of the creative spirit within every person: a sense of the obstacles that stand in its way, an insight into symptoms, a response to its suffering. The therapists know that illness is part of the whole story. What could we do without it? How could we grow without the blows that lay us low?

Common clay! This is a language too. Listen! We shape it with the gestures of our hands and feel our innnerness rising to meet it. We feel the sculptor living in the movements of our hands. We hold a piece of clay quietly in our hand, rubbing it softly, stroking it, smashing it, forming it, and we feel a dialogue begin. Listen: who is speaking?

This process resembles the speech of our throats: how the column of air is shaped by the larynx and by the tongue and lips. It is all motion and sound and our warm pulse. Clay is a language too.

Now let it tell you more of the story.

(The lecture closed with an exhibition of clay vessels, objects, and beings.)

# IV

In September of 1966, I was invited by Vilma Harrington, of the Community Church in New York City, to lead a retreat of Unitarian Universalist Women, at Senexet, Connecticut. Since I was innocent both of "retreats" and of Unitarian Universalists, it worked out pretty well.

In October I was invited by members of the Wallingford Potters' Guild to lead them in a Clay Retreat. It was a fruitful challenge. We spent the week end together at the Art Center, cooking our meals and sleeping on the floor, to keep the form of our retreat intact. Certain exercises in clay and inner source I tried out there for the first time: working, for example, from a sound, from a feeling for a particular space (clay hung across a window, for example, or off the edge of a table), to hold a particular object (like a shadow) or to fill something (like a seedpod).

In November I left for England, to study projective geometry and plant growth with Olive Whicher for four weeks at Emerson College in Sussex. I had met Miss Whicher earlier in the year in this country, had read with great excitement the book she and George Adams wrote, *The Plant Between Sun and Earth,* and had taken a summer workshop with her at Threefold Farm in Spring Valley, New York. It seemed to me that I had come upon the mathematical counterparts to the intuitions upon which my book *Centering* was based. These experiences influenced what I had to say when I returned from England in March 1967 to speak to graduate students in Art Education at Pennsylvania State University.

Edward Mattil, then head of the Department of Art Education there, asked me to prepare a lecture which could afterwards be printed, and I took this as an opportunity to create a text which would be alive on the page as well as in speech. The visual experience of the page served the purposes of both *score* and *canvas* — perhaps even of a sculptural impulse to model the page, according to the breath of the phrasing, and the dynamics of meaning and emphasis. I used the two colors of my typewriter ribbon and the space of the page as my materials. I also wanted to assimilate into the flow of the talk the different moods of "voice," rather than limiting myself to the monochrome delivery of lecture models. I moved therefore as naturally as I could through a continuity of poetry and story and exposition to the closing prayer and sung song. This was the first time that I had made a song to sing as part of a lecture. This one seems to me to have in its form the flavor of a "spiritual." Also for this occasion I wanted to connect the talk with the Easter season in which it occurred.

I gave this talk at Penn State in March, 1967, and at Swarthmore College and Rhode Island College in April, 1967. Later, the text was published (with an introduction by Professor Mary E. Godfrey) as No. 3 in the series "Penn State Papers in Art Education." As presented in this volume, it follows the original typescript.

# The Crossing Point:
## Nine Easter Letters on the Art of Education

i
Ladies and Gentlemen,

I want to talk to you about
    art education and the art of education
about
    the relation of art to education as a whole
    education of the whole person
        to extend the feeling for art to include
            all the arts:
                    song, dance, theater,
            drawing, modeling, handcraft,
            building,
                indeed the arts of
            government and of community,
            the arts of conflict,
                of history,
            the art of science,
                of prophecy and prayer,
            the arts of teaching and learning.

ii
In New York City

I sat in my bathtub thinking about this talk,
and looking at the bouquet of four red anemones and one blue one on my table
and thinking about being home in America again and
the people I want to see before I return to England April 15,
and I suddenly understood that this talk was going to have to

bear witness to

my feeling about heart and art, about living and arting, and I had a
vision of how I would bring a bouquet of beautiful flowers when I
came to meet you and I would make bread and bring it too,
I thought of making many small loaves which would have the forms of
letters and numbers possibly, and then I said

education is the art of inner enjoyment
art education is festivals and ceremonies. When your pet hamster dies
or you find a dead bird, and you have to have a funeral, and you make
a parade with your friends, and a shroud and a casket and a hole in a
special place and a grave marker of some kind, and you pass around
food and maybe do a dance or write things on pieces of paper to put
in the grave, or some treasured object, and sing a prayer for the
beloved creature, that's art education. Or when your dearest and
most trusted friend and sweetheart walks out on you and you have to
know what to do with that material, or you have it there in your lap
at least, in your heart, a big rough raw crude stone, and you have to
shape it into something that will be true to what has happened and
not just a dead weight, that's art education.

or spring, what do you do about that?

OR THE FIRST TIME YOU GO ON THE SUBWAY ALONE

or if you have a nightmare

OR, BURN, THE, COOKIES,

I mean, what is there to do about anything
besides gulp or yawn or go to sleep

43

or eat something or smoke something
or drink something or go for a walk
or call up a friend or have a daydream
or jingle your keys
or count your money
or wish you were high or dead or something

doesn't art education have to do with the way you

plant flowers or pick flowers or give them to people or receive them

and not just the way you see them or paint them or look at paintings

of them or read poems about them and go all moony

doesn't art education have something to do with knowing that autumn

is really a form of spring, when the plants sow their seeds, and winter
is part of it too, everything is hatching underground and getting
ready for the ascent into the visible world, and isn't it too about
remembering what we know very well, namely, that things are going
a long time before they're visible, and a long time after

there is something important in art education about light and shadow

this whole chiaroscuro art, and perspective, and seeing how
WHERE THERE IS LIGHT THERE IS ALWAYS SHADOW, there must be

and vice versa

there must always be a shadow or else watch out

44

this is one of the many truths art education teaches . . . psychology,
especially the depth psychology of C. G. Jung, is beginning to
stress this, to integrate the shadow into the picture . . .
theology hems and haws and worries about it, calls it the
problem of evil . . . BUT ARTISTS KNOW, ART EDUCATORS KNOW,
BECAUSE THEY TEND TO LOOK AROUND AND SEE HOW THINGS REALLY
ARE AND WHAT THEY REALLY LOOK LIKE, INSTEAD OF WORRYING
SO MUCH. Mostly, it seems to me, artists and art educators
KNOW IT IS VERY HARD TO DO SO BECAUSE IT IS ALWAYS CHANGING
SHAPE AS THE LIGHT MOVES. Art educators know that pictures
are subtle, like life, full of PLAY — it is very hard to
make verbal formulas about them fortunately

iii
I went to college for 9 years and might be there yet if I hadn't
unwittingly completed my work, and then been hired as a member of the
faculty in English.

I liked school. I was what they call docile,
i.e. teachable, though I was not docile in other ways. I failed in
deportment and application, but did well in my studies. That was the
first indication I had that morals could not be judged by success.
Also that success could not be used as a moral bribe. Also that
brightness and disobedience have an affinity for each other —

There
was a brief time of a few years when I thought I would be a student
of Oriental languages in order to learn to write with a paintbrush
and make paintings at the same time that I was writing which seemed
a natural way of doing things, and also to translate into English
the beautiful poems of the ancient Chinese.

After I had earned my doctorate, I began to teach in different kinds
of schools because I was interested to learn what education was all
about, and how it worked in different places. One thing I soon felt
was that my own work was too bodiless to satisfy me. I was a physical

45

person and my work was too bodiless: mostly I used only my mouth
in talking or my right arm in writing on the blackboard. Poetry must
be more substantial than that!

I didn't want outlets for my energy, I wanted inlets. It was hard
because the propaganda was all toward making me think of myself as
a verbal intellectual type, though I instinctively knew that this
was a small part of the picture. I have been trying to work toward
a true idea of the whole picture, and that is what my book Centering
is about. It turns out it is not so much a picture as an evolving
life-line. The vine.

               The lie that teachers are not artists puzzled me.
All sharp divisions puzzled me, and rivalries. I was not a good
fighter. I used to think it wasn't nice to fight. Now I know we
have to fight for our lives all the time. Usually the fight is an
inner struggle with dragons and cloud-castles, but never mind about
that. The point is, we suffer by being told by others what
we are supposed to be like. Either what we are like, or what we
should be like. It is very hard to survive as a person with all this
pressure on us. It calls for heroism.

We have to keep saying no that's not quite the way it is.
It is very hard to keep saying no and yes at the same time. NO to
what's false and YES to the dialogue. There was a wonderful
woman at Black Mountain College where I worked for several years.
She was Viennese and she taught music. Her name was Johanna Jalowetz
and she had an expression which I think should be taught in the schools
as fundamental to life. She used to say it all the time, no-ja, no-ja,
NO-JA.

One of the reasons I went to Black Mountain College from the University
of Chicago was to get some more body into my life as teacher person
poet etc. At Black Mountain we had to do all our work, maintaining
the grounds, office work, the farm, preparing programs and parties.
It was a whole life of working out of a common center, and into one.

46

Life is physical, that's what makes it artistic. That's what makes
artistic practice its central discipline.

Of course it's deeper than that. What makes life artistic in its
physicality is that it is created by inner processes. Inner processes
are generative, life in fact is creative. That is how come science
is an art and the poet writes from a sense of fact. The imagination
is a fact.

After awhile I took up pottery as a craft. I also took up dancing
and woodworking and printing and farming and cooking and sewing and
cutting stencils.

Art and community were instructive forces and shared the rulership
with intellectual skills.

I'll tell you something important that I learned there. It is a
paradox. It is no good getting a bunch of artists and bright people
together and thinking they will solve problems that have been breaking
everybody's back since who knows when. Artists and bright people
are clumsy and ignorant like the rest of us. I learned this at BMC
among other places. People there were always congratulating themselves
on being special — scholars, philosophers, composers, poets, painters,
architects — and meanwhile the place was going to pieces. For awhile
I was very depressed by this and felt cheated by my higher education
which was supposed to have prepared me to lead the good life and look
at me I was a mess, a moral coward; but after a few years of misery
and self-examination, and making pottery, I got through that depression
and learned what it had to tell me: namely, that I had had a false
picture of what it is to be a person. I had thought there was a way
of doing things right, and that was what my education would give me.
I had not been taught about the tragedy of life, about the swing of
life between the light and the dark, about losing everything and
regeneration. I had thought that either all would be won or all would
be lost. No. The gods are not so simpleminded as that.

Now I know that's how you know it's us. We undertake something and
do our best and maybe it doesn't work out. We try again, carry it
a little farther, and collapse. It is not a matter of doing things
right or of succeeding. It is a matter of plasticity, of recommencing,
of pressing on, of taking our punishment without flinching, of feeling
the life-line stir us into activity and awareness for a period and
then return into the darkness. We have our seasons. They are all
part of the picture. So-called failure is a form of success. Without
it we would never get anywhere. Failure is a transformation in the
form of our expectations. It is a reminder that the evolving self is
a deep matter. That is why failure is said to teach humility. It's
like touching home base again. It's like touching a magic stone, it
doesn't look like anything special, but when we touch it we can feel
that it has spiritual power. It deepens our awareness.

Perhaps this is the reason that in the new curriculum we do not want
to pass and fail people in the old sense. It is a delicate matter.
In the curriculum laboratory where I will be working this spring,
in London, they don't talk about cheating, they talk about sharing.

The model for the new curriculum
is in our imaginations;
we are meant to create
the possibilities we envision.

'I referred to the gods a moment ago, and I would like to return to
them for a moment. There is a lot of loose talk going on about the
gods. Well, I'm glad they've come back into our conversation at
least. But I think that when we talk about the gods, we should
remember whom we're talking about. We're talking about a god and
not about our pet hamster whom we loved and who used to comfort us
and now is dead. When we say a god is dead, we have to remember who
a god is. A god is not dead in any ordinary way, even as his living
is not ordinary. Whenever a god dies, we know we must look to see
him rise in another realm.

48

iv

not to let

       bigness and machines

              stupefy us;

to take simple human steps

remembering the power of the small,

           the power of the mustard seed

recently walking on a hillside in Switzerland, I thought of a title
for a book of poems: WRACK AND RUNES. Actually a wrack is a ruin,
and a rune is a character in an ancient Teutonic alphabet, its message
is secret.

Rune 1

4 hens
4 black hens
dance.
Il pleut. It
is raining and weeping.
Ses pieds grattent.
See how the legs tremble and
      paw
backwards
the straw.
How the neck trembles
     and turns
the feathers and flesh
     alive
in the dance.
Come. Come.

Rune 2

How the little bird sings
out of himself
his song.
How long
   it takes me to find him
he is so small in the tree
   so singing in his dance.

Rune 3
how the catkins tremble
    with their shape
        so soft
        in the air
like wattles
    in a dance
the soft combs of hens
        the soft bird
how they dance
    in winter
    to the spring

How they dance
    in winter
    to the spring within them —
the springing up,
        the source and waters,
        well.
Hear it scratching the ground
hear it mounting the tree
see it changing the color
            of twigs.

Rune 4
JADE RABBIT
Yoko Ono told me
    in London
I was born in the year
of The Dragon,
conceived in the year
of The Rabbit.
She said
it is hard
for a woman
to have been born in the year of
The Dragon.
Jade Rabbit,
born to fire,
conceives
in terror and screams.

        v
Why is it that art
        and the art teacher
are so needed today
        in the renewal of education?

I think it is because a new understanding of man is
awakening.
The search for new forms of consciousness is a symptom of this
widespread invasion of the human psyche by new concerns and new
capacities and new struggles to break old patterns.
The artist and art teacher are being asked to accept leadership in
a new curriculum, that is to say in a new course of action. A
curriculum is a running: and a course is a course one runs, in the
double sense of running it as governing it and running it as going
through it.

     To renew curriculum
  is to set a new course
  to set sights anew
  to re-view, re-vise,
  i.e. to have a new vision
     a new way of seeing
     a new understanding.

Art and artists know about this. They know about working where
goals are not clear beforehand but emerge as the work proceeds —
unfold organically out of the working — the dialogue between materials
and person — they know how to live in this mystery of genesis and
generating:
               nourished at the center,
this secret knowledge helps us
to engage in life —
strengthens us in disappointment
and depression and sickness and
  calms us down in flights of conceit;
the artist in us knows it's all part of the story,
understands conflict is
  an element in creation,
knows
  unity in diversity.

Also the artist in us knows, as the child in us knows, about

spontaneity and the revelation in found materials. see what I found
oh LOOK
We do not need to wait for high moments
>money
>inspiration
>good weather
it's happening where we are
>STOP
>LOOK
>LISTEN
>where are you
>what do you see
>what do you hear
>what's happening
>this is the poem
This, this is the poem
>what's happening
This, this is the science
>what is really happening
>going into it carefully in depth
This is the worship
>to celebrate
>as a sacrament
>>what's happening

Artists and art teachers move between clarity and unclarity
as between 2 musical modes — the song is intact whatever
the state of our clarity. examples: one is working on a
painting, or a research paper, one knows what one is doing
in that one sets certain things in motion, yet if asked
to explain or justify, may be unable to be clear verbally.
Clarity in one dimension does not translate easily into
another language: especially from union with an impulse

to observation from a spectator's viewpoint. And yet explanation and elucidation also have their artistic center — and I am working here myself — how to explain and elucidate in a way true to living process. Not to translate the living into corpses in order to make the situation clearer.

> It is no good to be clear about
> what is in fact muddled. The facts of life
> need a round-and-about telling — or, as a
> character in Edward Albee's Zoo Story says,
> you have to go a long way round to come a
> short way back. Peer Gynt too, Peer Gynt
> learned that.

The artist in man knows that we can't suddenly be a certain way — we can't suddenly be free, be independent, be mature, be peaceful. We have to become what we are growing to be. Inner growth takes time. And trust. It takes a sense of the seed forces in ourselves, and some knowledge of the stages of development, seasons, deaths and rebirths, something about a feel for life processes at work, patience. It takes patience and steadiness and humor and commitment, like a farmer has.

Therefore art teachers understand the need both for unsupervised time and for instruction

> they understand that the occupations of one's
leisure are the deepest labors of one's being
> are, indeed, one's work

WE ARE NOT MEANT TO WORK FOR WAGES BUT FOR WHOLENESS
what is wholeness? ah a good question . . .
> it isn't half persons
> it isn't half truths
IT IS A GOOD QUESTION   the question is the quest

Rune 5

Hyde Park, February 5, 1967

LOOK:

The maple trees in Hyde Park
are sending tiny fireballs flying
out the ends of twigs
yet holding by a thread
as Juliet dreamed of holding Romeo,
and sending sparks, tiny, bright at the tips,
a dusk of spring's first aura
thickens in this afternoon.
I look into the lane of crowns
and suddenly light darkens into life,
surfaces of trees flame molten red.
Awakening brims at the verge of sight.
Somewhere overhead some bird is racketing
a dozen voices and as many songs,
what kind of creature steaming so?
I catch him with my eye, a catbird;
and across the space a fat ring-necked dove
purrs and shifts her weight.

Rune 6

I wake after long sleep
to catkins, snowdrops, daffodils.
The night within
turns to day, and yet
the nightness of its knowing
flows within the light.
On waking
I may no more separate my night from day
but feel them breathing
inward and outward.
On waking now
I may not leave the night behind
but see it grow in the ovary
as the snowdrop wilts —
night darkens the white petals,
swells in the seed.

54

On waking
I stand in the door.

vi
In an Irish fairy story
the hero goes a long journey on a shaggy nag
who carries him safely through thick and thin and then asks to be
slain
in order that the threshold to the city be safely crossed and
the trusted horse-sense be allowed to change into its next shape:
a radiant being.
It is especially difficult in our day
to give up the picture one has of oneself and of truth
and to keep ourselves open to transformation.

How does transformation come about? Not only of consciousness but of charac-
ter? This is one of the questions in the new science of man. In my book Centering I
wrestle with it in various ways, through the experiences which have taught me some-
thing: through the potter's craft, the poet's craft, the teacher's craft, and the evolution
of person through the ordeals of life. Someone else would come to the question from
other directions.

The central images in the book are taken from the potter's craft: centering, and
the ordeal by fire. But both are archetypal and occur in other contexts as well. Center-
ing is a term used by the Quakers for a feeling of flowing toward a common center in
their meetings for worship. It is also an ancient Sanskrit term used in spiritual disci-
plines of the East. What it means, I think, is to feel the whole in every part. When you
center clay on the potter's wheel, you take a lump of clay, and by moving it upwards
into a cone and outwards into a plane, you create a condition of balance between the
outside and the inside, so that when you touch the clay at a single point, the whole
mass is affected. Centering has nothing to do with a center as a place. It has to do with
bringing the totality of the clay into an unwobbling pivot, the equilibrium distributed
throughout in an even grain. The substance of the clay has to be brought to a condition
of stillness at the same time that it is spinning, it has to be worked so that there is no
difference in quality between the surface and the interior, a balance between the inner
consistency and influences from without. So that when we stick our fingers into it to
open it up into a vessel, the inside will be as firm and malleable as the outside, and

55

will be able to create a space which will be a container. It is poetic and mysterious and yet very actual and concrete and messy and common clay. COMMON CLAY! WHAT'S THAT?

Centering is a spiritual discipline working through the body, on earth as it is in heaven, as the bard said. It is a dialogue between the clay and the hand, or rather between the clay and the person.

The art of the fire is likewise archetypal: practiced by the alchemists of old, as well as by present-day studio potters, and there is a way of looking at inner development also as an art of the fire.

The goal of alchemy was the transformation of crude substance into refined substance. The alchemists were trying to create a philosopher's stone which would turn lead into gold. The philosopher's stone, they said, contained all the opposites: it was both impermeable and waxlike. It was both indestructible and able to be melted down. It was a stone, but it was a healing unguent as well. Its value was judged by the number of times it could melt down and recoagulate.

That which contains opposite extremes within a whole has healing and transforming properties.

In the potter's art, mud turns to stone. Goosh turns into a vessel. By means of fire.

In life itself, it is the capacity of being open, a feminine receptivity of soul, into which new awareness may play. It is interesting to me that the Greek word for cell is kytos, which means hollow vessel. And it was interesting to the psychologist Jung that the feminine aspect of the soul is least developed among us; part of our task today is to develop it consciously. And it was also interesting to him in this connection that the Catholic Church officially declared the assumption of the Virgin Mary (the feminine) into the heavenly family, indicating a development in the inner world of beings whom he calls Archetypes. He found also an increasing experience of the Christ archetype (the androgyne) in the individual psyche.

Centering is a discipline of surrendering in this sense of receptivity, and of integrating. Moving in from the outside toward a center which is not a space but a function, a balance, a feature; distributing the center itself from within outwards. By undergoing a change on the inside, the clay comes as we say into center: which is a quality, not a place.

It is a discipline because one is often tempted to say "nay" rather than "yea" to life, and centering is a process of bringing in rather than of leaving out. As Emerson said, "Do the thing, and you have the power. He who does not do the thing, has not the power." There is no substitute for experience.

56

To see the whole in every part leads to a new kind of teaching. Last year, when asked to teach a design class, I presented design in relation not only to graphic art but to economics, government, poetry, sculpture, architecture, philosophy, natural science. Since it is an ingredient of the whole, many features may be examined in its light.

Or take clay. In a 3 weeks course at a loosely structured school where my students ranged in age from 5 to 15 and parents and teachers dropped in as well, I mentioned the relation of clay to geology, chemistry, ancient civilizations, the development of writing, industrial ceramics, building materials, artistic forming, agriculture, and asked them to contribute their "wild connections" — as Robert Frost says, it is the poet's freedom to make wild connections. Of course they are not wild at all in the sense of being implausible. They are wild in the sense of being natural, like wilderness is. The connections we make, wild, are in the nature of things. Poetry is a branch of the same vine from which science grows. The children made up songs and poems about the clay: what it is and does. In musical speech. That is to say, speech where we are conscious of the music, which we aren't mostly, though it is playing all the time. Our ears are so sleeping we only begin to listen when someone says HARK!

Curriculum in America is up for revision. Young people are dropping out of schools that have lost their savor. New schools are springing up, often started by drop-outs. And they are choosing their teachers less by formal qualification than by personal character, integrity and experience.

Writers are entering the classroom, rather than sending their texts. Children are being encouraged to make their own books as well as to respect those made by others: to have an eye for the beauty of a book to the eye and the hand, as well as its content. Handicraft is being offered as an ingredient of other subjects. Movement and drama are part of history. Visual perception is part of geography. Technical knowledge is part of art. Number is part of music. And rhythm is part of physiology. Man and his knowledge and feeling and deeds are a continuous organism. The time is ripe for leadership by people who have a point of view about education which awakens the spirit and enriches relationships.

An acknowledgement of man as intuitive, imaginative, inspired, whatever form his life takes, whatever his work, may add to the curriculum of our schools.

What we know may be only what we are able to ask. The asking may be a doorway into our next development.

I am returning to England to participate in a curriculum laboratory at University of London Goldsmiths' College. There, teachers in secondary schools are developing resources for a curriculum innovation called IDE: Inter Disciplinary Enquiry. The

thematic rather than special-subject approach is, I was told, widely used in elementary schools. Inter Disciplinary Enquiry asks questions which awaken our wholeness. It has been the experience so far that where this program has worked best, it has been under the wing of a person in the arts. Otherwise it tends to be the teachers who are creative rather than the children. It is encouraging to see what happens when we come into our knowledge through our senses and our imaginations, when we see that knowing is lifting matter into the light of a living inner world. This is an expansion of consciousness beyond analytic and reductive techniques.

The awakening of artistic impulse in teacher and student, no matter what the subject, creates an art of education.

    to stand in the door, looking both ways, and feeling the flow

  The estrangement between matter and person which has characterized
the age of modern science of the last 400 years has been necessary
for the evolution of man's freedom. Now that estrangement is being
healed. One way I find healing is through linguistics, through a
renewed awareness of what words mean. In words themselves we can
find hints of the source of our inner unity. For example, I
learned recently that the French word noyeau means seed-nut, nucleus,
and stone.
     How true, how true. Our bodies are stones, they are
     mineral. In them burns a fire, a generator, a sun
     raying out warmth, a nucleus. And in us also lives
     a seed-force, the possibility of a new being.

the very materials of life are its poetry
in them is a fire and a resonance and an inner drama

  vii
a child in school my favorite subject was
arithmetic: all
that adding and subtracting and multiplying and dividing,
and if you had 2 apples and 10 people how many would each person get;
the feeling of inner activity doing the exercises, like playing ball

or swinging on the rings or digging tunnels or racing round.
columns and columns of figures like the Parthenon

in high school I loved algebra, the thrill of x the unknown quantity.
( . . . equations, and putting numbers above and below each other, back
and forth across the equals mark, drawing the square root symbol,
putting little tiny numbers above big numbers, it was art and it was
sport, an elastic dance of the mind among its contours, at the same
time as good as shooting rubber bands or picking up garter snakes and
scaring my mother. )

then came euclidean geometry. we proved again what had been proved,
memorized axioms, and drew pictures of fixed angles. it was said to
be a picture of truth; to me it was <u>unbelievable.</u> I dropped out and
picked up the life-line across the hall in Ruth Word's English class.
We read Sohrab and Rustum, and I saw that arithmetic had another form
which Mrs. Word called poetry. that was all right with me. so long
as I could feel the inner stretch and could care about what to do if
there were 2 fishes 5 loaves and 1000 people.

while writing my book Centering, my interest turned again to number
forms, in relation to dialogue, meditation (the root of the word
<u>meditation</u> is the same as for medical, it is an old old syllable
meaning a grain measure), the oneness yet manifoldness of the
world, concepts of freedom and union, macrocosm and microcosm, these
seemed arithmetical in the sense in which number and its quality
and its processes are not different in their truth from poetry. I
call my foreword to the book the arithmetic, the bush, and the plan.

we are connected in our inner life to the processes of non-euclidean
geometry and to growth forms in plants. I have always felt this,
and now my intuition has been confirmed.

last year I came upon 2 essays by an English mathematician George Adams.
One was entitled Space and the Light of Creation, the other Physical
and Ethereal Spaces. There I was introduced to the concepts of

59

space and counterspace, raum und gegenraum (there is a book by this title by Louis Locher-Ernst). These concepts have been developed in projective geometry especially since Einstein, though they came into human consciousness much earlier. Projective geometry has to do with the manifestation of invariants through successive transformations.

The new geometry accommodates a nonspatial realm in which living energies play invisibly to produce visible bodies and behavior. Inner sculptors at the growing tips of our manhood. As I read about the infinite center and the infinite periphery, the interpenetrating realms of space and of light, the transformations which occur in a dimension more like time than like space, I felt life rising in my heart, I felt a resurrection of trust, or should I say a trust in resurrection.

I went to England last autumn to study for 4 weeks with Olive Whicher, co-author with George Adams of The Plant Between Sun and Earth. Miss Whicher painted for the book 24 color plates of growing plants and geometric forms. I wanted to study where mathematics and color and form and life process and inner unspace were mutually affirmed. To make a small beginning. I hoped this would help me to work across the divisions between the arts, sciences, and humanities.

From England, I went to Zurich to visit the Jung Institute of Depth Psychology. I wanted to talk to a physicist who is working there on the application of physics to the concept of the unconscious, on synchronicity, and on qualitative aspects of number. Also I wanted to talk to a psychologist who is making a study of alchemy and its bearing upon depth psychology.

Another application of alchemy to modern man is to be found as well in theater. Some years ago I translated into English a book by Antonin Artaud called The Theater and Its Double. Its central chapter is entitled The Alchemical Theater. Artaud says that the theater, like alchemy, has a spiritual double. As the alchemists were trying

to make material gold by processes which were more than physical,
so the theater tries to make spiritual gold in a poetry of space.
The theater, he says, is an exceptional power of social redirection
and renewal if it keeps faith with the hard facts of life,
which, he says, are metaphysical, and have to do with the great ideas
of Being and Becoming. Because of the public's hardness of hearing,
as it were, he calls upon the theater to make use of its exceptional
physical resources to penetrate the spectator's guard of habit and
indolence. Society will not be changed until the individual is
changed. He will only be changed, says Artaud, by surrendering to
an experience of the gods.

        The implications of a scientifically acknowledged objective
nonspatial realm shared by human beings and by nature are tremendous.
It means that poetry and science are demonstrably one world.
It means that theater and religion and politics are indeed one world,
        of inner drama.
It means there is a way for people to develop an intuition of the ob-
jective psyche and to observe its forms just as we discover and observe
the visible forms of physical differences. It gives new meaning to
the old advice: know thyself and study nature.

I can barely touch these things here. My hope is to kindle your fires,
kindle questions which will become your quests.

It means that education and inner development and the physical arts are
one world. Communication exists between all the languages of man.
This is the territory of our new curriculum.

A small group of us explored it last summer in a three-weeks program
called CROSS-OVER: Towards a New View of Language, Verbal and Non-Verbal.
We worked towards experiencing communication between visual arts, theater
arts, writing and speech, handcrafts, dance and natural science
(botany in this instance), from the inside.
7 leaders met together through the winter, feeling our way toward

61

doing something we didn't know how to do.

We knew we wanted to study with each other, to deepen our inter-
connections, and to carry our own lives forward. We were interested
in sources of communication within the human being. We hoped there
would be students, but we were not dependent upon them.

These subjects we proposed as a beginning:

> movement for those who haven't thought of movement
> images and sources of dance
> sensory awareness
> how to play with materials
> how to make a play
> storytelling and singing
> color-form-words-movement
> writing as a handcraft
> working with clay
> sewing in relation to light, color, space
> written words, speech sounds, and eurythmy
> the life-cycle of mosses

The final schedule was by consensus with the students.

A hypothesis was confirmed: it is possible to move organically
> from one focus to another, feeling the
> continuum. Inner structures unfold
> meaningfully within materials.
Good. Here is a truth to build on.

Other groups of people with special interests who want to learn
from each other will carry Cross-Over further.

> Students and teachers learned side by side.
Adults and children. A schooling was created by the people in it.
> Governed by a form in its life-line.
> A mood of mind.

Our study of nature was basic to all the other arts.
We need to try others: e.g. history, law, medicine, geometry,
linguistics, mechanics, banking, politics, ballistics, farming.

Cross-Over does not take the place of study-in-depth of a special
field. Specialization is illuminated by Cross-Over — and in turn,
Cross-Over is illuminated by depth perception.

Inter Disciplinary Enquiry now being introduced in English secondary
schools takes one quarter of the time-table. The other 3 are
filled by autonomous subjects, courses for special needs, and
independent projects.

   viii

               when we are children, we experience the
               world as of the same nature as ourselves.

          for the world to be of the same order
     as oneself means that it too is alive, thinks, feels, acts,
          laughs and cries — is all the things one is
     for out of it one has been created — what one is must be in it.
          The discovery of the world then is
     like the discovery of oneself, a delicious secret.
It feels good.      It feels important.      One is not cut off.

There is a time when creation divides. Into information and
knowledge, separate people and languages and arts and sciences
and religions. Adolescence is like this. Full of excitement and
sensation and the 10,000 things. And loneliness.

Eventually the soul asks to be born again into a world of the
same order as itself — a second coming into innocence, not through
a glass darkly, but face to face, in consciousness. a beginning
of goodness
We pass through cruel ordeals on the way. Estrangement, coldness,
despair. Death.

By going through the experience faithfully, we may come through
on the other side of the crossing point,
and find that our faithfulness has born a new quality into the world.

To think of the earth's body as part of one's own will help
to renew the arts
of caring for the land and the air and the water, the art
of growing and preparing food, a feeling for
the seasons and their festivals.

    ix
closing prayer

may we carry our center as a vessel in which play all the members
of the family. The sheep must be fed. The frightened ones who
bite the hand that feeds them or skitter away trembling, oh thou
my fearful little sheep, speak oh speak to me

> sit with me at table
> oh my fear
> sit with me at table
> oh my fear
> sit with me at table
> oh my fear

> give yourself to me
> oh my fear
> AND I WILL MARRY THEE

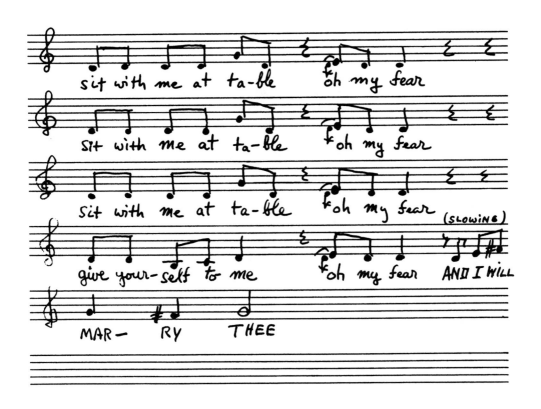

sit with me at ta-ble  oh my fear

sit with me at ta-ble  oh my fear

sit with me at ta-ble  oh my fear (SLOWING)

give your-self to me  oh my fear  AND I WILL

MAR — RY  THEE

# V

After the Penn State talk, I returned to England to be visiting American professor at the Curriculum Laboratory of the University of London Goldsmiths' College. My participation there helped me to experience individual initiative within a group dynamic, and to experience the life process of persons as in itself creative. Its extraordinary founder and director, Charity James, has written about the work of this Lab in her book *Young Lives at Stake*. She helped me to accept how all our lives are at stake; adults as well as the young need to be affectionate toward self. Reports of my work were published by the Lab, and are included here.

"New Resources" was contributed to *Ideas*, a periodical publication of the Curriculum Lab, edited by Leslie A. Smith. It appeared in No. 5, January 1968. I had written it the previous autumn, after my term's work.

The title "New Resources" was taken from the theme of Pilot Course Seven, of which I was a member. Beginning in 1965, the Lab worked each term on full-time courses with in-service secondary school teachers and administrators, between a dozen and a score, to explore for themselves some special aspect of current needs in education, in company with a Focus Group of five continuing individuals, one of them a visitor from America. My associates were Charity James, Leslie Smith, Edwin Mason, Sam Mauger — and our indispensable secretary Mary Darby.

The title of the news sheet, *Ideas*, came partly from the initials I D E (Inter-Disciplinary Enquiry), which was the foremost aspect of a fourfold curriculum proposed by the Lab. *Ideas* has grown into a larger publication (now distributed in this country), though the Lab itself has ceased.

How I came to work with this group has the hand of destiny in it: When I arrived in England in November, 1966, to study for four weeks in Sussex, my only friend in London, Molly Francis, welcomed me with a book by Seonaid Robertson called *Rosegarden and Labyrinth: A Study in Art Education*, which her bookseller John Watkins had recommended. I devoured it, wrote Miss Robertson a fan letter, sent it to Goldsmiths' College, where the jacket copy said she worked. I went to Paris for Christmas and New Years, with Paulus Berensohn, to visit potters Fance Frank and Francine del Pierre. Just before leaving for home, I received a much-forwarded letter from Seonaid Robertson saying she had been in America for a term at Penn State University, was just back in England, and would I visit her. I stopped in London to say goodbye to Molly and to meet Seonaid. She invited me to lunch at Goldsmiths'; there she told me about the interdisciplinary adventures of the Curriculum Lab, knowing from my life and work that I would be happy to hear. Charity James came into the refectory, Seonaid introduced us, Charity invited me to join a meeting of the Lab that afternoon, and very shortly she invited me to join the group as visiting professor. I said I had to go home to give

a talk at Penn State! Go, she said, and come back. I did. We have all become great friends.

I spent the rest of the year 1967 in England and Scotland, making an important pilgrimage to the holy isle of Iona and to the Pictish stones in Glamis and Meigle.

# New Resources

WHAT is the source of a new thought?
— or a story or picture or poem or song or dance?

When children or adults say, "I don't know what to make" or "I'm not creative," how can they be helped to find sources for making?

I would like to discuss here how the making of things and ideas and relationships leads to new resources in persons and in social forms.

In Course Seven of the Curriculum Laboratory at Goldsmiths' College, we were given an assignment by our graphics teacher to make an abstract picture of a civil riot by stamping with a potato stamp. First we looked at some examples of abstract forms, and discussed what kind of movement was characteristic of rioters and police. We were asked to remember that the white space (empty or negative space) would be part of the total form and would contribute to it. We were to be mindful of the *interaction* of filled and empty space and to notice how the filled space was molded by the empty space. Then the teacher turned on a tape recording of civil rioting with gunshots and shrieking, in order to stimulate our activity. We all made different pictures, but each called upon sources of movements in patterns of attack and defense, some remembered and some spontaneous or imagined.

Also I noticed that many of us were eager to play around with the stamp and ink, and we had trouble controlling our restlessness under the authority of the assignment.

Here was a double need: to learn by playing, and to learn by being taught.

This is the point I wish to stress: we created our pictures of the civil riot from inner sources of feeling and motion and thought connected with attack and defense. The restlessness was a symptom of other *moods wanting "to stamp."* A picture comes from the inside out. A certain spirit moves in our hands. This spirit gives the picture life,

regardless of artistic standards. When people resist playing with materials, it may be because they feel uncomfortable when certain moods are aroused within them. This can become a truly learning situation if sensitively and courageously lived through.

Can we, by awakening new inner moods, create new physical forms? If so, can we create a new society by awakening new inner resources?

Let us think about making pictures (and it would hold for all making, even making a school) from the point of view of source rather than product. For this is our concern, in education, to awaken resources within the individual. Let us, for example, think of working with color (or playing with color) not in order to make a painting but in order to experience how colors flow on a piece of wet paper — how they look when they are separate, when they touch, and what hues and forms they make when they mingle. We will have made a painting in that we will have covered a surface with paint, but the painting will be a means to an end, namely, an experience of flowing color. An experience of flowing color may bring into consciousness and into behavior, sources within us which counterbalance the "civil riot" patterns of dark and light forms moving to frustrate each other.

There is a point to be made here about the relationship between documentary art and prophetic art. Documentary art imitates popular reality and enables us to gain insight into forces at work within popular reality, for example: attack and defense
<div style="text-align:center">

explosion and withdrawal

the rat-race and mindlessness

power and anxiety

eating and soiling.
</div>

Prophetic art calls upon sources, or awakens sources, which lie, as it were, in the future, rather than the past, whether the past of conscious memory or of unconscious repression. As Mircea Eliade says in his book *Images and Symbols*, the more developed a person is, the more he transcends historicity. It is this prophetic resource which asks for special encouragement in our time.

What is a prophetic resource? Taking our cue from the word *prophecy,* we can say that our prophetic impulses are those which cast their light *ahead:* i.e. into a realm which has not yet been embodied. Or one could put it another way: they are impulses which receive their light from this realm. This is the realm which is perceived by imagination, inspiration, and intuition. Some people call it the unknown, or empty space.

We can think of a human being as being pushed from behind, from the past. This is a popular view of history and evolution: that one is pushed somehow from behind in an endless wheel of inevitable consequences. This is what, in religious language, is felt as bondage.

Freedom, so much in our hopes today, consists in getting out of bondage. This is a deep intuition in human beings — that somehow it is possible to get off the wheel, to get free of past pressures and patterns, to enter into the promised land. The promised land, again we take our cue from the word *promise,* is an offering. The promise flows toward us from the future.

This is important to recall because we so tend to identify ourselves with our roles — "I am a teacher, therefore I cannot be myself" — or "I am an administrator, therefore I cannot be an artist." Pushed always from behind, from the past — living in congealed forms. Caught in the works.

Where is the new resource to come from which will help us to begin to alter our view of ourselves — to soften the edges — to allow a plasticity and openness and flow to transform our picture of ourselves and of human nature? It is likely that we will be more effective helping students to find themselves if we have started on the path. This is a new collaboration: young and old learning together a new way to the future, uncoerced by the past.

Epidemics of our time, like war and drug-taking and mass fantasy, are efforts to get free of what feels like a "lock-up." (The sages have always told us that disease is a symptom of health-seeking.) The longing for freedom has its source in the inner life, in our deepest dreams of ourselves, and this is what is so compelling about it. The search is for a new order, new visions and peace of mind, and freedom from emotional patterns which create anxiety.

I cannot undertake to discuss in detail here what this deeply signifies. But one thing we must stress. And this is *the search by young and old for a new inner life.* Flowers, beads, bells, hair styles, colors, love-ins and be-ins, are rituals of this search. As are heroism on the battlefield and the tribalism of mass media. What seems new, however, is only new to Western civilized man in this epoch, with its imbalance between a bright intellect and a dark spirit. It is the dark spirit, the dark brother, who is crying for freedom, for a new balance and wholeness. The arts of personal adornment, war, and total mass identification are archaic symbols. Archaic symbols are connected with our human spiritual beginnings. *Archo* means *I begin.* The ground or seedbed of

beginnings is eternal, i.e. free from ordinary time; it is present in the human psyche now as it was in prehistory. Therefore to turn to symbols is to turn to archetypes who animate the inner life of human beings.

The history of religions, depth psychology, anthropology, and archaeology, all furnish us with ever increasing evidence of these archetypes. The most radical voice in theater of this century, Antonin Artaud, calls for a rebirth of an "alchemical theatre" through the rebirth of metaphysical or archetypal "personages." He cites the Oriental theater, especially the Balinese, as exemplifying a mythic archetypal drama. And he calls for this rebirth because without it, our society becomes more and more robotlike, mechanically operating from programs written in the past.

One of the features of Oriental theater which Artaud stressed was its geometric imagination. To connect the gods, or archetypes, with mathematics is a prophetic impulse in our time. Not to make the gods the slaves of arithmetic, but to re-experience geometric symbols as containing more than spatial ingredients — that is, sacred ingredients.

This is part of the territory of the new mathematics — an exploration of counterspace — a realm of qualities which, when assimilated to quantities, create nature and human experience. This counterspace or inner space is the realm from which prophetic impulses stream into us. It is this realm which interests me most as a researcher into New Resources for learning.

One way of making contact with this invisible realm of sources (or formative forces) is through artistic practice. Both in free play with materials, and in guided practice aimed at awakening new sources and new rhythms and new feelings.

Another way is through exercises in sense perception, and in thinking based on unprejudiced perception.

From work in the arts, we learn that causes do not explain what people make. This is corroborated by psychological research. (I am suddenly reminded of what Robert Browning said about an obscure passage in his poetry, that originally only he and God knew what it meant, now only God knows!) There is another principle, that of the creative purposeful — making something according to a purpose which is not yet manifest. It is like being pulled out of sleep by a beckoning hand, or pulled out of ordinary consciousness into a new vision. The point is that instead of being pushed by our past, we are offered something from within and we respond by offering ourselves to it.

The plot thickens here, when we recall that in the archaic world, the world of spiritual influences and archetypes, there are all kinds of forces at work, forces which

would imprison us as well as free us. For this reason, each person's individuality must be continually strengthened and his free will awakened so that he may choose his way and not be swept up in overpowering demonic visions or lost to a mothering bliss. The strengthening of individuality is part of education, as well as is the awakening of prophetic imagination.

It is for this reason that we offer in our new resources for learning, experiences in community as well as in art. Grouping, shared responsibility, and collaborative learning are forms of community. The aim is to sharpen one's own sense of being different from the group, to come into personal relation with others, not to identify with them. This is a process of growth. In psychology, it is called differentiation. The new resource is an ability to give and take, to help each other give what we have and ask for what we need, and to help each other by responding. It is the interplay of initiative and active surrender.

Would it not be interesting to work with these themes in the arts as well as in group learning and discussion? What graphic images, what clay forms, what dramas can we make out of the interplay of initiative and active surrender? This would be an alternative to attack and defense, explosion and withdrawal, power and anxiety, conformity and delirium.

Other aspects of a fourfold curriculum apply likewise to a strengthening of individuality and refining of will so that one is not easily overwhelmed and can help to create his future rather than passively submit to it as if he had no choice. Courses in autonomous subjects such as foreign languages demand of the student a capacity for sacrifice and self-government. Likewise remedial courses and special projects speak to the needs of the individual person.

Teachers and students are invited to share in a new spirit in education. This new spirit seeks to strengthen the individual, at the same time teaching him the arts of working together with others of all ages and abilities. It also seeks to awaken a new image of man, as a prophetic being as well as a historical being. It seeks to enliven sources within persons through play with materials. This helps to develop trust in imagination, inspiration, intuition. It seeks also to develop a living thinking which draws its life from phenomena directly perceived, rather than from abstract definitions. This includes phenomena of the inner life, psychological and religious phenomena, mathematical phenomena, phenomena of archetypal reality as well as physical manifestation. It is a spirit of wholeness. Through this spirit we may become makers of the world.

The new spirit
offers itself as an
axis
connecting the
planes of being,
inner and outer,
allowing a continuum of
experience to flow through
the realms which in our ignorance
we separate
as heaven-earth-hell
assigning to each a spatial realm.
It is the breaking of this ignorance
which is the threshold experience
of our lives today —
and education must
acknowledge this breakthrough
if it is to
meet the needs of young and old.

As we break out of an old order of time and space, we enter hell as well as heaven.
And so we must be prepared to suffer through terrible encounters with our own
darkness and despair and guilt, our shadow. If we can keep the axis firm, we find, as
the sages say, that self-knowledge is a path to freedom. Not bound to love, but free to
love.

Part of the fun of making pottery comes from shaping containers and vessels
(which are forms especially meaningful to the human psyche), or pillars and posts
and standing stones, archetypes of altars and fountains, wells and caves and moun-
tains, harbors and sacred places, temples and gardens and families of lovers and chil-
dren, angels and circles and stars, heavy stones and thin surfaces, animals and faces

and names, imprints of grasses and flowers, footprints and worms, landslides and musical tones. Playgrounds and circuses and parades. Beads, blocks, and doorways. People.

Finding the clay, squashing it around and molding it, making the kiln which will contain the fire, preparing fuel and feeding it in, beholding how the shape we have made out of raw materials takes on a new quality which we can see and touch, through a process in which we have shared, co-creators with earth air water fire wood — these are nourishing deeds. They have the feel of being MORE than just themselves. They feed us with a living food. And our dreams gain in confidence. We may yet be able to make something beautiful with earth.

We ourselves make something. This is central. Without it, we can hardly be expected to take ourselves seriously as makers of the world. We can see that everything we do is "a making" in some deep sense and that we help to create history by being accomplices to it. But the question I am stressing here is how we may create new resources for making, so that we do not merely make the waste products of what we consume or the actions forced upon us by one cause or another, one pressure or another. The question is, how do we develop sources within the human being for a new consciousness, a new era, a new man. This is our task. The mills of the gods grind, the forces of evolution persevere. The human being's part in the drama is to gain his freedom from history and passivity, and to awaken his initiative, the creator-spirit with his original face. If then he speaks with that power for making new, he will be co-creator of a harvest devoutly to be wished.

This is a long way to take questions of education. But we must acknowledge that the creative purposes of humanity are the creative purposes of education.

The compelling quality of certain themes or images or symbols, or of sharing in an art or handcraft from the beginning to the end and thus having an experience all the way from natural sources to final form — this whole field of personal and therefore of educational value has been beautifully and movingly and convincingly described and documented by Seonaid Robertson in her book *Rosegarden and Labyrinth: A Study in Art Education.*

Why not try such themes as
enemy, friend
monster, hero
treasure, search
the 4 seasons (beginning with your favorite or the one you are in)
island / tunnel / cave / harbor / waterfall / pool / bird / witch / wolf / prin-

cess / magician / elf / king / pilgrim / old wise man / gold / fireman / police-
man / astronaut

Not to force the experience, not by any means. For these may be too powerful to
handle. When this happens, we learn something about ourselves and others. I remem-
ber how devastated I was not long ago in a class taught by a friend. He asked us to lie
full length on a piece of brown paper and get someone to draw our outline. Then we
were to fill in the picture with our portrait. He passed around mirrors and colored chalk
and paint. I was horrified at the prospect of exposing myself in this public "comic
strip." Others were already setting to work laughing and chattering. I groaned and
wept as I undertook the ordeal. My friend and teacher was altogether taken aback, for
he had not known my terror of mockery, my fear of being exposed to public ridicule.
He had used this assignment with children, apparently with great success. It had never
occurred to him to think of the difference, emotionally, between children and adults.
He had to reconsider the impact of his teaching from the inside. I on the other hand by
going through the pain was cured of my old wound. In the past I would have run away.
My new resource was my ability to weep in public and press on.

Why should not color and form be everybody's business as a natural part of life,
since we live in color and see color all the time? Why should color become important
only when it is framed within a painter's canvas or a fashion designer's sketchbook?
Why should we not build our houses and our schools and paint them, inside and out, if
we wish, according to the colors and forms that really please us, and change them ac-
cording to our moods? Why should we not write all our lessons in color? Color is an
inner experience connected with feeling. Why should it be dictated to us as if we were
blind and dependent upon others to tell us what colors we need? If we are blind, let us
learn to see. Let us go into nature and drink in her colors and forms. Let us feel the
growing forces and the decaying forces which bring forth the seeds of new forms,
growing and decaying and growing without a break in the life-line though the physical
forms change in front of our eyes. Look at the leaves falling off the trees, the naked
shape of the crown, the winter buds, the color of the new shoots blood-red in January,
the gold of spring's first green. Have a touch festival, blindfold, and discover how your
skin can see! Left to themselves, children tend to do this naturally. It is adults and
young adults who need to rediscover the child in themselves, the growing point. There
is an old wise saying, that "whatever is real has to be built again."

New ways of doing things seem strange if you look backward and compare them
with past customs. (Remember Lot's wife, who looked back and turned into a pillar of

salt; or Orpheus, who looked back and lost Eurydice). If we look ahead at the unfolding forms of the future and enter into collaboration with them, this will help us overcome the fear that accompanies doing something new. Fear is an appropriate reaction to the unknown. Without fear, we are foolish. Overcoming fear with a sensitive courage gives us two hands. We do not see well with one eye, we do not handle things well with one hand. It takes two.

The future is part of our continuum, always playing into us, creating us, like rays of the sun, nourishing our growth. Like spring plays into autumn when the plants sow their seed. Outer space, though it is in fact filled with rays of the sun, looks dark to the physical eye. We are asked therefore to re-see the dark, to see that it is sun-filled, full of the light to come, the dreams and inspirations and seed-forces.

There is no discontinuity in the life-line. Discontinuity is a perception by that part of the mind which looks at matter from the outside and sees atoms which are separated from each other and therefore discontinuous. That part of the mind looks from the outside at the differentiation of physical forms, rather than from the inside of the continuously unfolding forces from which they originally arise.

If then there is something in the human being which asks to be let to make, to be helped to grow, to have time in which to become conscious of one's life, to expand and deepen one's awareness and one's mobility, these askings point to new resources for a new learning.

Clearly, survival will not always be a matter of physical endurance. Man is being freed from most of the routine work of production, and will be in a position to choose how he wants to serve society. He will therefore need another kind of time for he will be occupied with another kind of work. We cannot hope to be saved from ourselves forever by the need to make money. There is a shift taking place in consciousness which underlies the shift in ratio of assigned labor and unscheduled time. *Schola* in the old days meant *leisure*. Learning took place in free time. This is what gives wit to the saying, "School interrupts education."

Why do we not begin now to build free time into the timetable, for teachers and students alike? When, if not now, shall we embark upon the new forms which lie ahead? Why not experiment with a shorter "school week" as we are doing with a shorter "work week"? Why not have mornings or afternoons off with no planned work? Studios open, library open. But no instruction, no assignments. Surely if we are to develop a new attitude toward free time and play, we should begin. As it is now, free time is a clutching for release from pressures (or a chance to work harder than ever catch-

75

ing up with all that has been left undone, like the laundry and writing letters and entertaining). No wonder people are scared of increased leisure. It's a nightmare if you think of it as having to spend even more time seeking insensibility and relief from tension! Can we begin to create a new spirit of work *which will refresh us* rather than exhaust us? Can we discover sources for living with unscheduled time?

Likewise, let us open workshops for teachers and students in Sense Awareness. Let us exercise our touching, smelling, tasting, seeing, hearing, moving, speaking, so that we may feel body and soul present in each sensation. Sense perceptions become sharper and deeper as inner resources awaken in them.

One of the purposes of *Ideas* is for teachers to share with one another their resources and ways of working. Artistic "making" has answered to my need to be close to nature and my love for materials out of which expressions are made. It has answered also my interest in process, structure, "building" — how things are made. Interests in science, history, the humanities flowered naturally on this life-line. An exploration of "making" leads also to discovery of makers. All these elements seem to have something special about them. It is a quality we also feel when we pick up a stone or a feather or an old tool, or really look at a human person, or at the morning star. The capacity for Wonder is the life-line of learning.

It is my impression that this is the direction in which human consciousness (and therefore education) is evolving. "Psychedelic," the new word of our decade, means "conscious-expanding." Though it is an ancient art, it has now to be experienced in a new way right for our epoch. The awakening of inner sources has always been a part of The Way of inner development. It is relevant to us now as teachers, as the concerns of education and the concerns of inner development come together.

Since the Renaissance, man has separated his secular and spiritual values, partly in order to get ahead with the work of science and partly to get ahead with the work of individualism (finding the Source within himself). Now our concerns are shifting again (our built-in search for balance), and we feel the inner world beginning to light up. Young people are born into the world asking new questions and with new aptitudes. We seek food for our souls and spirits in daily life. This, I believe, underlies the Interdisciplinary movement in present-day thinking. This accounts for our growing dissatisfaction with half-measures, half-truths, partisanship of all kinds. It is not a matter of morals, it is a matter of changing awareness. Divisions are being healed at the same time that differences are affirmed. This also accounts for some of the strain we feel as the changes occur within ourselves. It is hard work and it takes time.

76

As I suggested earlier about archetypes, we should be prudent about turning to expanding consciousness as if it were a new entertainment. The inner world contains as many dangers as do the marketplace and battlefield. We have only to look at ourselves to see how inner blindness can overtake intelligent and sensitive people. It is not a question of how much we see, but of the quality of our seeing.

I hope I have been able to suggest the mood of mind out of which my concern for new resources springs. We are the co-creators of ourselves and, in a sense, of each other. As consciousness expands, we have still the task of receiving into it qualities of insight and sharing, of warmth and mercy.

If artistic work touches so deeply into the inner life, it is no wonder that our culture has put it behind special doors. Now that the inner life is crying loudly for liberation and for community with others, perhaps the arts will be embraced as a friendly component of curriculum. We may start from where we are and practice slowly and steadily the limbering of our awareness, as dancer and athlete practice slowly and continuously the limbering of their bodies. The hope is that our awareness will live in practice.

# VI

I wrote this report in the summer of 1967, after my term as visiting professor in Course Seven at the Curriculum Laboratory, University of London Goldsmiths' College. It tells what the Lab experience was for me, and how it worked. Fuller discussion of the fourfold interdisciplinary curriculum may be found in *Young Lives at Stake* by the Lab's director Charity James, in *Collaborative Learning* by Edwin Mason, and in course reports published by the Lab. These reports are available, though the Lab no longer exists.

This piece was published in *Report of Pilot Courses Six and Seven: Curriculum and Resources in the secondary school*, edited by David Hoffman, Edwin Mason, and myself, and issued in 1968 by the Lab. On the cover was a photograph of a piece of embroidery by needlework teacher Clover Prince, seen through the coil of a bedspring which she found in the rubble of a demolished house nearby, and arranged like a spyglass hanging between the embroidery and the viewer's eye.

It contained other *samples* of the life of Course Seven: photograph of a group exhibit, poems, pensées, doodles, notations from actual discussions, e.g.: "We are artists who never took up art." . . . "It is important to the educational process that the teacher come into dialogue where he knows no more about the subject than others do." . . . "It is the relationships which animate a curriculum which are important — not whether it is an integrated curriculum."

Well, obviously I would just like to quote the whole thing. It is lively and fully felt. And the people were all practicing teachers and administrators — bedrock and living water, and salt!

In introducing the report, Edwin Mason writes:

It would be truer to say that we preach what we practice than vice-versa. The Pilot Courses in the Curriculum Laboratory have never been predetermined or structured, but have proceeded in the way Dr. Richards describes so subtly in her article. Teachers have come together with us and entered into a close collaboration from which the policies we published have emerged. The diversity of personalities and viewpoints has always been honoured and welcomed; and we have sought to know and communicate with each other in a variety of ways, expressing our moods and feelings as readily as our findings. To give a full picture of the process would demand both a book and a film. But since our practice has led us to preach that education is a collaborative enterprise, to be conducted in circumstances where people can be unabashedly self-revealing and self-accepting, and that if it is not genuinely personal it is nothing, we make no apology for publishing these SAMPLES in a report on CURRICULUM AND RESOURCES.

# Pilot Course Seven: New Resources for Learning

I

IN the beginning we imagined there would be no report of this course.

Toward the end our imaginings changed, on the evidence of the changes we had made in our environment and in ourselves. Individuals began to prepare work papers on projects they had undertaken; groups pooled their thinking on topics of shared concern. During the course, individuals had spontaneously prepared statements of viewpoints they wished to share and to receive response to. Poems and drawings helped to convey what was happening. There was some spontaneous grouping in the preparation of lists of resources or an approach to an IDE (Inter Disciplinary Enquiry) program. In addition there were individual ploys such as visits to schools on the initiative of course members. And a body of made things, as well as thoughts and feelings, emerged from workshops in art and the handcrafts. Though we invented no new resource at the commodity level, I came to feel how substantial our course was, however modest its material expressions. Because I was given responsibility for helping Course Seven to become conscious of its uniqueness, I found at the end that I wanted to share a report with others of what it had been like. I would not feel that our work was finished until this effort had been made. What follows is a summary of my impressions. It is not a matter of putting our best foot forward, but rather of sharing with others the human story of what we actually did.

Ours was the Seventh Pilot Course for experienced teachers sponsored by the Curriculum Laboratory at Goldsmiths' College. Its theme was New Resources for Learning. What this meant, practically, continued to be hotly debated throughout the course. Some members were disappointed that the territory of new resources had not been more clearly mapped in advance by the Curriculum Laboratory, and the research systematized. Our first unsettling experience was the discovery that what we were to do was largely up to us. This precipitated many of us at once into a conflict between

79

what we thought we ought to be doing and what we might be inclined personally to do. The abyss between *role* and *person* yawned in front of us; the very chasm which the Curriculum Laboratory exists to bridge. Almost our first new awareness was that in such a collaborative undertaking, without hierarchy, one is oneself the laboratory. We were not to be allowed to maintain a consumer role, picking and choosing among resources which someone else had packaged. On the contrary, we were asked, by the situation, to become co-creators. Our self-image, as experienced teachers and headmasters, had either to adapt to this change or to feel betrayed. We soon realized that new resources lie within us as well as outside us in materials and hardware. We began to turn inward as well as outward in our explorations.

At the beginning we were often at odds with one another. We felt we were talking different languages. We resisted each other's meanings. It is often difficult for us who are teachers accustomed to talking while others listen, to listen to each other without wishing to win points; and to co-operate with each other as co-creators of meaning. Some members, uneasy at the "waste of time," demanded that we "get cracking." But there were no obedient underlings to scurry on fixed tasks. Our demands could be met only by our own efforts.

We were asked by the situation to become learners in public. We were asked to develop humility, patience, honesty, and other difficult and basic "skills." We were asked to come out from behind the desk, psychologically, and join with each other in a simpler humanity, a sharing of our strengths and our weaknesses, an acknowledgement of ignorance as our most valuable resource for learning. Meanwhile, as we began to feel keenly the pain of the new situation, we fretted and stormed, and sniped from concealed positions. But there we were, committed to working together and talking to one another for eleven weeks. Gradually, because of our mutual caring for one another as persons (this is my way of putting it), we began to be able to listen to each other; also roles fell away or receded. And gradually, because of our increasing trust in ourselves and respect for the originality which has been built into each one of us, we began to be able more and more to persevere in our differences, finding them to be the very bonds between us. We were interested in each other and useful to each other because of our differences. I, for one, have been immeasurably bettered by this long and uncomfortable ordeal.

With the help of my fellow course members, I have taken another step toward being able to persevere in a direction which is meaningful to me without requiring endorsement by others and yet with the hope of sharing my concerns with them. This has happened partly because we did in time develop speech and ears for each other. These

are new resources in communication fully as important as any technical media. We grew comfortable with our own and each other's initiatives as a part of group dynamics. We came to feel more at home in the paradoxes of freedom and commitment.

It seemed to me necessary to build a bridge between a "psychology of responsibility" and a "psychology of inquiry," so that there might be fruitful interaction between them. Teachers are used to living according to a fixed timetable which keeps us busy meeting obligations which are defined largely by the needs of others. In a Curriculum Laboratory we may do as we like. Initiative has to be awakened, and anxiety assuaged. Responsibility transforms as we begin to be able to contribute something to it. So unused are we to taking ourselves seriously as resource, that we feel angry and lost, and complain that we are not being sufficiently instructed and led. We find to our dismay that we are being asked to speak for ourselves, and, what is worse, to enjoy ourselves. Enjoyment we connect with leisure and self-interest, not with work and service. If we are going to engage in a laboratory, we have to be willing to re-examine assumptions continuously. We find ourselves in the midst of our own re-education. How much deeper were the reasons for our coming together than most of us had appreciated at the start.

Growth and learning and discovery take time. We took a few modest steps toward awareness of what we deeply enjoy doing, allowing ourselves to be led from one activity to another, one relationship to another, as much by pleasurable fulfillment as by harsher guides. In education as inquiry, we ask what the world is like and what we are like. Both keep growing and changing. We ask ever new questions and consider new answers. It is an open-minded dialogue. It is therefore our responsibility to be explorers, our duty to inquire, our obligation to acknowledge the changes that are natural to human beings, more precisely the changes occurring in our own epoch. If we refuse to inquire because it is unsettling, then we risk rigidity and outdatedness. Human perception of reality is changing during our lifetime. As teachers we ask: How may we free ourselves from the habits of our past thinking? How may we unlearn automatic responses? How may we learn to share our enjoyments with each other and with students as part of our professional obligation? It is our task to function as the persons we are in the jobs we have. Otherwise our own duplicity infects the young, and they think of schools as artificial because the people in them behave artificially.

The spirit of our age blows toward integration — that is, toward healing divisions which are outmoded. In the old days, for example, we could get by with saying that we were personally against conditions that prevailed, but that circumstances prevented our doing anything about them. Idea and practice could be separated. Theory and

practice became opposites, whereas in fact theory in its original meaning is a "seeing," "understanding," "contemplation," which is a source of practice and its fruit. There is a continuum of seeing what is to be done and doing it, and seeing what has been done and reviewing it, reseeing it and redoing it. Theory and practice are continuous. And by our practice may ye know our theories. If our practice is full of talk of necessity and devoid of joy, if we are different persons away from our work, then we may know what divided creatures we are. This division has characterized our age; we accept separation between the inner man and the outer man, the fantasy and the mask. The question "Who am I?" and the "search for identity" are symptoms of our fever and our chills. Young people all over the world are rebelling against this division. A new morality is asking for a new honesty, rejecting the hypocrisy of the adult world. When the inner man has not his rights, the outer man tends to punish himself and others, obsessed with control because of the prisoners within himself.

Changes in the curriculum of education are not basically external changes of timetable and course of studies. Changes at that level work if they are carried out by enthusiastic persons. How may our fear and timidity change into confidence? This is a question asked by experienced teachers about themselves as well as about their students.

In Course Seven at the Curriculum Laboratory, we began to be aware that something was happening to change us when the tone of the dialogue between us changed. This change occurred to the degree that we dropped defenses and came out of our holes — that is to say, to the degree that we listened and spoke *to each other,* rather than to each other's roles or each other's words. The enriched feeling came about through shared practices, shared workshops, shared discussion, shared mounting of an exhibition. More of the natural inner person began to be revealed, indirectly, by the work we did in photography, embroidery, pottery, silkscreen, "found" sculpture, poetry — also the quality of the inner person had altered. As I say, something new stirred in the air between us. Something warm, humorous, forbearing, committed, incomplete, lively, thoughtful, sad, quizzical, shy, guarded and unguarded, but somehow shared. A common substance. A presence. A trust. We had created a new spirit. We were different and the world we perceived was different. That is what I mean when I say that inner and outer were not divided.

Before one comes, one understands that the Curriculum Laboratory is an experience in change, that it is structured in unfamiliar ways, directed in unfamiliar ways, providing experienced teachers not with instruction but with an open-ended environment in which to raise questions and find new resources. One knows all this, but the

experience is quite another thing from the understanding. The difference is that experience is physical, not abstract. Blood rushes into the face, tears come into the eyes, a whine comes into the voice, anger surges beneath self-restraint: one responds in patterns of the past before one knows what is happening. Then, seeing how we respond in old ways though we are searching out new ways, faced with this hard knowledge about ourselves, we can then undertake to check our automatic response and to become conscious co-creators of change in actuality, in practice. Isn't this part of what we wish to learn and to teach: how to transform our human behavior through the light of a new awareness?

In-service re-education of teachers, this is a frontier. People say that skilled workers will have to be retrained every few years in the future because of the speed of mechanical invention and obsolescence. The fact is that we are all going to have to see that education is lifelong and that its various forms correspond to the stages of our development. In a sense, education begins after one has finished one's schooling. The free teacher is not content to teach only what he has been taught. The adult may grow far beyond his formal schooling. College graduates are still pretty much a product of prescribed thinking. Processes of individuation accelerate in the second half of life. Teachers need opportunity to make contact with themselves in free play and return to their jobs refreshed and a step closer to their originality. The processes of aging can be processes of casting off the husks of collective values and emerging in one's own "body." The sages say that we age toward a second birth.

As curriculum laboratories increase in number, teachers and administrators will find that centers for open-ended inquiry will make teaching and learning part of the same process. Students benefit from seeing how their teachers explore territory that is new to them. So long as we are pursuing knowledge and not dogma, we need to be able to live within questions as well as within answers.

II

In the beginning and throughout
we could not agree
upon even the title of our course:

Was it NEW RESOURCES FOR LEARNING?

NEW RESOURCES FOR TEACHING?

NEW MATERIALS FOR . . . ?

or, as one member quoted the announcement he had received, NEW RESOURCES FOR LEAVING!

This will give a hint

of our DIVERSITY

and the tenacity with which we clung

to the old psychology of definition: as if we needed to know the name of what we were doing before our deeds were valid or meaningful to us. We had eventually to ask ourselves whether prolonged dependency upon intellectual structures via definitions was useful to us in an inquiring situation. Was there a growth-potential in other structure-giving faculties: for example, observation and invention? Could we learn to stand *within* our experience, rather than outside, criticizing and finding fault, without a clue as to how to proceed? Standing *within,* we were able to sense the lifeline of our endeavor and to allow it to grow from the inside. We cautiously broached the subject of "wholeness," asking how we might make more use of individual resourcefulness. How may we work out of a personal heart-thinking center into other vocabularies of shape and gesture and sound and rhythm and color and tone and phenomena directly perceived, and trust intuition as well. We began to see that what we perceive depends partly upon how we are feeling. This led us to acknowledge, to differing degrees, that perception is a single field, in which cognitive and affective elements interpenetrate. Failure to realize that accomplishment, by itself, is a desert, gives wit to the saying "Nothing fails like success." The reintegration of material and psychological values has yet to develop modes of assessment. Meanwhile, we can bear personal witness to the experiences of insight we have shared.

The gap between an adult's claim to concern for the individual and his outwardly expressed mistrust and resistance is no longer tolerable to the young. Adults who work with them in schools need to listen to what is in the air, what the hunger is, and try to share a mutual voyaging toward wholeness.

New moods in education

signify an awakening of internalized authority, a growth point, a toe in the door of

self-government, free initiative in an atmosphere of shared initiative, ways of experiencing from inside rather than filtered through abstract packaging, awareness of stages of development, from ever new beginnings, education becoming more and more indistinguishable from life itself, a mood of mind asking the questions of our time and growing to the answers. The waters of life hold us in a common flow, and yet each person is a uniquely shaped container. Unity is diversity. Sharing and individual containment.

Course Seven, it turned out,

was Interdisciplinary Enquiry into Resources and Materials for Teaching and Learning, all very loosely understood.

The group made attempts
to sharpen and systemize its thinking,
but the effect was shortlived; for example:

What do we mean by Resources? Do we mean equipment? personnel? increased awareness and resourcefulness within persons?

What do we mean by New? Do we mean we have never seen or heard of it before? do we mean a new use of old materials?

What do we mean by Teaching?

What do we mean by Learning?

And so on. Even the definitions we agreed upon did not seem to take us very far. What we learned, I think, was that we do not want to be led into clearer definitions, but rather into new forms of living experience. Definitions tempt us to believe that we can settle matters by classifying them. There is plenty of evidence that this is untrue.

Naturally
we each one of us came to the course with
our own expectations, preconceptions, hopes, fears, opinions, intentions.

3 needlework teachers

1 economics teacher from Pakistan

2 headmasters

1 head of a lower school

1 teacher of technical drawing

1 music and English teacher

1 history and music teacher

1 physical education and French teacher

1 history and sociology teacher

1 English teacher

1 biology and careers teacher

3 veteran members of staff, who had been through six previous courses

1 visiting professor of English, potter, author.

It was soon apparent that
most members of the course who had come for the first time expected to be instructed in new materials of a tangible sort: audiovisual aids, etc. It was with considerable irritation, backing and hauling, confusion, and dismay

that we discovered
            we were in a laboratory, not in a classroom,
it was up to us to create, discover, inquire into
                    NEW MATERIALS? NEW RESOURCES? FOR
                        TEACHING? FOR LEARNING?
                    *We were the course!*
    In my opinion, this is the very heart of the matter: persons
                and their commitment to working
                        with each other
            discovering how to move toward initiative
                    within a group.
    A curriculum laboratory is itself a new resource:
it helps us to cross over from the old to the new
        without penalty.

    What anxiety there is is self-generated and therefore may spend itself fairly
quickly. It is not possible to make mistakes since nothing is expected and no goals are
set. Enjoyment is given by awakening new impulses. How often do we have an oppor-
tunity "to loaf and invite our souls," as Walt Whitman put it, or indeed to do whatever
seems most apt to invite our souls, and, in due time, the souls of students.

    It is the soul-less body in a convulsion of rage and shame which is the agony of
our time.

    What do we care deeply about? How can we bring this into our daily work and
living? How can we be true to ourselves and responsible to others at the same time?
How do we make our needs known? How share our gifts?

                                    III

Certain opportunities were made available to us at Goldsmiths' College:
                    the television studio
                    the photography workshop
                    silkscreen and graphic workshop
                    pottery workshop
                    embroidery studio.
In the planning of the course, it had been arranged that we would begin with a four-
day exploration of a mini-television unit invented for school use. A half-dozen members
of the course continued to work one day a week in the TV medium, and at the end of
the course they presented their programs to us. One was a lesson in TV techniques; the

other the use of TV to give instruction in needlework which would stimulate activity.

It had also been planned that we should spend one day a week in graphics. In the first session, we were asked to concentrate on the development of an abstract image made of dots with a potato stamp. A documentary sound track of a civil riot was used to stimulate our activity. The forms and rhythms of our stamping were the counterpart of movements of rioters and police. We needed to know something about how rioters move to disturb established forms, how police move to protect property, et cetera. Though the exercise was simple, it awakened awareness in dramatic ways of how graphic form has its source in the formative forces within experience. Possibilities were stressed for working from dramatic conflict and from actual movements or emotional flow into graphic expression and design. There seemed endless sources to be explored for visual forms which are the counterpart of inner forms, as it were, that is, energetic forms. Likewise we can develop the capacity to see what "inner" forces have brought about the graphic forms we see. In this way, again, we see that the material and psychological worlds are not separate. And as teachers, we gain insight into the relevance of drawing and painting to psychological and social development. More specifically, when we see the connection between what we create graphically and what is going on inside and around us, we can use graphic exercises to develop freedom from the patterns of civil riot as well.

Since one of the members of our course was a physical education teacher, we continually had the opportunity to explore new connections between the direct experience of physical movement and its application to the arts and to three-dimensional design. A visit from Michael Laxton of the Three-Dimensional Studies Workshop at Goldsmiths' extended these interdisciplinary connections yet further.

Working between the visual arts and other activities would appear to invite many new insights and compositions. It seemed to many of us a language fully as important to be developed as words. In the second session, we discussed symbols and signs as visually-psychologically meaningful.

After this, we focused on photography, and many of us took, and enlarged, photographs for the first time. We worked from two directions: taking pictures at random, shooting without looking through the view-finder, and being thus led into interests and perspectives which we would not otherwise have had. One person, for example, had her fear of turning wheels changed into interest after having shot a roll of film at random at the heavy traffic on Lewisham Road. The other direction was to select shots according to a theme which would aid in a lesson: people, stones, putting up a tent, making a rock garden. Of course some pictures were simply beautiful records of places we

would not otherwise have seen. We found connections between photography and needlework, painting, dance, sculpture, poetry, as well as with social science, journalism, storytelling. We saw how we changed our meaning by changing a focus or a size or a shade of gray. Small groups of individuals benefited by working out a way of clustering their pictures together so that connections emerged which had not been planned. This kind of group composition with individually made objects was felt as a particularly fruitful resource by some.

I was the only person who worked in silkscreen, and my interest was to find connections between silkscreen printing and writing. Most other printing techniques move from right to left, so that the natural movement and flow of Western script are impossible. I wanted to find out whether a person writing could work immediately into color and form onto the page, with the possibility of reproduction. I have satisfied myself that it is possible. Mostly I worked with litho crayon, writing and drawing on the screen, brushing the screen with glue, washing it out with turpentine, and screening through the image onto a background which I had prepared in advance. I used no stencils nor patterns and thereby avoided the hard-edge quality characteristic of much silkscreening. Each print of a series varied slightly from the others. The quality of the crayon was present in the print. I worked also with a soft brush. The calligraphic power of letters and script affects me deeply, as drawing, and I get great satisfaction from making poem-prints or message-symbols or word-paintings or whatever you may wish to call them. It is important for writing students to realize the visual potential of their medium. The visual forms of poetry and prose are not gratuitous. They are the counterpart of inner forms which are connected with the breath and with rhythms of meaning. In this way they are connected structurally with the exercise in graphics which I described earlier. The forms of poetry have as much to do with space and number as they have to do with emotions and metaphors. In our course we tried to open the range of communication media, and for this reason our report moves between the poles of prose and poetry, word and picture. We were interested in developing a flexibility and range of mood, which we felt is truer to life than the monotone we usually employ. (Perhaps if we used more of our human sources for communication in and out of school, we would find we were in better touch all the way round.)

Writing (this includes printing and typing) has contour, weight, movement, plasticity. The gestures and sounds of its forms are connected with other forms in life: it is not a mechanical skill any more than the art of numbers is. When we teach it mechanically, we squeeze the breath out of it. In my opinion, we deserve, in such cases, the disastrous result that we get.

About half the course members wished to be introduced to clay as a medium. We worked out of a variety of impulses, exploring what clay will do and what heat will do to it. We shaped containers and tiles and figures and beads, working both in the pottery workshop and in our own hut. We pressed plants into clay to catch their imprint and explored their glaze properties. Where did sculpture, handcraft, and science begin and end? Teachers are sometimes uncomfortable as beginners in a new field. The overcoming of this discomfort may help equip an adult for understanding processes and difficulties experienced by children. The dichotomy between learning skills and being creative begins to dissolve.

In our course we debated hotly whether skills should be taught before, during, or after making something we wanted to make. It is doubtful whether this question will ever be answered to everyone's satisfaction. I myself am sure that the experience of how to do something is impoverished by regarding it as "merely" a skill, again by taking the life out of it and the person out of it. We are the persons we are in whatever we do. We are no less sensitive and creative in our perception and performance while we are centering the clay on the wheel than when we are raising the walls of the vessel. My impression is that our experience of "technical skills" is changing. As our conception of man becomes more wholistic, what formerly might have been thought of as means are now seen to be value-creating in themselves.

The form of a skill should be felt from the inside, like the form of the civil riot we have discussed. Or like standing upright on one's own feet. Humanly speaking, there is no such thing as mere technique. Every physical or mental coordination has its counterpart in feeling. English grammar and punctuation have the feeling of architecture and drama; they are not "technical skills." "Skill" means discernment: an ability to distinguish one thing from another. In this sense it is a kind of knowledge. It is also closely connected with wonder. When we teach skills — that is, when we teach the differences between things or stages in a process — it is our duty to keep wonder alive. This is the divine afflatus, the wind in our sails. The same wind that blows through the handling of the chisel feels out the carving of the form. I believe that however hard and long we sometimes have to practice to master some part of a process, we must pay attention that we do not let it die into technique.

My Chinese painting teacher in New York City, Mr. Ho Tit Wah, told me that the stroke of my brush had to begin deep in the center of my body, just behind my navel, the seat of my breath. Breath, or *chi*, he said, must live in the line one draws. Otherwise it will be merely the surface of a line with nothing inside. Even the simplest straight line of a pine motif, he said, must have many things inside. Painting, he said, is writing.

89

One is saying many things. I had to practice endlessly drawing with a brush a thin straight line which did not vary in thickness from its start to its finish. I couldn't do it. It was too simple, too evenly grained. My breath was still too volatile. How much I learned from the mysterious interplay of the *chi* and the brush.

Or take dancing. As Yeats wrote, "How do we tell the dancer from the dance?"

In the embroidery workshop, the integration of personal impulse to do something and learning how to do it was beautifully demonstrated under the guidance of Constance Howard Parker. Because of the lively and rich approach to needlework in the department at Goldsmiths', its interdisciplinary usefulness became readily apparent. Each one of us was encouraged and helped to find and use his own source for the image and flow of color, texture, shape. We were encouraged to observe and draw from nature: plants, animals, clouds, bones. Our hands responded to stories, social events, mathematical symbols and proportions. Again, as in graphics, our sense of the resources available to us was immeasurably enriched. Connections were made with our experience of history, anatomy, both technical and free drawing, with religion, drama, children's fantasy, death, ceremony, agriculture, botany, biology, just to name some. To this was added the enjoyment of working in colored threads and wools and beads and feathers and grasses and whatever else we could manage to sew into place. This work is of interest to both boys and girls, men and women. Weaving, tapestry making, rug knotting, stitchery of all kinds including tailoring, have traditionally been man's work. Likewise, it is men who have been the great cooks and bakers.

It is reassuring to see among boys a renewed interest in the arts of personal adornment. There is a long and rich tradition in jewelry making, goldsmithing, watch making, for young people who wish to be artist-craftsmen to turn to — as well as woodworking, pottery making, bookbinding, silversmithing, and print making. An interest in making things oneself, not as a hobby but as a vocation, has been precipitated by the overwhelming anonymity of automated mass culture. Perhaps as a result of the painful experiences of our century, individuals will awaken more and more to the resources which sleep within them.

It is important that we take this point seriously. Machines will soon be doing most of the rote work of industry. The question of what kind of job a student should prepare for will become a more and more creative question. That is to say, our jobs will more and more be created by us. We will become readier to *give* shape to society rather than to *take* its shape. The struggle for survival may well turn into a struggle to develop the resources of one's humanity. One's lifework may be the expression of this struggle, as a teacher, a craftsman, a business man, an inventor, a headmaster, a farmer, a person.

It is partly for this reason that I urge teachers to take imagination seriously as a practical resource, and to think of themselves as artists in the creation of the future. It is not enough to allow oneself to be shaped by the past and by the present: one must also develop an imaginative relationship to the future. Imagination is the power to envision what has not yet been embodied. It is an artistic perception available to us all. It helps us toward a self-image and a conception of man which is more in line with the open-endedness of our educational goals. It also gives us more opportunity as individuals to be co-creators of those goals. Just as we came to the Curriculum Laboratory in Course Seven and found that if we wanted to develop New Resources, we could not remain consumers of what was already fixed, so in our schools, if we want new resources, we have to develop our faculties of imagination. Participation in the arts is an eminently practical discipline.

I did not have much success in our course in getting this point of view across. And I think it was partly because of the rigidity with which my new friends separated artistic imagination from practical necessity. When I suggested that we discuss the "art of administration," one of the headmasters exploded with impatience and shouted, "There is nothing creative about administration." I continue to be unconvinced, however. When I pressed my question further, to try to find out the source of the unyielding resistance to thinking of educators as artists, one teacher said, "Artists are special, and we aren't special. There, you've forced me to say it." I was extremely touched and regretted the pain I had caused. However, I felt that the cat was now out of the bag, and we could begin to explore the basis of this prejudice. We must enlarge our view of man and of ourselves if we are to be responsible and open-minded about new resources.

## IV

An earlier course proposed a revision of the timetable in secondary schools. It proposed a division into a fourfold curriculum, stressing the introduction of a block of time devoted to Interdisciplinary Enquiry (IDE). The other three ingredients were Autonomous Studies (regular subjects, like foreign languages), Remedial Work (I prefer to call these Courses for Special Needs), and Independent Projects. The general lines of this proposal have been presented in other publications by the Curriculum Laboratory.

The response to IDE in our group was mixed. It ranged from one extreme of those teachers who had come from schools already happily working in an IDE spirit, to those whose mistrust was based either on habits of caution or unpleasant personal experience. In between were a few who had come to the Curriculum Laboratory, as they said, "hoping to be converted," hoping to be swept up in a religious fervor. Here was a hint

of longing for magic: the formula which will bring about the new paradise. But facts show a different necessity. There is no magic save in our personal commitment and perseverance. There is no "take-over." We found out soon enough, by a few trial runs at preparing an IDE presentation, how much time and slow growth and labor are involved, however deeply inspired and naturally enthusiastic. This is a situation in which the realism of artists is helpful. Artists know that no inspiration gets embodied without blood, sweat, and tears, especially sweat, at some stage of the total process. Lots of hard work of the simplest physical kind. It is the artist's realism about the collaboration between physical work and our dreams and our spontaneity that may give sinew to a kind of integration unfamiliar to most of us who have been trained to separate our bodies and souls. "An artist is not a special kind of person, but every person is a special kind of artist." Every person may, as an artist, use himself athletically, inside and out.

In the initial presentation of IDE to the children of a school on Day One, it is recommended that enthusiasm be brought to a boil, groups formed, and material resources distributed. In order to prepare for this "blast-off," the focus group of teachers spends weeks planning and thinking through the theme for the Enquiry. We proposed such themes as Camouflage, Man The Explorer, Flight, Circles, Beginnings, but didn't get very far with them. Why not? I think the reason was that we were trying to simulate a school situation when we were not in one; in fact, the laboratory represented freedom from that situation so that habitual motivation was low. It seemed tiresome to try to concentrate on a blueprint that was not organic to us. We needed something that would capture our interests as the persons we were in the situation we were in. I have since thought that if we had continued our course, we would have developed a theme which we personally would have been motivated to explore. I did suggest, early on, that we select something we were actually involved with, for example something from needlework or pottery or photography, and make one of these a theme of general inquiry to see where it would lead. The suggestion was not acceptable to those who wanted something "practical" — that is, a model to use in their schools. The only practical tactic — I am more than ever convinced of this as a result of the doldrums into which we fell — is to begin where we are ourselves strongly motivated. The life-line leads from living experience to living experience. The "practical" model we take home is ourselves, better equipped for learning and sharing after what we have been through.

Ways of adapting IDE to the needs and personnel of individual schools continued to be discussed. One of the recurrent questions was assessment: How can new values be assessed? Another was: How do we bridge the gap in emphasis between IDE and examinations as now enforced?

Toward the end, we collaborated to mount an exhibition of work we had done. Our purpose was to share individual resources, and to point up interdisciplinary connections within a project or between projects. It was organic to the mood of our course as a whole, for it had been our custom to share with each other what we were interested in. The walls of our hut were an ever changing and colorful bulletin of messages. And most mornings, as we convened over coffee, we shared things we had brought from our gardens, our studies, our collections: flowers, books, pictures, rocks, clippings, poems, doodles, sculptures, jokes, twigs, postal cards, menus, catalogues, rough drafts of proposals, and scheduling possibilities. Plus typewriter, tape machine, overhead projector, blackboard and colored chalk, colored cardboard, paints and brushes, clay. We had gotten used to painting or modeling or embroidering during discussions.

The first question raised was: Who should be in charge of putting up the exhibit? I replied that no one person would be in charge, we would do it together. We were an ensemble of soloists and would take this opportunity to practice our new resource of collaborative composition. Certain impulses in contemporary music and dance and theater as well as business management reflect a similar mode of co-creation. In protest, some members opted out. But as they saw that the show was really going up in spite of their pessimism, gradually all joined in. Ultimately it was the work of all of us. We sustained our commitment to a way of working together through the dismantling as well. I feel that endings are as important in a sense of form as are beginnings and middles and climaxes. We returned our hut to itself, except for a colorful invitation to reconvene socially in the autumn at The Red Cow.

When we put up our exhibit, we went next door to a site where buildings were being torn down, to look for interesting bricks and beams to use in display. Quickly the demolition site became a New Resource, and in addition to providing bricks and tiles, provided "junk" for spontaneous constructions erected in the garden round our hut. Two needleworkers found a long curling fern growing in debris at one side, and saw at once how it fitted with the curling and uncurling rhythms of their embroidery. An old gas meter was taken apart to furnish delicate wheels inside, again a surprise counterpart to the sewn designs.

The construction out of doors stimulated sudden recognition of forms in old screens, tools, tubing, stones, machine parts, rusty kettles. This was troubling to those persons who were not comfortable handling what had been discarded. Others expressed delight both in junkyards and in junk sculpture. The town dump where I used to live in New York State was regularly combed by members of a local school for materials. One never knew what one would find.

93

At another level, namely a national seminar on The Role of the Crafts in Education, held at Niagara Falls last year, it was the recommendation by experts that there be in every neighborhood a junk center: a workshop for free play with materials, open to children and adults alike, with work space attached, where one could come to explore and to make. Things may have a longer life than their owners' interest in them and may go through transformations like the rest of us.

In Course Seven, our most vocal opponent to "garbage art" on the last day tied a used tea bag to the cross-shaft of a sculpture, and it swung or lazed in the wind to the delight of many.

The embroidery exhibit tended not only in the direction of found flora and cog wheels, but also toward carefully mounted roots and leaves for dyeing. It was the consensus of the exhibitors that schools need a connection with nature. It was agreed that we want to find ways to associate schools with farms and gardens and quarries. It was specifically recommended that there be animals to care for and observe, and crops to raise, seeds and fibers and wools and hairs.

Inevitably the exhibition was vigorously debated as to its meaningfulness and relevance to individuals and to the course as a whole.

Groups formed to write reports on the exhibition and on other resources. It was felt by some members that photographs would help to give a picture of our spirit.

v

How do we know if what we are doing is valuable?

This question is particularly keen in a laboratory where new experiences are being suffered through. We do not know how to measure rapport, crisis, transformation, though we may feel them fatefully enough. Most of our measuring rods apply to space and quantity. Experiences of another order, which are not defined by gravity and space, like love and life, are so far measureless. Mathematics is grappling with the *gegenraum*, the negative or counter space (an absence of quantity but a presence of quality) and with the way this living "ether" interpenetrates with denser substances. It is a mathematics of space and light. Here I see as well a picture of the human being, a creation of space and light. It may be that with an increasing insight into human science, we will yet be able to validate inner experiences of growth and change.

What can we say about the desirability of change, and of conservation as well, which may be helpful?

In a laboratory devoted to the education of persons, we may have little to show for our pains but ourselves.

94

How can this be justified? How, except by the fact that it is ourselves who live and learn and teach. What more central than that we shall be initiated and reinitiated into further stages of our development, so that the laws of inner growth may work freely. Curriculum will become indistinguishable from our lives and the nourishment they require. Teachers may see themselves as human beings who want to help to infuse into schools the spirit they wish to see at work in human relationships at large.

My fellow course members may complain that I am becoming too philosophical to be useful. But with their help I have learned to press on in a direction that is meaningful to me, in the hope that we will find ways to share our paths. Questions of value are in part questions of moral philosophy. If they were less difficult than they are, we would not be as at sea as we are. Because the art of evaluation is the most difficult of all the arts, we usually settle for "personal reaction" or "diagnosis." Meanwhile the search for values goes on.

Intelligence is not stored in the brain, nor feeling in the heart. Hands can be wise and tender. Brightness can be blind and callous. How wide our perceptions must range if we are to acknowledge all the data! A concern for inner development is part of the new science of our time. Physics, psychology, education, medicine — all stand at a frontier. Problems of synchronicity, of wholeness, of fluidity and metamorphosis within a continuum, are stirring in such a way through our thinking that we feel the fusion of mathematical and spiritual perception. There is evidence that qualitative and quantitative structures are reintegrating within a new consciousness.

It is partly because of this development that the intellectual virtues are being reassessed and their function reappraised. Also, it is partly due to this development that the arts just now are being invited more and more into the curriculum of schools to be integrated into other subjects. It is through the arts that we are often led to feel the "quality" of a physical material. Physical materials are as appropriate to science and to history and to writing as they are to painting, modeling, sewing, and cooking. Where, after all, do they have their source, if not in common nature? The colors we use come from stones and animals and plants. How does it get into them? Where does color really come from? Or shape? Perhaps they too have their origin in spaceless realms.

Research in education, represented however modestly by the Curriculum Laboratory, moves now in a variety of directions. Toward psychology and perception, toward making, toward community, toward new ways of assessing quality, toward a balance between interdisciplinary inquiry, in-depth special study, corrective study, and basic subjects.

We are in a time of change, from being spectators and critics to being co-creators.

We have come to a threshold. When we are led across it, we find that we are re-entering life from the inside. From the inside there are no cleavages. We dwell not only upon the surface of the globe, but also *within* a living sphere. There are no hard lines, though there are continually moving and differentiating forms. But because the forms are in motion, we do not see outlines in the same way. And because we see forms from the inside, as if they were transparent, we do not see mass in the same way. This table where I sit has its invisible solar system. We are beginning to perceive with the inner eye. When we see the physical world with our inner eye, we have healed the breach between artist and scientist. When the painter depicts this table as a plane of rotating suns, his surrealism is objective fact. At last we are entering one world.

The new resources which seem most potent for the future, then, are within us.

A felt commitment
to persons
to process
this makes all the difference.

Important undertakings
in intentional communities,
in colleges,
in marriage,
with earnest individuals,
have had their life-lines mutilated
because commitment to persons has been unsure.

There is often enough commitment to purpose
or, even, to love,
but when the purpose changes or is betrayed
or the love changes,
participants withdraw,
we withdraw because the purpose or the love has changed.

At the Curriculum Laboratory
(perhaps I should speak only for myself),
I found myself sustained through betrayal and change of feeling,
sustained, by others' commitment to me
and mine to them. However at sea we were,
muddled and searching, however desperate or derisive,
we arrived each morning at ten, for coffee and discussion

96

or individual ploys. We did not go away.

I am better equipped, as a result,
to suffer through the vicissitudes of common human endeavor, better able to trust the
ability of human beings to solve their problems, to err and forbear, to expand awareness
and versatility of response.

A psychology of inquiry:
this invited forth our consciences
        toward acceptance of diversity (gradually)
(still a long way to go, but a beginning has been made,
no one of us will think the same way about values as we did
before we came)
        and relationship through differences,
this too.

Following clues
outward, from one's personal center,
        and
receiving clues from others, and from environment —
this helped us
        to free our initiative
and extend our awareness
and widen our connections
and deepen our sense of
        being separate
and together
        simultaneously.

A LABORATORY
is NOT A CLASSROOM.
This is a NEW RESOURCE
which effects CHANGE
        in those who join it.

Sharing conflict
communicating privacy,
        living in paradox
                and polarity

97

not knowing what will come of it
    unpressured to achieve
willing to wait for it

WHEN YOU CAN DO WHAT YOU WANT TO DO, WHAT DO YOU DO?

We agreed we need
    languages
        to convey so much more than
concepts — ears to hear how our words feel to others.
An ear for the languages of others,
    often silent,
            implicit,
a way of sitting,
a glance, a timbre in the voice,
    the names of ROSES members of our course brought:

        peace
        yellow peace
        pink perfume
        josephine bruce
        wendy cussons
        super star
        virgo
        orange sensation
        cabaret
        penelope
        dearest
        zephirine drouhin
        henry martin
        pink grootendorst
        chrysler imperial!
Transcending the grammars we teach and learn,
can we own up to who we are
    and the mystery?
    Can we awaken
ourselves in ourselves,
    and in ourselves

each other?

A quality of caring,
a mood of mind,
        sustains
the whole
and lets absence play
        as well as presence,
lets exceptions play,
lets each person and moment play
        "come when you can,
we are all always here,
        somewhere."

It is a quality that begins to rise
        in consciousness,
like blood in the cheeks,
        our countenance in our deeds.
        We say yes
            and no
        to one another
always caring
        and including
                the negative
                the enemy.
        We bear the cold
            and the hot,
finding our balance
                in floods
                in fires.
        There's a lot to learn,
growing up with each other's help.

We begin at the center
        where conflict is —
                separateness
                and

differences,
this is peace.
War wants to get rid of differences,
        wants sameness
        wants victory for one side.
Education for peace
        is
education in differences
        savoring our differences
        listening to what isn't being said
        seeing what isn't visible
developing perceptions that are open doorways,
moving and turning and yielding,
to new combinations.
We learn to find our way with each other
                        around each other
                        in the presence and absence of each other
        as on a dance floor
        or in a dream
        or over the telephone
        or through memory.
The sphere of presence and absence is
        continuous,
we are aware of each other
wherever we are.

        Much of our work in Course Seven
was to develop and maintain a sense of human community
which does not depend upon sameness;
        a respect for persons and their life-lines;
        a feeling for unfolding process.

        I am glad I have had to struggle in this unexpected way, forward, into the future.
To survive freedom, I have had to make humble gains in personal resourcefulness.

# VII

At New Year's, 1968, I returned from England to follow through on a proposal I had made to friends here. It was that we should hold a two-week festival of kiln building and pottery making, on Paulus Berensohn's farm in Pennsylvania, where he had a pottery shop and big fields for camping and outdoor firing. The festival took place, with thirty-six people, including two kiln builders whom I had met in England and invited to join us: Ann Stannard and Helen Penny. My particular interest in doing this festival was twofold. I had attended a Craft Conference (sponsored by the Society for Education Through Art) at Chichester, where kiln building was part of the offering in pottery. To my knowledge, no such opportunity was available in America, where the building of kilns has tended to be regarded with awe as the province of experts and the wealthy. The idea that ordinary people with modest resources might build their own kilns as part of a total pottery experience was new — as was the integration of primitive firing methods. I was eager to transplant the seedling in America. I may say it is alive and doing well at the present time. Also I wanted to see what we could do on our own, without sponsorship by any school, institution, foundation. People often seem to feel that they can't do anything without piles of money and buildings and organization. What could we do, a motley crew, on our own, to solve problems of food and shelter along with other aspects of socio-artistic practice, using our own resources, sharing costs and opportunities; no one received pay. It was an exercise in the art of initiative, and the ways initiative can be practiced by all the members of a group, flexibly. We built six different kinds of kilns and made pots to fire in them, had a garden, baked bread, enjoyed ourselves, suffered. My only objection was that there weren't enough children in the group: only one. I find that people of all ages and backgrounds working together is to my taste.

Before the festival, I went to Antioch College to give a talk at a Symposium on Current Trends in Education, June 7–9, 1968. A number of young teachers, who had been given Danforth grants to develop creative teaching procedures at Antioch, had arranged the conference and were present. One of them, Karen Shirley, who taught pottery and who was making a film about her feeling for clay, invited me, as one of three outside educators who were invited to prepare papers: one on a philosophy of university education, one on student revolution, and mine on a teacher's values. Each of us was followed by a critic, who had prepared an evaluation of our presentation. Mine was Professor Judson Jerome, poet and pioneer in experimental education at Antioch, and I fared reasonably well in his generous hands. I think the most important step it represented for me was that for the first time I introduced the concepts of karma and reincarnation as part of a philosophy of learning.

# Current Trends in Education:
## A Teacher's Values

**I** have a friend who is writing a book called *Arm in Arm*. It begins with a children's joke about two octopuses who get married and walk down the aisle arm in arm in arm in arm in arm . . . I propose this as a picture of current trends in education: interdisciplinary curriculum, community participation, and sacramental commitment "I do." As a teacher, I live consciously in these realms.

Heart, head, limbs "arm in arm." Mind works through sense organs, imagination, digestion, breathing, as well as through head-thinking. Wholeness of mind. This is one "arm in arm."

Human consciousness is crossing a threshold as mighty as the one from Middle Ages to Renaissance. People are hungering and thirsting after experience that feels true to them on the inside, after so much hard work mapping the outer spaces of the physical world. They are gaining courage to ask for what they need: living interconnections, sense of individual worth not based on accomplishment or success, shared opportunities and shared costs, natural leadership, nourishing food, it's a big breakthrough. Our relation to past symbols of authority is changing because we are awakening to ourselves as individual beings with an inner rulership. Property and credentials and status are not as intimidating any more, by themselves, and thus are being questioned in colleges and elsewhere in society. New symbols are rising: pictures of wholeness: mandalas; divinity at the center of the four directions; and yin/yang symbols reconciling the opposites of feminine and masculine, receptive and creative; the cross, symbol of the end of an old authority and the rise of a new man. Freedom sings within us as well as outside us. Sages and seers have foretold this second coming. Disciplines are not of subject matter alone, but of human being. The word is getting around.

Codes of privacy and decorum are being challenged. Who am I? Who are you? People don't want to feel stuck, they want to be able to change. They want to see a relationship, an "arm in arm," between knowledge and human values. If we want to give students knowledge, it may need to come through our sense of its relevance to where we are in our lives. Moral harangues and intellectual oneupmanship are less convincing than personal example. Knowledge has to be experienced in an inner way in order

for it to feel real. It may do so imaginatively as well as materially. One of the arts of teaching is to discover how the human life-line weaves through the forms of knowledge.

For a lot of people it doesn't work to tell them to go read a book. Teachers are human mediators of experience. We need human mediators. We need to be told stories and shown things, shown how to do things, taken for walks, companioned. There is no substitute for contact in the human learning process, though this contact may be felt in diverse ways. I am not dredging up the hackneyed model of a teacher at one end of a log and a student at the other. Some of us who are bookish feel enormous living contact with the spiritual community of poets and philosophers of the past, and with luck we can convey it live. But we may need simple human guidance in doing sums, distilling brews, modeling forms, creating an imaginative happening. We can be guides for each other. We can tip each other off. "This is pay dirt, dig here!" And then we try it for ourselves. Some things we discover independently. Someone may ask us what we have found and we will tell them. They may look there and find it too, or not. It is the spirit of inquiry we pass on from hand to hand. Building our base camps and settling in for a long dig, or not, depending. Everyone is following a scent in his own way: we may be teaching one subject, but the student may be learning something else. I am reminded of a little boy in the second grade whom I thought I was teaching to work with clay. But when we were washing our hands together under the tap, he said, "When I first saw you I didn't like you, your hair was too long and your face looked like you was getting old, but I like you better now that we've been making these clay things." My heart leapt! I had supposed that I was teaching him clay, but he was learning how our impressions of people may change when we work together! What a miracle! We all learn and teach in unexpected ways. It is another "arm in arm."

A teacher is a learner who wants to share his learning with others, and to learn from them. One of the current trends in education in which I am most active is the setting in motion of workshops where teachers from various disciplines come together to share learning, working with each other and with a group of students in a spirit of collaboration. This releases the professional teacher from the lock-up of his expertise and allows him to work at his growing tip, as well as sharing with others what he knows and they don't. The teacher's role is changing like everything else. He doesn't need a role any more. Now he needs to be the real person he is, if he is going to answer people's needs. They are his needs too, actually, now that the feudal establishment is crumbling and officialdom is being replaced, one hopes, with individual conscience.

The myth of higher education crumbled for me a long time ago. In 1945 I was

appointed to the English faculty of a distinguished midwest university. I quit after three terms because I couldn't stand the atmosphere. The "role" of the teacher was to conform to the syllabus and to prepare the students for examinations. (The students refused to do any work which was not clearly meant to prepare them for the exams.) The style of the teachers was to expose ignorance through sarcastic questioning and to humiliate the student into what passed for knowledge. This was called the Socratic method. Then they put the student through a battery of punitive examinations, which, if he survived, made him feel superior to others. He then went into the adult world sarcastic and arrogant in turn, with his brain honed to play games to win and to escape traps and to set them for others. His character tended to be concealed and explosive. I didn't like it.

I went from there to Black Mountain College, an educational experiment, to see if there was hope at the other end of the stick. There was. At BMC everyone participated in everything and there were no roles to fall back on. If a person was rude, it didn't help him that he might be chairman of the faculty; he might still get punched in the face by the person he had insulted. It is very educational to see how teachers fall upon each other when they have nothing to lose but their composure. It was a life-changing lesson for me to experience how shallow our education is in terms of equipping us for self-government, patience, charity, creative social imagination, nonviolent conflict. How are we to learn these arts unless we have reciprocal forms in education — collaboration — co/creation. There is no substitute for experience.

One of the current trends in education is the new will rising in us to practice what we preach. Honest action is the cry. I have pondered since childhood how long it would be before the values mouthed by adults would come to life in their deeds. During my adulthood, particularly because I am a teacher, I have wrestled with this problem. After I left Black Mountain College, I did not teach for several years because of my despair over the gap between our knowledge and our behavior. Since then I have studied continually the arts of crossing that gap: the arts of transformation.

There are in all of us two rhythms (at least), one contracting and one expanding: one seeking rest, the other seeking motion. We have to remember that rest is only healthy if it is an aspect of motion, and action is only healthy if it is an aspect of rest.

By "healthy" I mean "whole." That's what healthy means, everything working and working together. Heal, whole, holy, these words come from the same root. I am interested in these beings: wholeness, holiness, healing. You have asked me to share with you my values. My goals as a teacher are my goals as a human being.

Since I am interested in wholeness, I am interested in diversity. In differentiation and the suchness of each thing; also in Oneness. In freedom and in union. In organic process, birthdeathrebirth, metamorphosis. All the arts, because of my interest in materials and the mysterious connections between them and us in the creation of symbols. The importance of intuitive experience. I am very interested in communication of all kinds, verbal and nonverbal: the communication that underlies words and makes oneness possible between separatenesses and differences. Something is communicating. I have come to see that connections are built into life. When we experience connections or write equations of connections or poems about them or analyses or diagrams of them, we are experiencing in our thinking the sources in events themselves. Since we derive our thoughts from experience at some level, thoughts have their counterparts in experience. There is therefore some kind of "consciousness" in everything. To be "in touch" is to be in touch with this source. Current trends in consciousness-expansion reflect a similar intuition.

Thinking, which we express through our various verbal and symbolic languages, is not invented by the brain. It may well be, on the contrary, that the brain has been created by thinking! Thinking is an activity of the universe which our faculties translate into "human thoughts." This activity may be sensed by other organs than the brain, as any craftsman knows, or artist, or lover, who relies upon the intelligence in his hands, ears, eyes, limbs, heart to tell him what's happening. Or scientist, whose intuition leads him, as Einstein's did, to the great equations. Since our being participates in this objective inner living continuum — shared by nature — thoughts and experiences can be shared. I tested this hypothesis in a three-week program of interdisciplinary experience two summers ago; I called it "CROSS-OVER: Toward a New View of Language, Verbal and Nonverbal."

We know that consciousness is not defined by the iceberg tip of ordinary daily waking. We know about sleeping, dreaming, states of extraordinary consciousness. Therefore let us acknowledge as teachers that to be whole we need to develop organs of perception in other realms than abstract intellectualizing and mechanical model-building. We need to develop intuition and imagination and inspiration, just as we have needed to develop rational thinking. We need to develop a crossing point from one order of awareness to another, we need to come to understand what thresholds are and be prepared to cross them when the proper time comes. This is the teacher's territory in the evolution of consciousness and the evolution of values. Life is a series of initiations at different stages of our development. We need to know something about

what initiation is, something about the difference between wisdoms developed in the Orient and in the West, in the North and in the South, and we have gradually to develop the capacity to experience their integration.

An interest in wholeness has also to do with one world and its health. Questions of circulation of money, political rights and responsibilities — transformation of underdeveloped countries into the family of man, of overdeveloped countries likewise into the family of man. The psychological parallel is clear, the inclusion of the underdeveloped sides of our nature, loving the enemy, humbling our pride and fear of rejection. It interests me very much that the social question today is experienced in terms of color. Again psychologically, we are coming to be able to look at the total spectrum, life in all colors, and to resist the falseness of black and white images, black or white alternatives. I think it was Goethe who first began to show us that shadows are not always black.

Commitment to wholeness requires that we probe the mystery wisdom of death as part of the life story. What is the function of death? Death serves to separate us from whatever we are attached to, physically and psychologically. It is the drastic acting out of nonattachment. Yet if we observe nature and read the sages and meditate on the deep inner changes in our own lives, we see that the life-line is not severed. In some deep sense the being does not die, it contracts into a seed point encased in a corpse, and when the outer form drops away, the seedling appears. Corpse/seed. An important emblem to meditate on. This is a plasticity of perception I have learned partly from the potter's craft in working with clay, partly from the history of language and practice of poetry. Also from observing the continuum of the seasons in nature and the continuum of consciousness. The Now Moment is played into being by time flowing from two directions. From the past and from the future. The past pushes us from behind. The future invites us. We feel rooted in the past, we feel ourselves grow out of it. And like a good root, we are nourished through countless little root hairs, contact points. But we are not all root. We are not all dense substance drawing growth from what already exists. When the sprout forms, it has a characteristic hollow at its center out of which new leaves appear. Rays of light play into this hollow. Out of the growing point arise new forms which are sculptured by what streams toward them from the light as well as what feeds in the fertile dark below. These are the prophetic or seed-forces of our history. It is important to say this so that adults will know how alive life is, how full of alternatives and hope.

We grow partly from what is present in us through heredity and environment and personal karma, partly from what seeks us out from the future. It is important

throughout our lives to stay in touch with our growing point as well as with what is already formed. This is the child in man. The eternally youthful element in all wisdom. It is this that bridges the generation gap. At the top of the oldest oak, the meristem provides growth cells. An open end. When we feel our life-line from the inside, we sense this continuum of growth and metamorphosis. Thus we feel the wisdom of both insecurity and security. We feel both in motion and at peace. Firm and yet experimental. We are rooted in the flow of life, like a good carrot. Homeless, we are at home.

An educational environment, like any human environment, should in its forms acknowledge this interplay of past and future which characterizes life process. Part of what we need to learn is to contain the tension that gives life its energy, to come into conflict without a compulsion to win or to lose, but to make of peaceful conflict a life-style. To transmute our fear of conflict into perceptions of its inner form: the interplay of opposites, the relationships of differences.

To achieve death then is to be able continually to relinquish one's past possessions, to go through the narrow gate. This is both an inner and an outer discipline. This is hard work in education: to yield, to listen, to sacrifice, as well as to bear witness, to press on, to fight. There is a time for everything under the sun. I know from experience that emotional preoccupations cause deafness and retard intelligence. How may we create a flow of feeling which is unfixed in past patterning, a flow which is fresh and generative?

Current research into artificial intelligence is helpful here. We need to explore where our behavior is automatic, conditioned, unfree, and why. Part of adulthood is casting off the sheaths of habitual response, parental identification, and rote procedures which have helped us to grow. We enter the second part of life during which individuality seeks its wholeness. This may involve sharp encounters with what has been repressed or underdeveloped. This is adult education, life-long. Teachers particularly need to re-educate themselves, to show the way.

Science too is changing because of what is awakening in human consciousness. There are signs of a new integration among different modes of knowledge. Another "arm in arm" toward a new union. For example — and this is very important for anyone interested in current trends in education — certain concepts associated more with Oriental religion than with Western science are receiving study by Western minds. Western minds bring to these concepts a kind of scientific thinking which gives them contemporary relevance. Arm-in-armness of East and West is part of what's due.

Karma is a term widely used in the East for continuity with the past: Karma is what we carry with us as inner patterning from the past, either our own or a family

past or even a racial past. It is very complicated. The sins of the fathers are visited upon the children, there's no doubt. We know from psychology how we are bound by the unconscious of our parents. One of the aims of our lives and therefore of education is to gain our freedom from coercion by the past and in this sense to make new karma. It takes a lot of spiritual understanding to move in this territory. That's why I study depth psychology and alchemy and initiation science. Public journalism and textbooks are insufficient to equip us for self-understanding or world-understanding. The young people are sensing this. That's why they are looking for gurus and taking drugs, because they want to make contact with the forms of the inner world. If we have any better tips for how to do it, now is the time to speak out.

It may seem strange to be talking about esoteric science in a lecture on teaching goals, but that's where we are. The doors are opening and the young people are rushing through. Every generation is born asking new questions — and it seems to me that the new questions for our time are "What is man? What is cosmos? What is the inside story?" The sciences and the arts now, it seems to me, are pushing ahead "arm in arm" to map the territory inside and out.

I could talk about trust and fairness, taking enough time with people and things, about telling students and colleagues what you need from them humanly, and not trying to be the big wheel or big mommy/daddy all the time. But these things we already know. Also I have talked about my values of free perception, free participation, and free initiative in my book *Centering*.

So, to come back to karma and the East-West. Recent work in information theory and genetics, and biopsychic investigations, suggest that experience is in fact digested and stored in the tissues and may indeed affect our children. This "information" has all the dimensions our experience has, it is a record of our feelings and thoughts and capacity to respond, unconscious as well as conscious. As a teacher/researcher I have learned something about how this "information" can be transmuted by personal inner effort. A pattern need not become a prison. Creative fantasy can help us learn new ways of being. Imagination can be developed and used for inner freedom. Intuition can be encouraged to keep us in touch with inner generative sources. Inspiration can be cultivated through patient devotion and inner work. Also there is a kind of inner will which can be awakened to work for freedom and balance. Education is a combination of joy and toil!

If someone is studying poetry or pottery and finds himself caught in past prejudices and fears, he can be helped to struggle free. This is part of the work, to struggle free of compulsion, ignorance, shame. Ignorance leads to suffering. The Buddha gave

his life to this truth. It leads to suffering because it binds us in forms we try to protect because we ignorantly think that's who we are. Desire is an impulse to satisfy our compulsions. To be free of desire is to be free of pressures and to be able to choose what we do. If we know what ignorance and prejudice are, how they are lodged in our tissues, we will have compassion on ourselves and set to work with some idea of the size of the job to be done. If we see how desire and power are connected, we will know something about the difficulty of disarming the power principle and we will see that inner education may help us get free of games and compulsions.

To act out of oneself, this is the task. To tell the truth and to be an individual. Very difficult. To act out of ourselves in free association with others, not to require endorsement and approval. To keep the lines open between all our differences, and to make a life-style out of them. Differences constitute wholeness. Work in the arts can be helpful here. I believe that all teachers, all people should practice an art. There is in every person an artistic center which, when activated, can give him an experience of his difference from other people and courage to be so. An original vision, filling out the picture we all together make. If one of us is missing, the picture is incomplete and therefore imperfect. To be perfect is to have *all* the parts included. All of them. Education is an art, science is an art, politics is an art, life is an art. That's where I am. That's what I teach. What we do out of ourselves is an art, it is creative, it contains feeling and vision — it's not what we say or do in life that makes the difference, it's where it comes from within us

Of course if we act out of ourselves, curriculum does become something new, something organic to the people concerned. Also we have to keep aware that "ourselves" is not only what we so far know but also what we don't yet know, what we are becoming. So if we act not only out of our historical selves but out of our prophetic selves, we can combine experience and vision in a productive way. We want to be practical and we want to be visionary. We are by nature idealistic animals. Good, another "arm in arm." We have natural evolution working for us as well as the celestial pantheon. This is what "turned on" means. It means turned on to the flow from both directions. This is what the cross means, it means on earth as it is in heaven. This is what higher and lower education mean. Lower is the horizontal earthward horizon-line gravity aspect of our necessary animal rootedness in instinctual life, and higher is the vertical levity aspect of our psychic transformation and resurrection of the body. Resurrection of the body means getting free of hang-ups and filling the membranes with free and loving spirit, and practicing what we preach. This makes a lot of difference to the way bodies behave and look.

We teach through our bodies because that's where we live on earth, and we learn things through our bodies that we can't learn any other way. They are part of our mind. It is important to experience number, language, proportion, form, inner conflict, rest, through body movement. Unless body wakes to what spirit knows, it is going to be sluggish and obstructive and stupid. And if I don't recognize through insight what my body is telling me, there's likely to be a war on. It all comes down again to this "arm in arm" matter of wholeness and healing and suffering through the conflict, the digestion, the transformation, and calling upon the prophetic powers of light to dissolve the deposits in our souls, and calling upon the sweetness of the dark to give human flavor to what grows in us. We weave between darkness and light. We are all rainbows. The rainbow tells where gold is. It's a big order: to stand in the interweaving of darkness and light and to feel at home there, but this is what I think character is, an ability to live life as it really is, according to its inner laws: to let it grow in us, to let ourselves grow and change and evolve: to feel the breathing in and out and the life-line; not to try to put a clothespin on the flow and say "that's enough" — to try to bear the beams of love, as William Blake said.

There are a few concepts which I have found very helpful in understanding current trends and so I am sharing them with you. As I said, my values as a person are operative in my teaching. They are not my subject matter, but they are a kind of metabolism turning experience into nourishing meaning, like spiritual enzymes! Centering, Metamorphosis, Transformation, Karma, Reincarnation.

Reincarnation, also a term from Eastern religion, is likewise being re-experienced through Western scientific objectivity. Reincarnation means re-embodying. It means taking a new visible form from an inner process of growth, development, and change. It means rebirth. Again, evidence from microphysics, medicine, biochemistry, depth psychology, suggests that matter may indeed be "created" (precipitated) from immaterial sources. This opens up the scientific possibility that there is an invisible supersensible continuum which is as it were pulsating into material forms, following certain rhythms and periodicities. If you look at history this way you can feel more at home with the lawfulness of all our seasons. The seasons of withering away, of repose and latency, of springing up anew, of flowering and dying and bearing seed and again rhythmically pressing on, the life-line from the beginning never having snapped. In the learning process, we have the concept of stages of development and metamorphosis of capacities. This way of looking at things helps to free us from abstract achievement compulsions and possessiveness about being always "right." It helps to develop an ear for growth seasons and it helps to understand when we tell each other that something

isn't working for us any more. It may be that what worked last year isn't working this year, maybe it's a different stage of growth, and if growth has an open end, we have to see that the new demands are in some real sense original and creative and ask for original and creative response.

Here's where we have to be creative persons because there are no blueprints for what is not yet born into being. Here's where we have to trust intuition developed through experience, and act where we don't know what to do. If in some sense we are always standing at a frontier, we have to be willing to be pioneers and figure things out as we go along. I think that we are pioneers, and that the frontier lies within the new forms that life presents us with. We have no maps for a lot of the new territory we are entering, but we have good humor and courage and imagination. It is true space exploration. Inner space as well as outer. It takes courage from all of us, teachers/students/administrators, to work together toward the future. We may well ask ourselves what equipment we need. We ask the questions and grow to the answers. We are exploring the new terrain, in our time, of a revolution in values, a new human consciousness and social order. Does somebody prefer the hazards of moon travel? I don't blame him.

Life is a great adventure, if you look at it this way, with new impulses always beating up out of it. There's plenty of work for everybody.

A technique called *Action/Research* may be helpful here. It is the rhythmic doing of deeds and coming together in groups to meditate on what has been done, what needs to be altered or eliminated, to refuel, to have continuous opportunity for interaction and learning from it. It is an entirely different mode from the attack-and-defense psychology of old-fashioned negotiations. Teachers, students, managers/directors, may go out in this way, and return, participating in the experiences which will be researched in common. The research need not be all verbal. Here artistic expression in painting, modeling, dance, improvised theater is very useful.

The new consciousness is "inclusive" rather than "exclusive." It embraces artistic consciousness, religious consciousness, scientific consciousness, social conciousness. In it we want our own form and we want to communicate with others. And we want a quality of being that contains all this, and I think that one of the disciplines of the teacher is to participate in this human quest. It is what I call the discipline of centering.

Students bring changing values with them into learning situations. They are more and more out in the open. And they are part of a teacher's palette of resources. As Buckminster Fuller reiterates, the college generation today have been born into a

world that contains Hiroshima and television, and, I would add, an underground press. It's pretty hard not to know what's going on. It used to be somebody had to tell us. Now more and more we can see for ourselves. This tends to make instructional rhetoric, authoritarianism, and moral duplicity seem outmoded. The left and right hands are beginning consciously to clasp one another as serving the one being.

I will point briefly to some symptoms of the emerging spirit.

1) A worldwide dialogue on the subject of social change. Instead of revolution being considered exclusively as an attack from outside upon an established form, it is being considered as a potential resource — an art of transformation voluntarily undertaken from within. Revolution arm in arm with evolution, creating a balance which is neither rigid nor explosive. Perhaps we will learn to relinquish voluntarily our patterns of power and subservience (however masked they may be as sacrifice and loyalty), and work together for organic change. In an educational environment inquiry should be continuous into issues of oppression and liberation. Oppressors may be Ignorance, Prejudice, Impatience, Sloth; or they may be Hunger, High Taxes, Invading Magicians, Mass Media Persuasion Tactics. There are many kinds of oppression and many paths to freedom.

2) The spreading demands for Dialogue indicate that life is increasingly felt to be a two-way street. Consumers are beginning to realize that they are accomplices to what is being produced. They are beginning to question their own passivity and to see that they may influence production by making their wishes known. In education there is more ease with divergent thinking, and curriculum created out of the mutual initiative of students and teachers.

3) Discoveries in physics show that the see-er is part of what he sees. (See, for example, Hansen's *Patterns of Discovery*.) Experience is formed by what comes from within us waking to what comes toward us. It is a co-creation. The stimulus-response arc is obsolete. We are not sponges who collect impressions and give them off without inner involvement and consequences. The involvement and consequences may not be felt consciously, but we can be sure they are occurring. Every person creates environment by what he gives off out of himself. The young people call it Vibes. Part of our human work is to become conscious of what we ourselves are bringing to an occasion, for others will be feeling it and learning it. Teaching is an art of self-study and receptivity.

4) An international movement to make educational policy a group endeavor, a mutuality of trustees, administration, and college community. This requires flexibility on the part of former power holders, and a willingness on the part of students to share

the daily work of maintenance and planning. What lies behind the demand for participation is the fact that persons all over the planet now are having a strong inner experience of community, of "arm in arm"; they feel interconnected. It is a new capacity for relatedness and responsibility growing within them. Many persons are also aware that very little in their education has prepared them for community. They realize that new social forms will come only if an inner path of self-development is undertaken. The human potential movement is connected arm in arm with a concern for new impulses in education and society.

There is widespread acknowledgement that we have to work on ourselves as well as on society. The widespread study of meditation is a way of coming into contact with the springs of true freedom, freedom from past patterning. Meditation is an inner activity by the individual, who develops exercises to free his thinking and his emotional reactions and his bodily habits from their compulsive activity and their hang-ups, in order that he may become a living vessel able to receive a new message. This is what the sages mean by "emptiness." Emptiness means being free of opinion and clutter and zeal. Ready to listen. People who don't know how to listen will naturally tell you there is nothing to hear. It takes long and diligent work to awaken the inner ear. How is it one sage puts it? Oh yes, in order to know you have been asleep, you have first to wake up.

Community is an art of education. It is being called into being in many spheres, not only in education, but in sports, government, family, theater, therapy.

The world is trying to struggle free of the remnants of feudalism. The lords are as in need of freeing as are the underlings. No more packaged values. We are tired of being manipulated, judged, rewarded, and punished. Teachers as well as students want to be their own masters and to come into relationship with each other as equals in humanity. And they are saying so.

There are movements also to develop community forms in industry: as for example the Scott Bader Commonwealth in England, described in Fred Blum's book *Work and Community*. Educational environment, and this includes classrooms, should permit the sharing of "management functions" and "labor requirements." A sixth-grade teacher said to me recently, "I never teach anything I don't talk over first with the children." I myself tend to work along with a class, doing many of my own assignments. It is helpful to students to see how their teacher does something she hasn't done before. Who was it said that intelligence is measured not by what you do with what you know, but by what you do when you don't know?

5) A shift in motivation among learners is one of the most striking current

trends. They are interested not only in information, but in beauty and wisdom, in well-being, in goodness, in "a new morality." These are broader than past formulas of getting ahead and income-producing achievement and social respectability.

The concept of work is changing. Work used to mean what you do for wages. It still means that to many people, but to many it does not. Work is inner involvement. Work is caring about something and expressing your caring in some way whether you get paid for it or not. Our work may be to learn and to grow and to help one another. It does not mean employment necessarily, nor necessarily having something visible to show for how you spend your time. It takes energy. We can sit in a cave in Tibet for fifty years and chew stones and be really involved in our human being, doing research in our own way — or we can look at the stars, build a house, keep a diary, be president, can tomatoes, murder. Everyone has his own unfolding to contribute. This is why it's dangerous to be hired to teach only what we already know. It tends to make people nervous about their need to grow and to change direction. I have observed that money tends to encourage reiteration. There is a big question here.

Finally, 6) a strong drive toward spiritual breakthrough. Young people are looking for teachers, their music and poetry are full of quest, at the same time an unsentimental realism. "Religious" is a word that is being liberated. It means "binding together" what has been separated, healing the split between body and soul and spirit, visible and invisible, ordinary and extraordinary — healing the mind that was broken when creation divided into light and dark. The light is becoming visible in the darkness. There is increasing interest in ritual and sacrament and silence and singing, in prayer gardens and prayer art. These touch realms which are breaking through into consciousness: the realm of the gods, the archetypes, the spiritual guides and daimonic forces, that powerful and dangerous and creative realm which we need to learn gradually and carefully how to come into a right relationship with. Religious consciousness animates the mysterious crossing point into this realm through ordinary persons and things. The sacred standing stone, as Mircea Eliade has so beautifully documented for us in *Images and Symbols,* is both an ordinary stone and a "boundary" where two realms meet. Thus the sacred "boundary stones" across the earth: Stonehenge, Carnac.

People of all ages are strongly motivated to coming into touch with new parts of themselves, to turn their heads-hearts-bodies around, to be "liberated." They are hungry for release, for relevance. There is a strong intuition that there is more to life than money, status, pride, power, and greed. Since we can't find that MORE outside in the world, we are looking for it inside in the spirit. Starting from a new source, we will try to offer to the world a new quality.

In the April 2, 1968, issue of *Look Magazine*, there was a feature called "Campus Moods." The gist of student statements was this new feeling for values:

> Joel Kramer offers an explanation for the students' growing dissatisfaction with the relevance of their education, an explanation agreed upon by many of the undergraduate editors on *Look*'s panels: "This is the first generation of students that is not going to school for purely economic reasons. At Harvard, most of their parents are professionals, and the kids don't have to go to school just to make a living. Most of them are not worried about that. They therefore become the first generation, I think, to look at education as education. You begin to be very critical of it because you're more interested in what it does to your mind than in what degree or diploma it gives you when you get out."

This use of the word "mind" seems to me to indicate a resurrection of an ancient use which included "heart" and "spirit" in the "phrenos" or "mind." See Ronald Laing's book *The Politics of Experience,* in which he proposes that "schizophrenics" are in some deep sense "broken-hearted."

> "There are no national heroes," says Stanford Hanson, "but I think there is still such a thing as a hero. It is the man who is totally honest. We are not respecting a man because of athletic ability, political or scholarly ability, but rather for the characteristic of being open, and honest.
> "Most of our parents grew up in the Depression, and they were really very hurting. They are concerned with money, status, and they're very insecure. Most of us, on the contrary, grew up in the most abundant society the world's ever seen. And to us, abundance and all the trappings isn't something to work for because you have it. You're used to it, it's nothing. So you start getting into human values because you've gone beyond the security thing. And our parents just can't understand that."

Or take this comment from *Look* Editor George Leonard, quoted by Sister Corita in her book *Footnotes and Headlines:*

> Education in a new sense will be the main purpose of life. Learning is what human life is. Humanity has travelled a long way to arrive at that essential truth. Man in the past may have been a hunting animal, a fighting animal or a working animal. Future man will be a learning animal, not just during what we now think of as the school years but during all of life. To go on learning, to go on communicating that learning to others, will be considered a purpose worthy of man's enormous and ever-expanding capacity. . . .
> California corporations spend so much time on such a variety of learning that there is

115

no way to add it all up. In addition, nearly a million Californians are engaged in some form of adult education. Housewives and grandmothers crowd 18-year-old freshmen in state college classrooms. Other Californians invent things no one else ever thought of to study and teach.

Already the old artificial lines between school and world blur, fade. We glimpse the university of the future . . . not an institution apart from real life but the very axis of existence, the communications-work-recreation center of the community. Every citizen will be, to one degree or another, a member of the university.

We can give life to old words. "Education is not just working algebra problems or listening to lectures on Greek history. It is doing anything that changes you. . . . There may come a time when we realize that solving an elegant mathematical problem and making love are only different classes in the same order of things. . . ."

These are signs blowing in the wind. Let us add our own wisdom to them.

We are entering a time of new coordinations. Teachers should be encouraged to explore and respect their own values as resources for teaching and learning, rather than to rely on official sponsorship. We need to probe new amalgams of community-art-research-interprofessional centers to replace outmoded stereotypes. Many of us in special fields are moving into a field which holds us all. A person feels in himself a source of unity and intercommunication between the different "languages" he uses. I picture the core of a tree (*arbor vitae,* the tree of life) and the growth rings: our development is not in a straight line; it is an inner metabolism and metamorphosis out of which new functions differentiate, fed from the old wood and the periphery simultaneously. I am thinking a lot about this now: How to assimilate the things we have learned, into new forms which are right for our time and which are capable of still further development. How to share in the evolution of new educational forms, again in the sense that education is what human life is. I have a hunch that some forms will arise from *persons,* rather than theories or endowments or acts of the legislature.

Certainly a variety of persons have been my guides and friends in schooling. And I have personally always enjoyed their wide variety of teaching styles. The long-winded absent-minded dry-as-dust scholar who talks to a class as if he were alone in his study but who knows his material in depth and has worked to refine his insights rather than to develop his charm; nutty boyish pipe-smoking types late for class, ill prepared, but magical in improvised class dialogue; motherly women who carefully guided my steps and punished me firmly when I misbehaved, I knew they cared for the well-being of my soul and I worshipped them; beautiful inspired poet-philosophers who lit the world of man's endeavor from within but whom you couldn't get near with a ten-foot pole;

116

friendly companionable workshop leaders, patient and noninterfering, willing to explore materials and processes, yet undelivered into ecstasy by what their senses beheld; lecturers, seminar leaders, radicals, conservatives, Harvard men, GI's, professors' wives, cooks, conscientious objectors, artists, persons devoted to teaching and discovery, persons not at all devoted to either, formalists, informalists. The world is a big place, there are all kinds of people in it, all kinds of things to learn and ways of learning. Recently I studied an ancient art of curative movement from a Chinese sage who speaks no English. I have no words to describe the communication in his silences. A young professor of American history at Princeton, Martin Duberman, who conducted an experiment in his seminar this year by eliminating grades and examinations and introducing self-study (reported in *Daedalus*, Winter 1968), next year proposes to include a therapist in the group.

As I said at the beginning, I believe that education is an art of healing, of making whole. In the resonances of the word "heal," we hear a concern for functions which need special care and also a concern for celebrating the "holiness" of our world's tasks and enjoyments. One way to feel the holiness of something is to hear its inner resonance, the more-than-personal elements sounding-vibrating through. We live both in time and out of time. Something that is time-less forms in us. The basic molecules contain the codes of an individuality that crosses the threshold into time when, as it were, the time comes. It is obvious that the person I am to become cannot be itself physically contained in a submicroscopic gene change. It is a portal through which the formative forces flow; or I like better still the picture of a transformer, where you get a lot of one kind of energy coming in, like water for instance, and it crosses a threshold and turns on the lights and heats my house and cooks my eggs and fires my kiln.

To learn to live as a person in this transforming point, in this double realm, takes energy and skill: to feel the extraordinary in the ordinary, the sacred in the everyday. We have to learn this, we teachers, if we are to answer the current needs.

At the end of my chapter on Pedagogy in *Centering*, I wrote:

> Study in depth! To press in, extend upward, widen, contract, to develop a feel for the centered position, and then to work out of a variety of impulses. Confirming each new form before we go on. Fingers always ready to release gently. Listen!
>
> To foster a sense of life at its profoundest depth and in its sacred value! Is this not the premise of our Pedagogy?

When we work on a potter's wheel, we do not expect to center the clay once and for all and then forget about it. We have to keep bringing the clay into center continuously as the form changes and tensions arise. Likewise with a teacher's values. We should not expect to develop an approach to education which will work forever. We are in a living evolution of values. Problems change, and we grow toward inventive solutions. Perhaps the trend in current education most fertile for the future is this one: from *Logos* to *Sophia*, from knowledge to wisdom.

# VIII

I lingered on at the farm after the kiln festival Summer 1968: to share in some additional firings with Karen Karnes, Ann Stannard, Helen Penny, and Paulus Berensohn. And to harvest my winter squashes. In October I returned to New York City, but not for long. I was mugged and robbed near my apartment, and as a result Paulus invited me to move to his farm where I had recently spent so much time. Then I left for the West Coast, to make new relationships with my sister and brother whom I had not seen for years. It was an extremely important winter's work in transforming the emotional patterns of childhood and family karma. A clumsy session at Esalen caused me not only to get in touch with my anger but to fall in love with it. I came home in March of 1969 eager to practice with those I love best. In the course of the inevitable setbacks, I learned to be less pushy about my latest insights. Time is not always ripe.

While in the west, I received a telephone call from Mary Nyburg asking me to share in a summer conference of the American Craftsmen of the Northeast Region, to be held at Bennington College, Vermont, July 7–8. The theme was to be "Insight 1969," and I was asked to develop something like a non-media-oriented exploration across the usual categories. No demonstrations on the potter's wheel, no glass blowing to watch — rather everyone would be encouraged to participate in small group encounters with materials they were unfamiliar with. The emphasis was to be on personal experiencing rather than on panel discussions. The conference was designed to "look into ourselves for a deeper understanding of our lives as craftsmen and teachers . . . by crossing media . . . expanding concepts of materials . . . exploring the field of design." Even the leaders were to be co-learners, participating like everybody else in the new experiences. It was a challenge I looked forward to: to open with a talk which would try to win people's trust for a brief adventure in discovery, of self and world, through materials and people. Also I was given the much appreciated and rare opportunity during the spring to conceive the conference and to invite its leaders from theater, dance, nature study, city planning and architecture, as well as from painting, design, craft, in the spirit of Cross-Over. The conference was a real experience for many of us, and extended far beyond either its formal beginning or its ending. I have decided to keep intact the record of human involvement which gave heart to my talk. Generally, when there's opportunity, I feel my way into my talks over a long period of gestation which draws life from particular human relationships. Where the source is specific, it seems vital to let the roots show.

# Insight 1969

Picture in your inner eye, your inner sight, four avocado seeds on the window sill. Three are suspended in glasses of water and have sprouted. One is still dry and papery and brown. Each of the sprouting seeds has its own character. One has two long roots, like two rubbery legs folding around each other in the bottom of the glass. Out of the top rises a cluster of tiny seedling leaves, and surprisingly, on this one, these leaves are white — little tight white albino avocado seedling leaves, coming out of that big hard seed knob. Another has one short straight root, and one straight shoot bearing green leaves at the top. The third has neither root nor shoot, but the whole seed has been split open by a thrust from inside, and the two halves shoved apart by the germinating seed force — that little bunch of stuff, big as the end of your pinkie, shoving those big doors aside like a tiny Samson. It is a wonderful sight. And now let us look at the fourth seed, dry and papery and brown, nothing showing on the outside. But within are a living force and a living plantness which we cannot see with our ordinary eyes. If we are to behold the wrinkled old seed in truth, we have to behold it with imagination, with our inner eye. Only with the inner eye of imagination can we see inner forms of Being and Becoming. In this lifeless-looking seed there is a germinating center, totally alive and totally invisible.

The germinating center: *and its mystery.* There is an invisible quality in things which makes all the difference. For example, as between a real seed and a fake. They may look the same on the surface, but one will live and bear fruit, and one will be forever lifeless. We are all familiar with the American specialty of food that looks good and has no taste and no food value. Cast in plastic, it has become a new pop art form. Or of persons who look beautiful and successful, and who suddenly kill themselves because they feel the lack of a certain essential inner quality. Sometimes they call the missing ingredient love, sometimes meaningfulness, sometimes sense. Life, they say, doesn't make sense, though it would appear that all the senses were being stimulated continuously. At least all the five senses which are the only ones we are ordinarily taught to take seriously.

There is a mysterious relationship between inner quality and physical material, between equilibrium and mass, between purpose and design. Working in the arts and in the handcrafts is one way to experience this relationship and to gain insight into it.

An experience of relationship between inner quality and outward form is an artistic experience, it is an experience as well of a wholeness in which spirit and body are not separated. Life seems to tell us that we need to learn how to be in touch with our wholeness: not only to get all our own burners lit, our resources awakened, but to feel the connection between our own innerness and the inwardness of others, an experience of community. Work in the handcrafts and in art helps us to experience the soul forces that flow through our senses: our sense of touch, of smell, taste, sight, hearing — and to these we should add a sense of life, a sense of movement, of balance, of warmth, a sense of word, of thought, of ego. A sense of being an individual in relationship to other individuals, and to physical environment, through the qualities that touch us.

Through the potter's art one may experience with particular sharpness the mysterious relationship of quality to physical substance. When a potter centers his clay on the wheel, he is not altering the weight or color or taste or smell or sound of the clay. He is altering its inner consistency. He is creating equilibrium.

An invisible center holds us all and is the growth source for our ongoing development as persons. The quality of person, being in us, is in the center — the quality of unfolding, likewise. Unfolding, transforming, withering, renewing — death/birth — history/evolution — words don't seem adequate to name the mystery of those avocado seeds, the mystery of clay, the mystery of this occasion and the persons present and their lives.

What this conference hopes for is to live consciously for two days in an ongoing process of growth and change. To bring refreshment into forms of living and forms of working, for everyone present, including the group leaders. To create flexibility of role. Certain persons will serve as a focus group to set things in motion, but they will become co-workers/co-learners with everyone else in the experiences that evolve. Person is at the center. *Every* person.

We have an opportunity here to introduce new materials, new arrangements, in order to practice as artists in a larger human framework than our private studios. As artists together — not adults in a classroom. There are escape hatches for anyone who doesn't want to join in. The spirit of this conference is inclusive: it includes all of us. I feel it is important to stress this in a world where cliqueism and the star system are so mindlessly acted out. And where individuals who lead don't get to enjoy what they have prepared for others. One of the arts of this conference will be to experience in areas with which we do not normally identify. A few experiences of ourselves in new ways — a few wordless glimpses of our growing tip, a few felt contacts — INSIGHT 1969.

The processes of this conference, it is hoped, will be processes of our ongoing

lives: thus they may feed nourishment and refreshment into ongoing forms. I am reminded of something Frederick Kiesler once said to me. Kiesler was the architect of the Endless House; sculptor, painter, poet, stage designer, prophet. He said paintings should go on continuously, and when anybody wants one, he should cut out a portion and frame it. Being and Becoming go on continuously. At this conference we have chosen two days to become aware together, in special ways.

Robert Browning wrote a dramatic poem in which the Italian painter Fra Lippo Lippi talks about himself. He says:

> a man's reach should exceed his grasp
> or what's a heaven for?

Whatever a heaven may be for, certainly our reach for Insight will exceed our grasp!

One of the reasons I like the idea of this conference is its title. When Mary Nyburg telephoned me in California last February to invite me to participate, she told me the theme we would be focusing on. My ears pricked up. "Now there's something to reach for! There's a challenge!" I thought.

The word *insight* has been much in my thoughts the past few years, ever since my own work seemed to change from pottery, poetry, teaching, to, you might say, *learning to live,* learning how to awaken certain qualities in myself as a person, which I wanted because I was hungry and thirsty for a kind of equilibrium. One of the first symptoms of the crisis was a change in my pots. I began pinching very thin bowls, thin thin, stroking out from the center, slowly, rhythmically, turning the clay in one hand, stretching it with the other. Suddenly I could not bear the automatic symmetry of the potter's wheel, which I had worked hard to master — nor the strength of clay slabs, which I had loved to build with. I pinched the clay, so thin, so vulnerable, so perishable, like petals, no, like myself — some with holes where my fingers wore through like an elbow through an old sweater. Beautiful, I thought, beautiful, how true. I wondered where it might lead, whom was I turning into? And what would the poems of the new life be? Or would there be any? One day in meditating on what poetry is, what indeed words are, I wrote in my journal that poems of renewal will be a poetry of insight, not of words. My focus moved to the poetry that flows beneath, as it were, language, the continually flowing stream on whose surface words form, shaped by the currents and transparencies and murk of that stream.

I tell you this at the beginning so that you will know that I am deeply moved by

the title of this conference, and that I am a mere student on the path. I have been asked to begin this conference with a talk. I hope I can find a way of speaking which will allow meaning to unfold for each one in our own way, a form which communicates and yet leaves everyone free. I don't know if I can do it.

So let there be a poetry of insight, out of which visible forms of living and working may grow. These may be forms which will carry insight into the world. These are living forms, living seed forces. One of the questions this conference is asking is how to design living forms which carry insight into the world.

Now let me trace a little farther the beginnings of this conference. I want you to know that it has an organic life, that the people who are setting it in motion are doing so as part of their work and growth; they are not observers above the battle. It is inspiring to do something together that carries everyone's work forward. All the focus group members are interested in having new experiences and in learning from each other: Paulus Berensohn, Carolyn Bilderback, Bill Holst, Shirley Kaplan, Janice Lourie, Don McKinley, Jerry Weiss, Willard Trask, Mary Nyburg, Virginia West, myself.

How did *Insight 1969* begin to take shape? As I heard it from Virginia West, its chairman, the Northeastern Regional representatives wanted a conference before the Crafts Fair, and they wanted it to have something to do with design — new resources for design — something that would bring craftsmen together in a learning experience, on a "mini" scale. They didn't want it to be instructional in the usual fashion of workshops, at the same time they wanted something more than a social occasion. At one point the feeling was for something like a "design-in" — then this metamorphosed into "insight into design," which then became simply "insight." Another element was the fact that the conference would be at Bennington, where there would be no studios for the usual craft-oriented conference, in which craftsmen watch craftsmen perform. This limitation turned into a possibility: namely a non-media-oriented conference, where we would focus on the resources within ourselves as persons practicing an art, whatever we do. Mary Nyburg, chairman of the Northeast Division, put the question this way: "How can we use more of ourselves as design resource?"

So our focus is upon human being as source. If the medium is the message, we are the media, and the messages are our insights or our blindnesses. I think this is a fruitful way to consider the phrase "mixed media." Mixed media are the global family of persons, an infinite mix. They are continually giving off and receiving messages. One of the arts of being human is to discern differences in quality between one message and another, and to exercise initiative in forming messages we value. In this way we may

become not victims of history but co-creators of it through our lives.

Mary Nyburg also said to me that the goal of this conference was refreshment of spirit which would nourish our work when we returned home.

Refreshment is another idea I have wrestled with the past few years. How can we learn to live and to work so that our living-and-working refreshes us rather than wearies us? What insight can we gain into forms of working so that they may become ways of living that replenish? When Virginia West returned from the American Craftsmen's Conference in Albuquerque and its sequel trip to Mexico, she said she felt wonderfully refreshed. I pressed for details: how did she get "refreshment"? "Well," she answered enthusiastically, "by getting away from old problems and old routines, from all you have learned and been taught about following the straight and narrow path."

Refreshment comes from change of direction. It comes from moving into parts of ourselves which want to breathe. There is an inner law here. To let some fresh air in means literally to breathe into areas which have been asleep. Enjoyment may be painful. If one is used to living under pressure, refreshment may come from release. If one is used to living amorphously, refreshment may come from commitment. What makes something refreshing is the satisfaction of our need for balance and wholeness — we hunger for fullness of being. And since society tends to reward us for our special strengths, we are tempted to stick to them and to identify with them. And we take vacations when it is all right for a short time to be refreshed and to behave irresponsibly and uncharacteristically.

Can we integrate into our forms of living and working this holiday/holy-day spirit, and continuously, rhythmically move into the areas where we are deprived — affectionate toward our shadow, our ignorance, our new beginnings, like a tender host to a living child? Can we learn to live in our growing tip, delicately digesting the past, delicately poised in our mobility? How to be vulnerable is an essential skill, it is part of our contribution to society. "The wounded surgeon plies the steel," as the poet T. S. Eliot wrote.

So we want to bring into this conference some elements which will disorient us from automatic responses and allow us to experience ourselves in other ways.

Forms of living and forms of artistic working, these are our concern. What do they have in common? Work is usually thought of as that activity to which we give most of our time, our best effort, and our awareness. Living can be thought of this way too.

I get up in the morning and do exercises before breakfast. Is this living or working? I prepare something to eat: living or working? I eat and digest, write letters, make

phone calls, go shopping, talk to people — living or working? I harvest the squash, weed the garden, clear out the ditches that carry water out of the planting area — mow the lawn, pick flowers — living or working?

I make eight pitchers, six candlestick holders, a plate, three teapots, two bowls, for the first firing of a salt-glaze kiln which I helped build at Karen Karnes's studio last month — living or working?

I go as an invited discussant to a monastery in Connecticut for a three-day outdoor seminar on Community in the Cosmos, drive to North Carolina to visit friends who are about to leave the country, stay all night in a motel to be alone and rest . . .

What is the difference between living and working? . . . If working is not living, what is it? If living is not work, I miss my guess. Work is expending energy and overcoming resistance. It takes energy and work to be aware.

Models of living and working should not be blueprinted in advance because living forms unfold out of each other in ways which cannot be predicted. Who can predict what will come out of that old avocado pit? Living forms grow organically out of many diverse elements:

> discovery
> relationships
> persons
> warmth / cold
> freedom not to participate and to participate
> freedom to be independent and to be dependent
> freedom to change direction and feel that one is
> not losing the track
> freedom to ray out from a center in many flowing forms and
> in a single radiance
> freedom to be affectionate toward self
> freedom to reject and to sustain
> freedom from judging oneself and others, freedom to be
> angry
> freedom to say yes no maybe we'll see merde
> freedom to let things alone and to change them
> freedom to conserve, and to expand — to give up and to persevere
> freedom to dislike, disown, disavow, and to respect others —
> to care about and to come into conflict with

freedom to go for a nature walk with Willard Trask where the wild
      orchids grow
freedom to skip all the meetings and do as one pleases
freedom to show slides and drink tea
freedom not to know what one is doing and to do it
      freedom to pursue special-interest groups
      freedom to share our experiences in both nonverbal and verbal ways —
      to make a physical environment together and have a discussion
freedom to be obsolete, to poison the atmosphere, to defoliate jungles
      and burn food, to pollute and defraud
freedom to be ignorant, prejudiced, slavish
freedom to be sick, violent, blasphemous
freedom to despair
utterly free we are
      to create alternatives,
      to develop insight and to take the consequences.

Old integrities abound in the world: there are many opportunities to learn to make pots, build kilns, weave, blow glass, develop film, put on plays. Good. We are going forward full steam in developing techniques and ever more astonishing effects of color/ shape/texture/sound. Natural energy is exploding at its customary mind-blowing rate. If we don't keep the grass cut at the farm where I live, it is quickly difficult to make our way from the road to the house. Left to itself, a living cell will propogate automatically. The most lethal disease of our century, cancer, is in fact a form of the rage for physical life. It is tissue which insists on its own growth, on autonomy; it cares nothing for context or relationship to its environment — it must get on with its work, busy busy, making more things, making more cells, it could not be more excited and alive, as the saying goes. How do we transform natural energy into human insight? How do we give insight FORM?

There are not many opportunities as yet where we can practice changing direction, changing role, exercising initiative, collaborating as a creative ensemble in a co-learning co-creating atmosphere, experimenting with surprises, seeing what happens when we have a chance to work things out for ourselves. This is what our conference is about, for Insight's sake. A trip from drawing to dance to clay to theater to three-dimensional design to weaving to nature to architecture. Robert Frost said the poet's

126

freedom is to make wild connections. The poetry of insight. Wild connections. Not wild in the sense of being implausible. But wild like wilderness is. The connections we make are in the nature of things. Poetry and science.

The inner laws and forms of life are invisible. We get hints of them through studies of growth, proportion, ratios, vectors, resonances. The human eye and ear cannot perceive what is taking place in either physical substance or metaphysical. Matter and electric circuitry are invisible. Mathematical equations are invisible. We have to develop new capacities for seeing from the inside out, from the invisible into the physicalized. We need to create opportunities to live consciously in both realms simultaneously, in touch with our feelings and our creative sources and observing how they turn into physical behavior, social behavior, and art.

Work is the overcoming of inertia. Inertia is the will to keep going in the same direction you started in; the movement itself is self-perpetuating. Maturity, according to the educational psychologist Laurence Kubie, is the ability to change motivation, change direction. Perhaps the very concept of "direction" needs to be overhauled. If space is curved, like the surface of our planet and the orbits and lemniscates traced by our space ships between here and the moon, then in order to go straight toward our goal we have to go in more than one direction. The word *straight* comes from a root that means *stretched*. It does not mean *rigid*. It means pulling oneself together, as if one were dressing a loom, keeping the tension — it means not sprawling loosely all over the place into every possibility. It means having a form, the form of the individual life-line, to be true to one's self: to go in a straight line in this sense means to change direction as a pot does or a weaving or a jewel; to make a beeline (if you watch bees) means to dart here and there on the scent, making a straight line for that nectar or that hive or that queen.

When man thought the world was flat, he said that triangles were made of three straight lines intersecting, and the angles made up 180 degrees. Now we see the world as a sphere, and we invoke geodesic geometry and make triangles of straight lines that curve over the bulging earth's surface, and the angles always add up to more than 180 degrees. We are adding the world of experience to the world of axioms. No wonder schoolrooms are in such an uproar.

The point is we do not make abstract trips from here to there, we make real trips. And the nature of the straight line between two points alters according to the terrain, the weather, the vehicle, the speed, the traveler. There is more to getting someplace than our starting point and our destination. There is more to life than our motives and

our goals. This insight is reflected in the science of ecology, which maps the inter-dependency of living forms and their environment.

The insight of our epoch which captures the essence of this perception is Einstein's insight about the multiplicity of perspectives within the universal sphere, and the unique truth of each perspective, and that each perspective is in motion and related to every other perspective. Truth is a movement art. This is the relativity theory. It is the insight that experience is a network of relationships in motion. *Experience is always related to something.* There is always a context, always a "community." No experience can be defined, isolated, divided, known, or measured by an observer from the outside. There is no outside. There is an infinitely articulated universe of experiences which are objectively real and subjectively experienced; that is to say, they are experienced by persons, by living beings. Experience and consciousness are facts of science. The relativity theory heals the breach between inside and outside — a division that entered man's mind as he grew out of the medieval "synthesis," separating himself from external authority by being able to question it, a step toward finding in himself a germinating center of authority, unfolding within his own person, a seedling, from the inside out. And then finding, as Einstein did, that this inwardness of authority is distributed in an even grain throughout the universe. As each individual awakens to it, he awakens to himself. This is the mystery, or part of it. The mystery of the One and the Many — of Communion and the uniqueness of Person.

The insight of our century, I would say, is that inwardness is an aspect of the physical world. And that physical form is an aspect of inwardness. Our designs are an embodiment of consciousness. All forms are language. Words are only one form of language, and words at their source are not verbal. "In the beginning was the Word" does not mean that when God created the world he used a big dictionary.

In 1966, at Penland School of Crafts, I designed a three-weeks session called "Cross-Over: Into a New View of Language, Verbal and Nonverbal." Carolyn Bilderback was there, and Willard Trask, and four other leaders besides myself. The seven of us wanted to study with each other across the divisions of our specialties. Not courses in classrooms, but a total workshop of ourselves and other students, working together out of a common center. As it were: asking a question and responding to it through different perspectives, moving from one vocabulary into the next, feeling the flow and the transformations. Perhaps we would start with an early morning nature walk — after breakfast a session in fabric collage on themes of dawn, with readings from Thoreau and primitive African poems. From there we might move to making

128

poems which were paintings on scrolls, or to botanical plaques printing natural forms in clay, or making clay stones and vessels, then carrying the contrasts of convex and concave into dance forms, or moving like stones or paper or wire in dance, playing with differences in quality, feeling them in our bodies, our sensory awareness. We made a composition out of the ordinary things we do *opening windows sweeping shaking out the sheets painting the woodwork playing the flute talking and reading and playing the piano knitting waltzing sitting quietly walking backward sitting down looking in a mirror writing running crying making costumes that change from one thing into another;* telling stories and observing the life cycle of mosses and baking bread. Is this a new resource? — small groups of people who want to live and work together at certain times, co-learners co-teachers, all ages, experiencing reality through each other's perspectives? I would enjoy being in a group for example with Jerry Weiss and Carolyn Bilderback and Bill Holst, moving from architecture or winemaking to movement to painting to geometry to laws and orders and social concerns.

Inner seeing: what are our needs? What do we need, what does each one of us deeply need, how can we find out? Just one, just one need, can we feel it and follow it? To be in touch with one simple need and to have the strength to follow it and not to program where it will lead, this is an art. To be led by our needs as materials to work with. Not to be overwhelmed by, but to respect, to listen to, and work with.

Is insight part of organic structure, part of our built-in resources as human beings?

There may be persons who regard such terms as *inwardness* as either mystical or in bad taste, in any case not really getting down to the brass tacks of craftsmanship. Now let me assure you that innerness is a form of brass tacks. If you don't want to take my word for it, read the biologist Hans Jonas. In his book *The Phenomenon of Life,* he cites the following as elements of organic life discernible even in its faintest beginnings: inwardness, felt selfhood, continuity of unfolding identity through the metabolism of changing matter, a self-creating self-creation, transcendence of self in needful contact with others and with environment, a concern for one's own being.

Inwardness, Metabolism, Transcendence.

Metabolism is the process whereby substances are digested and transformed by our biopsychic being into our biopsychic being. These may be food or they may be thoughts and experiences. We don't turn into lamb chops and traumas, they turn into us! The striking thing about metabolism is that we are changing all the time that we are digesting, and yet there is a continuity of felt identity or form. We go through all

the amazing changes from conception to birth to infancy childhood adolescence young adulthood middle age old age, always digesting always making new beginnings, changing in body soul and spirit, and yet always ourselves. An inner unfolding form is present through all the physical changes. Matter is continuously passing away while we grow and develop and press on. What is passing away and what is pressing on? Our physical presence is as it were *in-formed*, formed from inside out. Metabolism, this basic feature of organic life, constitutes then a special relationship between form and matter. And for this reason, it seems to me to have something to do with our feeling for design. In it there are opposite qualities at work: built-in obsolescence, every seven years a complete cell change, coordinated with stages of inner development. And at the same time a stability of continuum, of essence. Movement and essence — we live in paradox.

If the source of our design sense is in our biopsychic identity, this makes design-insight a part of ecology. It is important for us to develop our intuition for design ecology: for living inner forms (mobile and intact) and the health of the whole. It is something other than know-how. It is a feel for things, it is not automatic. It is something like being in tune with — in touch with, in a relationship that fits the way a hinge fits together, so that it can move smoothly in opposite directions. The Greek word for *heart* is *kardia* (our *cardiac*), and it means *a hinge*. In mechanics it has come to mean "beams which are let into one another so as to be turned"; in astronomy, it means point or pole, the four cardinal points, also earth as center of the universe; also extreme old age. By extension, or figuratively, it means that round which anything turns, i.e. the principal matter, the chief point.

To be intuitive about design, then, in my glossary of terms, means to have a heart, to move from a center, swing like a hinge, firm and mobile, changing direction, a doorway, a connection, a real place one lives in, in tune, hinged, intuiting through one's heart what the matter is, what matter is.

Last autumn I was invited along with 199 other women to a two-day conference on physical violence, its cause and cure, led by Norman Cousins. We divided into workshops, and I chose to go to the one on the neurophysiological basis of violence. The two leaders were both research doctors. One spoke of how there are particular areas of the brain which are connected with outbreak of violence in individuals. The other spoke about how *the physical brain is formed by experiences and ideas, by values* — the physical brain itself has no creative power. Thoughts in the environment cause chemical reactions in the tissues of our nervous system. Tissue so formed feeds back impulses which tend toward certain kinds of behavior. This scientist urged the women to

realize that ideas and values create physical tissue, and that physical impulses have spiritual origins. It is of the utmost importance, he said, to educate mankind through living ideas. What this might involve is not our subject here. But the insight is: namely, that a true feeling for design initiative does not mindlessly reflect the automatic materialistic values of our environment, but introduces insight from another source, from imagination.

We are crossing a threshold into a new age, a consciousness age, whether we like it or not. Medieval man may not have liked to cross a threshold into Renaissance, or primitive man into historical man. But we are an evolving species, on the move. Every crossing has its dangers. And as we move into the Aquarian Age of individualism and relationship and awareness, we who are designers must be particularly alert frontiersmen. It is risky to open up a new world so fast. The new age can easily become a hell where everything is "possible" and nothing *is*.

We need to keep ourselves in focus. Focus means warmth, it means hearth, the hearth where the household gods were kept in Roman times, *lares and penates*. One's focus is the shape of one's warmth, and most wonderful is the fact that the ancient root out of which the word *focus* grew is a sound meaning both *to shine* and *to speak*. What about that! A marriage of to shine, to speak, to be warm, to worship, to have a hearth and a heart. Focus is poetic because it marries the opposites of dark and light and makes new as flame does, always dark and new at its source, where warmth eats matter and metabolism flames into the fresh colors of life at a new edge of being.

Our transcendence as organism is in our interdependency. We need environment for sustenance and for space to move in. We are always organically MORE than ourselves.

Can we, when we are designing, learn to work from sources in the flow of living forms? Can we be in tune with keeping the faith and at the same time digesting, discarding, making new? Can the environments we design, the fabrics and pots and jewelry and windows and furniture, have a feeling for both the deep root and the tender growing tip? Remember the third avocado seed, which had just begun to open up: both *root* and *shoot* will develop out of that *germinating center*. The mystery is in the Oneness of these Three.

Let me offer you now a paragraph from the poet Rilke (from *The Notebooks of Malte Laurids Brigge*). He will help us to give body to these thoughts:

> For the sake of a single verse, one must see many things, one must know the animals, one must feel how the birds fly and know the gesture with which the little flowers open

in the morning. One must be able to think back to roads in unknown regions, to unexpected meetings and to partings one had long seen coming; to days of childhood that are still unexplained, to parents whom one had to hurt when they brought one joy and one did not grasp it (it was joy for someone else); to childhood illnesses that so strangely begin with such a number of profound and grave transformations, to days in rooms withdrawn and quiet and to mornings by the sea, to the sea itself, to seas, to nights of travel that rushed along on high and flew with all the stars — and it is not yet enough if one may think of all this. One must have memories of many nights of love, none of which was like the others, of the screams of women in labor, and of light, white sleeping women in childbed, closing again. But one must also have been beside the dying, must have sat beside the dead in the room with the open window and the fitful noises. And still it is not yet enough to have memories. One must be able to forget them when they are many and one must have the great patience to wait until they come again. For it is not yet the memories themselves. Not till they have turned to blood within us, to glance and gesture, nameless and no longer to be distinguished from ourselves — not till then can it happen that in a most rare hour the first word of a verse arises in their midst and goes forth from them.

I said earlier that the word *straight* means *stretched*. The word for clay in some languages means something like that too. Words contain so many important secrets! In German, the word for clay is *Ton,* which means stretched out, in tension, like a vibrating string, which produces a tone; the fired pot has a ring, it's all music to the ears; the person is *per sonnatus* (sounded through); musical structures are structures of proportion, of ratio; ratio becomes our word *rational;* true reason is in harmony with what is sounding through the nature of things, inaudibly; we hear intuitively with the inner ear, our source of balance; thinking lives in the unfolding harmonies; it contains insight; design is a projection of insight into physical forms. Physical forms are resonant. Listen!

In conclusion: this is our conference. It started months ago and this morning it has unfolded this far. It is an opportunity to ask our own questions and to answer them in new ways, if we want to. An opportunity to practice together without penalty or consequence, practice using what happens as part of the next insight, letting things grow and develop, guiding, pondering, trusting our intuition that we are actors as well as re-actors.

Contact as Resource.

Contact with Oneself as Resource.

A feeling for improvisation, theater is a place where a vision is performed, all the world's a stage, a place of happening, a spectacle to behold, to be entered into.

WE DIVE INTO THE SEA. THE WATERS CLOSE. NOBODY SAYS, "WHAT A BEAUTIFUL HOLE YOU JUST MADE IN THE WATER!" OR "MY, WHAT AN UGLY WAVE!"

... contact ... as Ezra Pound used to say, never mind if the reviews of your work are good or bad, just measure the inches!

Improvise, practice, get the feel of something coming into being, we need personal courage and compassion and inventiveness and capacity for play and exploration *with ourselves* as well as with clay or glass or fibers or adhesives or junk. A sense of play which is our work, child's play, the real thing, change direction, it's time for lunch.

... from pole to pole:

from primitive base to expanding technology, interflowing. The primitive unity where dance and gesture and clay and use and song make the pot (Cut, to) the floating toothbrush, gravity overcome, the song around the moon IN THE BEGINNING GOD CREATED HEAVEN AND EARTH and the seven days (stages) of creating (becoming) a human person, then the swift slide back to good earth, blue and brown and floating, home, base camp, in the middle of everywhere, sheer poetry, all of it, the shift in awareness, seeing the tenderness of seeing earth man as he is in the heavens, something in the pit of the stomach says love one another ...

Polarities: primary impulses / sophisticated impulses: the organic continuum between.

*Design* is one of the great words. *Da-sein*. It means to be alive, to be present: to be there, to be here. Designer handcraftsmen. To be here in our powers as persons:

design as technique (the handling of materials in order to achieve a certain effect,
      serve a certain function);

design as revelation (nature as designer, inspiration, accident, the living encounter
      between man and media, man and universe);

design as contemplation (being aware);

design as problem-solving;

design moving from the pole of improvisation to the pole of frictionless repetition;

design as primary experience re-encountered in adulthood — the return, the re-entry

— the mythological moment of renewal — the simplest things we see differently now, with another kind of fullness and enjoyment and curiosity, from another perspective, for we have been long away and have changed. We are not children, and yet the child in us lives in our growing tip and leads us. We have the innocence of adults who

design the world from their dreams of wholeness. May our insights ripen into the first things of the day and the night.

Think of old Matisse cutting out colored paper leaves with a pair of scissors as he lay in bed, very old, and making them into contemporary priest's robes and stained glass windows for avant-garde churches.

The human heart is of very great age.

How mysteriously this germinating center is designed.

How mysteriously our hands design.

Insight 1969.

# IX

In September of 1969, I drove the trans-Canada highway in my old Volvo, to Alberta. Through the initiative of Pauline McGeorge, I was to be artist-in-residence at the University of Lethbridge till spring. Before settling in, I made a trip by bus to eastern Washington. There I gave a talk on Art and Wholeness in Learning to the Twenty-ninth Annual Washington Art Association State Conference, at Eastern Washington State College, in Cheney, on October 18. I had been invited by Howard McConeghey, then head of the Art Department there, who had read *Centering* and my Penn State lecture. He thought I could help by speaking up for the creative being of individuals, against the influence of behavioral science, which tends to interpret freedom in terms of educational merchandising. Mr. McConeghey said he shared my concern for wholeness in learning and in freedom as a personal spiritual undertaking. This meeting sowed seeds for a Cross-Over program at Cheney the next summer.

Themes first broached in this talk were shared subsequently with other audiences, at Indiana University of Pennsylvania and at the Tri-County Fountain Center for resocializing former mental patients, in Lansdowne. I mention this in order to indicate that "wholeness in learning" and "the creative being of each individual" are themes close to the hearts not only of art teachers but of educators in all departments and of persons whose concern is mental health. The work has barely begun.

In the spring of 1970, before driving home across the continent, I went to Cheney to plant a garden, which would become part of the interdisciplinary workshop which was to meet there for a month that summer. Every day we would pick greens and make a communal lunch together. The cross-over in this instance was between the Art Department and Physical Education. I formed a Focus Group of Howard McConeghey (art), Peggy Gazette (phys ed), Remy Charlip (dance, play making, journal keeping, book illustration), Burt Supree (writing, eurythmy, theater) and myself (cooking, gardening, poetry, ceramics, educational inquiry). It was a wonderful experience, with thirty students, taking place mostly in the Field House, which was itself a theater of learning. We used as well the pottery studio, art gallery, local wildlife preserve, homes of students and faculty, and nearby construction sites.

# Some Thoughts About Art and
# Wholeness in Learning

OF course I have been thinking for several months about this conference and what I might contribute to it that would be relevant and organically connected.

Relevance is a value I have always asked for. When I was young I asked my elders why I had to follow their bidding. Almost any answer would do then, but some kind of bridge I needed between their world and mine. I felt intuitively that our worlds were shared, but I needed to be thrown a communication line, making the connection conscious.

Now that I am older and more conscious, I have given to relevance another value besides that of a psychological or emotional bridge. I think we may take our cue from what the word means in its root image: *to lift up, to be lifted up.* It is related to the word "relief." To be out from under a burden, undepressed, unbowed down. Heart, mind, body are lifted up, they feel good, they feel relevant.

Experiences which we can take hold for ourselves, in our feeling and our imaginations, these are relevant. As a child, I could be bamboozled into a feeling of relevance by fiat. I would be told that I had to follow a direction because it had been given by someone who had the power to reward me with his love or punish me by withdrawing it. This seemed relevant to me then. Now I am a grown woman, my heart is no longer lifted up by gratifying the desires of powerful adults, or children. My heart *is* lifted up by coming into a reciprocal relationship as an individual with other individuals and sharing our values and working through our differences. My wish to be relevant here today is to find a way of sharing with you some of my thoughts and experiences in the hope that they will speak to your concerns and that you will share your experiences with me in conversation after my talk.

Organic connection? Yes — Howard McConeghey wrote to me because he had read some of my work. He said he shared my concern for wholeness in learning, and invited me to be present at this conference.

The theme of wholeness has developed naturally out of my search for my own health and balance. My values as a teacher and artist are my values as a person. I have

lived an unconventional life as a result. I separated from the academic establishment long ago, twenty years before it was fashionable to do so, and began to search out for myself Other Ways.

I had taken the highest degree in our official academies, having been assured that if I did well in school, I could be confident of leading a good life. I learned to my dismay that my education had been very one-sided and that it had not equipped me with human insight nor a loving will. As the trusted clichés of our educational mystique began to dissolve, I saw that I would have to undertake a whole new phase of postuniversity education. Good. I had been educated as an intellectual of the verbal type, and in the middle of my life I had to begin to learn how to live the relevance of other parts of myself.

Wholeness. I don't even know what it is. But I know what it isn't. It isn't half life, it isn't half persons. It's a good question, and if we ask it, we have a chance to grow in answers — to find in growth an answering.

One part of wholeness is initiative, a trust in oneself as source. In school this is commonly repressed, through working in a one-sided way with books, authority figures, and social pressure; or in being too selflessly concerned with serving students. We tend to think that responsibility to others means either deferring to them, or doing everything for them, thinking nothing of ourselves. The roles that are stressed are those of dependency and authority. But how about give and take? How about flexibility of role, autonomy, self-trust, reciprocity? How about doing things not *for* others but *with* them? We must be vigilant on behalf of our wholeness in forms of living and forms of working. Otherwise seeds of violence are sown through self-neglect. We come to awareness slowly. Let us be friends on the way. Let us turn our psychology of responsibility into a psychology of inquiry and befriending.

William Stafford, one of your great Northwest poets, has written a ritual for us to read to each other:

### A RITUAL TO READ TO EACH OTHER

If you don't know the kind of person I am
and I don't know the kind of person you are
a pattern that others made may prevail in the world
and following the wrong god home we may miss our star.

For there is many a small betrayal in the mind,
a shrug that lets the fragile sequence break

sending with shouts the horrible errors of childhood
storming out to play through the broken dyke.

And as elephants parade holding each elephant's tail,
but if one wanders the circus won't find the park,
I call it cruel and maybe the root of all cruelty
to know what occurs but not recognize the fact.

And so I appeal to a voice, to something shadowy,
a remote important region in all who talk:
though we could fool each other, we should consider —
lest the parade of our mutual life gets lost in the dark.

For it is important that awake people be awake,
or a breaking line may discourage them back to sleep;
the signals we give — yes or no, or maybe —
should be clear: the darkness around us is deep.

Life is an art, for our social practices are embodiments of inner pictures and of inner feeling. Like art, life projects an inner world. What picture do we have of ourselves? Let us get to know the elements in ourselves which govern our choices. This is a lifetime's artistic labor: not to be gripped by faceless powers, but to see face to face whom we serve. Let us be careful about placating power figures in ourselves or others, playing secret war games as if they were harmless. The discipline of the artist is to know his materials. The bomb is an image of release. But we don't have to blow up the world in order to be free of enemies if we are resourceful artists. It is a misuse of materials. Insensitive. There are other ways to be rid of enemies. Befriend them. Love our enemies? Who said that?

If we want to practice a wise human art, we need to bring our wholeness as persons into consciousness. To carry ourselves as a vessel in which play all the members of our inner family.

To bring our languages into conversation with each other, through the common source out of whom they develop: the person.

We need to create opportunities for awakening and practicing our initiative and self-trust, becoming comfortable with it and with the initiative of others. When I was visiting professor at a curriculum laboratory in England, I was helped enormously to change my own direction here. I was working with experienced secondary school teachers and administrators who had come for a semester to take a look at themselves and to develop some new starting points. They examine their values and procedures, which tend to have been inherited automatically from the system, and get in touch with their own feelings and interests, and develop confidence in themselves as source. The Lab, because it works with all teachers, has developed a point of view which it calls Inter Disciplinary Enquiry.

When I came back to America I was emboldened to set in motion a two-week festival of kiln building and working with clay on a farm in Pennsylvania. There were thirty-five people, thirty of them living in tents, solving problems of eating and maintenance as part of our common socioartistic endeavor. Unsponsored by any school or foundation, we pooled our resources, shared our learning, practiced initiative. No one received wages.

In schools now there are frequent opportunities for instruction in subject matter and skills and audiovisual aids and testing procedures. Less frequently do we find a place to practice changing direction, to practice in feedback sessions how to learn from experience, so that our experience can become what it is in any artistic or scientific undertaking: an ingredient of an ongoing process. An artist or scientist is not punished or looked down on if his experiment does not confirm his hypothesis. It may suggest another and better one. He learns as much from what doesn't pan out as from what

does, because it is part of a long and continuing rhythm of work and involvement. No question is the last, no answer is the last. Unfolding, unfolding. It takes our lifetime to learn what our changing needs are and how to relate to them. Life is not an achievement course, it is a continually changing insight. Nothing fails like success, because success is quickly obsolete, the goal once satisfied changes. In every practical solution there must be growing points. All living organisms have one. In plants it is called the meristem. When social or artistic forms complete their growth, they decay and should be used to enrich the soil for future forms. Art and science help us to give up our desire to be right, because both art and science are disciplines of unfolding insight, one revelation giving way to the next. We learn to care for the *spirit* of truth, which grows and unfolds in our work and our awareness. Think of the history of science. How many scientists were "right" and how long did they remain that way? Insight grows through human tending. To match insight and behavior is a hard discipline; it is the discipline of the artist in each one of us, whatever we do: to give our inner hunches physical form, to feel the visionary quality in materials and deeds.

We do not want to be educated to be servants of a system, however benevolent. We want to be inspired to create forms of living and working which will serve the needs of persons and their development. Of freedom and community. Of self-government. We need places to practice.

I feel strongly about wholeness in learning because of the personal confusion and suffering that one-sidedness breeds. At the same time, if I hadn't experienced the pain and the illness, I wouldn't have grown in awareness, nor undertaken change.

Because I was bright and had a library card when I was four and a half, the experts said I was an intellectual type and kept shoving me into programs of verbal study. (They didn't notice that I read only books with pictures in them. And later they didn't believe me when I said poets were really inarticulate.)

Thank God I was a mischievous and irreverent child with a strong inner life or I might have been lost forever in a collective stereotype. I grew up thinking there were two kinds of people: bright and dumb. You could tell by their grades. No, three kinds: intellectuals, artists, and women. Oh yes, and athletes. And later on, priests. (And if you don't think this gave me problems with my femininity, you're mistaken.) What kind was I? I enjoyed doing problems . . . painting . . . making up songs . . . cooking . . . loving . . . praying . . . playing ball . . . eating and sleeping and dreaming . . . earning money. It took me a lifetime to discover, out of school, that human beings are unclassifiable because we are on the move, and because we live as much in an invisible indefinable realm as we do in a visible one. True scientific measurement, I later

learned, is a changing number in a changing relationship of changing elements which are themselves in motion, and one of the changing elements in motion is me.

The most thrilling moment of the moon trip was when I heard the flight director in Houston speaking in numbers to the astronauts: one zero zero three eight nine zero ten five three zero zero zero six two seven four zero eight . . . What is he saying, what is he saying? . . . Something about space and time and being on course, something about the Atlas Eclipticalis, the Great Circle of Stars, the sun moon earth, something about the men in the space ship and us holding the communication line here on the spinning earth. Those numbers: a high poem, dramatic, symbolic — a language of insights changing and correcting themselves to keep on course, paying close attention to what is really happening.

The poetry of numbers, the high poetic call of a quarterback in football: 2 8 9 36 42 hike 6 9 . . . "go round right end go through the center of the line watch for a lateral pass I'm going to kick." The beautiful speech of our total athleticism, on the playing fields of the cosmos. Art and science and man. Wholeness.

Life is dynamic, and character is capable of inner change. They didn't teach me *that* in school. I got the impression that by thirty I was going to be finished, set, formed, making the best of it from there on out. Until I met depth psychology through the work of C. G. Jung, I knew nothing about the stages of development in our middle and later years.

Children are too rarely given an imaginative picture of the inner life of manhood and as a result dread growing up. Adults have little idea of what maturity is or how to achieve it, and get helplessly stuck in emotional childhood. And so the world wags, obsessed with youth because it lacks insight into age and its frontiers. We in America stress the seasons of spring and summer, feel melancholy with the onset of autumn, and try to escape winter. How unwhole we are, bad farmers of the soul, callous to the seed-sowing burst of autumn, opaque to the underground happenings, the occult parameters of winter. Come spring, it's all open and above ground. Big deal. Withering and wintering are the childhood of spring. To feel the whole in every part. This is the art I call "Centering." All whole, all holy, all healed. Esoteric science teaches that age ripens to a second birth, a deepened inwardness. Inwardness, writes the biologist Hans Jonas in his book *The Phenomenon of Life,* is a basic characteristic of living organisms.

What is prominent in a child may be quite different from what is prominent in the same person thirty years later. To predict adult capacities from childhood symptoms is a ticklish art because of the metamorphoses our capacities undergo during growth. Who ever would have imagined I would turn out like this? Slowness in reading in child-

hood may develop into depth of understanding in adulthood, because the child did not develop dependency upon definitions too early. Learning of a certain kind, too early, leads to a kind of stupidity later on. We see this widespread in our society: the stupidity of literate persons whose security depends upon set patterns of response, preconception, and prejudice.

Knowledge is not subject matter, knowledge is the way in which subject matter is learned. Besides facts, we learn values. And these are what shape our behavior, consciously or unconsciously. Physical behavior has spiritual sources. Matter does not make us, we make it. Isn't this an insight out of which an art of education can take some new turnings? Education is an art of awakening inner sources for enlightened behavior.

Recently I was looking through a textbook in freshman psychology which a young friend of mine was beginning to study. *Introduction to Psychology*, it was called. Since I'm interested in psychology, I picked up the book enthusiastically to share it with him. I looked in the index to see what was listed. Depth psychology was not mentioned nor was the name of C. G. Jung; there was one passing reference to Freud, none to Adler nor Carl Rogers; one passing use of the term "Gestalt," no discussion. No mention of Erik Erikson in child psychology and the crises of youth, nor of Rollo May in existential psychology. Nothing on parapsychology. The picture of psychology to which the student was being introduced was totally one-sided. I felt sick. I looked through the text, and read that psychology was an art of testing and measuring behavior. In the middle of the night I woke with words on my lips. "Are dreams behavior?" I was asking. "Are dreams behavior?"

One of the greatest shortcomings of my own schooling was that my teachers did not take seriously the inner experiences of the poets we studied. Homer: we read his epics and made jokes about the Greek gods. Dante: we read the *Divine Comedy* and made jokes about medieval superstition. Milton: we read *Paradise Lost* and made jokes about Christian mythology. Wordsworth: the poetry, and jokes about pantheism and "thoughts too deep for tears." Blake: plenty of the poetry, but God help you if you wanted to know more about the angel he saw in the apple tree on Hampstead Heath. Yeats: great poetry, but don't mention his occult research in The Vision. Eliot: great poetry, too bad he took his Anglicanism so seriously. Pound: superb poet, but beware of the themes of his inspiration, like the evils of usury. Rimbaud, Mallarmé, Gerard Manley Hopkins — ah yes, "The Windhover: To Christ Our Lord" — beautiful sonnet, right? But don't get too close to his spiritual ectsasy, don't actually behold the Christ-shine gold vermilion off the ploughshare. Myths were regarded as fictions rather than

as true stories of the ordeals of the human soul. We were taught to criticize but not to experience. We stood outside the words. There was silence or disdain about everything that could not be rationally validated. I have had to work hard to correct this miseducation and to learn to enter life from the inside.

I know now that words are not the poetic source. The Source precipitates into language; to love the language and not to experience the source, the poetry of insight, is a sort of weird "touch but don't feel anything" approach. I since have developed my ear for the objective realm of the human psyche, personal and collective, and for the truths of spirit, and can stand my ground. I have learned that poetry is a spiritual offering. It is a way of entering into one another's reality. It is a form of community. When we are children we make poems easily because we offer ourselves so readily. The child in us knows, when we are grown, that almost anything can be a poem if we experience it in a certain way — with that inner feeling that is more than the words.

For me, the test of poetry is not the burnish of the words but their authenticity. There is a part of me that hates beautiful words. I would rather have them clumsy and broken and misspelled. When I taught freshman English at City College in New York, I was always glad when my foreign-speaking students wrote in the flavor of their accent. I felt that correctness sounded shallow and stiff. These opposites I am always struggling with: a love of the crude, the spontaneous and "natural"; and a love of the refined, the deeply worked, the "redeemed." Language arts are arts, they are not mechanical smoothly running frictionless programs of correctness. Punctuation is an art, it is dramatic, there are different ways of doing it depending upon the feeling you want. It is fun to play around with, especially if you make your marks in color, your capitals and small letters too. Diagramming sentences is fun too if you use color to make a beautiful page. I believe in the art of the scribe, decorating the page, illuminating initial letters, picturing and writing, acknowledging that writing is a form of drawing, it is a visual art, a physical art. Writing can be very pleasurable if you play around with it in feeling and in materials. It has a lot more sources than in your head.

Recently I have become interested in relief printing in relation to writing. You can find interesting surfaces of wood or metal or plants or old paper plates from the beach or you can make clay tiles — and you ink them and make rubbings or put them through a press. I am interested in making a print which is an environment for language: a place for poems, as well as a poem-print. When I started, I had some poems in mind which I wanted to bring into visual fulfillment through a print. In one I used a round disk of wood, and then wrote on the round shape after it was printed. In another I used cut paper and a weed and a rubber sole to make a kind of initial letter and

then wrote the poem in spatial/psychic relation to it. Well, I discovered something. The first print I made was of a cross section of a tree trunk which was actually a piece of driftwood so that it had opened up its grain. I inked this beautiful object, laid rice paper over it carefully, and burnished it at length with the back of a wooden spoon. When I lifted the paper, I was deeply moved by what was revealed: a vision of the tree. I felt I had come very close to the rings and tubes of its body, vulnerable to time and tide, long-lasting. How privileged I felt in this intimacy, the tree needed me as I needed it. My tenderness moved toward an opening. I put my pencil into one of the spaces of the growth rings and wrote "amethyst" and in the next "dial" and in the next "grass" and in the next "rise":

> amethyst
>
>     dial
>
>         grass
>
>             rise

How beautiful! The print had given birth to a poem. That's a switch. But no, this is the way it really is: nonverbal experience strikes sparks in the abyss, words flare into consciousness.

The nonverbal sources of writing, this is the territory. The poet hears the song within *things,* and brings the song to birth in color and shape and sound.

Another way I have worked is to combine creative writing and movement in workshops for teachers I have given with June Ekman. Without much success, I should add. The spirit of learning has become so bodiless that teachers tend to mistrust experience that acknowledges body as source. Poor ol' body has been made the enemy rather than the friend of inner development. When we write, we trace the contours of our experience with the sense organs of our speech, with our breath and inner ear. The inner eye of spirit radiates through the membranes of our bodies. If we want to speak and write truly, we ask our letters to flow true to those contours. Let that be the form and meaning. As we learn to write in new ways, we will learn to read in new ways, bringing more of ourselves into both.

In this kind of workshop, the group may spend the first hour in movement exploration, experiencing our bodies consciously, handling stones, paper, found objects, touching each other, touching walls and furniture, making sounds, tossing words back and forth as if we were playing catch. As we come to the end of a rhythm, say, with crumpling newspaper into spatial forms or dressing ourselves with it, making an environment, we sit down and begin to *say* where we are (in our feelings, in our actions,

144

in our thoughts): an afternoon edition of paper people, in waves of print. Since we take the experience itself as our content, we don't have to ask what to write about. In the room we have available a variety of artist's materials: paints, crayons, colored pencils, different kinds of paper, paste, scissors, compasses, rulers, erasers, ink, and pens. We begin to put words and sentences and paragraphs in color on pieces of paper. Sometimes we mount them on big murals of wide wrapping paper stuck to the walls with masking tape. Or we may sit in privacy and work on notebook paper, as we choose. What is writing, writing is drawing the alphabet and creating symbols of our experience. Writing is an art of becoming conscious without losing our wholeness.

There is an artistic quality to every subject. Just as every subject has its historical aspect, geographical aspect, chemical or alchemical aspect, economic aspect, sacred aspect. What we call subjects are really different approaches to the one subject, which is the human person and his environment, inside and out.

The common ground of the imagination is present in all subjects. It is the arm-in-arm between information and person. The lifting of information into the inner light of our awareness and our feeling, our caring and our wholeness, is artistic activity. For our own well-being we need to honor this part of ourselves: to work at agriculture as a human art, at merchandising as a human art, space travel as a human art, matching our practice with the wholeness of our insights.

Artistic materials and practices should be an organic part of all study. History, science, English grammar, arithmetic, biology and botany, foreign languages, crafts, sports, home economics — all should be humanly felt and experienced sensuously. Left to ourselves, we do experience in a living way; we do not experience nature or money "abstractly." It is only in school that we tend to obey the black and white rules of abstraction. Left to itself, the intellect can generate no life. It needs our senses and our hearts. I am reminded of a touching incident during a workshop in creative writing with children and their teachers. Puerto Rican children who spoke little English, and therefore were hopelessly out of it in their writing lessons, had responded shyly but warmly to the use of colored pencils, and were "writing" busily. One of the young teachers commented to me, "Oh my children would love to use colored pencils if I would let them." If she would let them? And why wouldn't she let them? Because she thought they were supposed to write with lead pencils on lined paper.

Learning occurs more naturally and fully as we include activities of color and sound and poetry and dance drama and plays and cartooning and costume-making and collage and sculpture and all kinds of spontaneous play as well as carefully planned projects. Teachers need to give themselves the same nourishment they seek to give

their students. The same affectionate regard. Making, dialogue, inquiry — these go together.

It is interesting for a whole school to take a theme and work on it for a month. This is one of the projects now being enjoyed in some English elementary and secondary schools. They choose a theme, like Green or Circles or Flight or Seasons, and have a month to develop it in all different ways and then to end in a festival celebration of exhibits and performances. I recall that in one of the schools where Green was the theme, the smaller children became interested in village greens, and made visits by bus to local towns to find out what happened on their greens. They became interested in folk dancing which was performed on the greens, and developed a repertory of dances. It was a beautiful combination of historical research and artistic involvement, without calling it either one. And the children seemed to pursue it quite naturally. They needed help to learn the dances, and their teachers were prompted to learn things they'd never thought of before. The children also learned about geography and transportation, and to be at ease in strange places. Older boys made a big construction which they painted green and called a monster of jealousy, and they made up a kind of drama of gang rivalry, which they acted and danced for their schoolmates. These were big boys from various difficult backgrounds who had been hard to handle. They were bored in school and angry. Their experience of creating something of their own, a personal political artistic use of physical energy, seemed to lead into more harmony with themselves and their school environment. And the teachers lost their fear of them.

Teachers who are interested can get something going, modest and true and real. Where two or three are gathered together, they can begin. We don't need unanimous support. What is needed is to correct the one-sidedness of education, not to slip into another fanaticism.

As I said, I dropped out of the academic establishment years ago, long before it was fashionable. I left my post at the University of Chicago in 1945 because I personally couldn't stomach the atmosphere: twenty-four-hour-a-day oneupmanship, students and teachers both; knowledge was the way to pride and power. Ech.

I went to Black Mountain College, which was an experiment in learning and community in North Carolina. I gained tremendously in self-knowledge there, learned to use initiative in creating courses and relating to students and colleagues, began to trust my intuition in the arts, which were the central discipline of the curriculum at Black Mountain. It was an unconventional college: no president, no trustees, no rank, no tenure, no grades, very little money, everybody helped do the physical work, small numbers of people, self-owning, self-governing. I took another step there toward whole-

146

ness in learning, a step toward integrating emotional and community values into education, a step toward being comfortable with more of myself feeling relevant. But Black Mountain College did not survive, and I think one reason was that most of us there were one-sided in our commitment to self-development and not equipped in the skills of trust and cooperation — self-development toward mutuality, you might say. Nothing in our past learning had equipped us, and at Black Mountain we were mostly eager to get free of repressions. But once one has gained some autonomy and freedom of expression, the next step is necessary: the step toward social imagination.

For a question inevitably arises: Why is it if we are so free and artistic and distinguished in our scholarship, how come our community is a tangle of ill-will, mental cruelty, special privilege, power plays? How is it that when we can do what we want to do, what we want to do tends to be to have our own way neglectful of others? Can higher education teach us the arts of give and take, the art of relinquishing one goal for the next when the time comes?

Education as it is widely practiced is based on an incomplete picture of what a human being is and what our stages of development are.

A person is an evolving threefold being of body-soul-spirit. His organism is likewise threefold in its functioning. He has a nerve-sense system functioning mainly through the brain and nervous system, closely connected with the head and with thinking. He has systems of breathing and blood circulation which are rhythmic, are centered in the chest region and connected with feeling. He has a metabolic system which digests and transforms what he takes in, and acts through the limbs and the will. Thinking, feeling, willing. Each of these is contained in the others! Feeling permeates thinking through blood and breath. Sensitivity of consciousness permeates feeling and doing through our sense perception and nervous system. Physical will to be active permeates our thinking and feeling. As a whole organism, then, we learn in a threefold way. We cannot take our human feeling and our human willing out of cognition without becoming sick, stupid, and cruel to ourselves. We need to feel our souls and spirits in our bodies, to feel love. Maybe love will learn to think and to act.

There is more than one kind of awareness, and these need to be acknowledged and developed in balance. Techniques of analysis are one kind. Observation another. Imagination, Inspiration, Intuition. Dreaming. Fantasy. Free-associating. One of the resources of consciousness is the unconscious or preconscious or superconscious. We may not agree on what to call it, but we know it's there. And we know something about the kind of information and substance each kind of awareness can handle. Dialogue between consciousness and unconsciousness generates our behavior and our insights.

Experience in the arts helps us to develop and to integrate this dialogue. It helps us to gain confidence in our intuition, that it is a resource for us. When we see what we have made, we may decide there is something in ourselves we want to change. Art work is useful in diagnosis and therapy.

Artistic play is an essential part of our human diet. Without it we are parched and starved. Nature is artistic: the plant unfolds from inner sources, from a germinating center. Root and shoot, seedling leaves, stalk, bud, flower, seeds — unfold at certain stages if all goes well, in a rhythmic sequence.

In our picture of the human being, we should see each stage as right for its time. A child is not an immature adult any more than a leaf is an immature petal. A child is a special aspect of our being, with special gifts of experiencing and learning. If these go well, the young adult has good roots. Certain parts of our lives may be most vividly lived in childhood; certain capacities may be highest in development then: we are most imitative, most feelingful, most trusting, least veiled. We learn languages easily, are physically mobile. We have active curiosity and healthy fear. We may also be at our most unconscious and most cruel.

In a way we might say that the child is busy affirming himself, the adult is busy affirming himself and others. The child in man is his growing tip, alive throughout our lifespan. The adult in man is a friend to wholeness and to differentiation in consciousness and practice. One of the labors of adulthood is to befriend in ourselves those handicapped and underdeveloped parts of our nature which we have set aside. I call this my "philosophy of the dropped stitches." The time comes when they call out to be picked up and included and nourished and woven in as part of our humanity, each with its special contribution to life-vision.

We come to a moment when we realize that our strengths cannot continue to expand and deepen unless we overcome their bias. Change of direction is necessary in order for energy to keep flowing. Development does not take place in a straight line. Energy does not expand indefinitely, but at some point begins to return, quickening into life the points of growth it had passed by on its outward flow. In order to keep to our natural tendency toward wholeness, these cues must be carefully answered.

Let me offer you to read here a short poem by Elizabeth Hamlin — one I like. It is called "Hunger."

> If I'm standing on a street corner
> waiting for an appointed bus
> and a car stops
> I'll get in

and turn to the driver with gratitude
and ride
and thank him for taking me out of my way.

In order to meet this hunger, I have developed an approach to adult education which I call "Cross-Over." Actually it works with mixed groups of all ages. Leaders and students from different disciplines work together as a single group, crossing over into the areas where they are least experienced and leading the group in areas which they know well. It is interesting to work, for example, through the different approaches of natural science, poetry, sensory awareness, movement, pottery, drama, and to see how a continuum of insights and skills begins to develop. Nature walks and botanical studies become the material of poems, clay forms, paintings, sources for dance movement, theater, and documentary. Soften the edges of any subject and it begins to show the colors of the whole spectrum. Soften the edges of English and it begins to show the colors of visual art and music and history and the practical skills of printing and book-making.

What are "books"? The history of the book, or an imagination of a book: this would be an interesting theme for a school project. I once made a hanging clay book, with clay sun title page and falling leaves, imprinted. Are sandpaintings books? Are Indian petroglyphs books? Bark paintings and message sticks of the Australian aborigines? *Liber* — the Latin word for *book* originally meant *bark;* and the English word *book* derives from *beech* — "from early Germanic practice of carving runic characters on beechwood tablets," says the dictionary. How about an inquiry into book-making — each one make his own kind of record. Is a box of letters a book? Soften the edges and let the light of imagination show through, toward a fuller picture.

I created a stir at the Curriculum Laboratory in London by wanting to discuss administration as an art. One headmaster shouted angrily, "There's nothing creative about administration." I was tenacious in questioning why he refused even to consider himself an artist. Finally he said, "Because artists are special, and I'm not special. There, you've made me say it." Our pictures of ourselves! Once we become aware of bias, we can undertake change. Administration is an art when it is in touch with an inner vision of human beings as living in both an inner and an outer space. To minister, to administer, these are holy words, serving human wholeness.

The territory of the sacred is just this inner space, the invisible source of the visible, where invisible beings work. Similarly we said that poetry moves between inner sight and the vocabulary of words. Sacred art. The symbols of yin and yang, of the

149

cross, of mandalas — the symbolism of the center, of spirals, of harbors and caves, of water and mountains, of fire, of the mask — these attest to a double realm of physical image and inner portent: the inner ratios of individual and universal in the mandalas, the inner ratios of masculine and feminine in the yang and yin marriage, the inner experience of unfolding growth in the spiral. Seonaid Robertson's book *Rosegarden and Labyrinth: A Study in Art Education* presents this double realm of art and man wonderfully.

Man is not a rat or a guineapig or a monkey. He shares with them qualities of guile and secrecy, of automatic response, of concupiscence and a talent for rote imitation. But they are much better at ratness or guineapigness or monkey business than we are because of other things we have that thicken the plot: like capacities for *wonder* and *conscience* and *compassion*. These tend to bring us into conflict with our ratness or guineapigness or monkey shines. This conflict becomes the material of our moral development, our art of morality. Let us stay on our human course, keeping to the lifeline, rather than going a mechanical or brutish way. To follow the flow, to walk the waves, as well as the solid land.

Man is a crossing point in whom two realms co-exist: call them heaven and earth. The future of heaven is on earth as we become better artists/scientists/learners at embodying materially our visions and our insights. Not to be seduced by power, cynicism, sleepiness, bitterness, discouragement. A crossing point between rootedness in the resources flowing from our planet and the resources flowing to our planet from sun moon and stars. A crossing point between gravity and levity. Like a good carrot: its dense juicy core pulls in nourishment through a thousand pores and its feathery light open floating foliage spins into shape through the sun's light. The great stone circle of Stonehenge or the standing stones of Carnac are ordinary stones but they are more. We are ordinary persons but we are more. When as little children we ask, "Where did I come from?," we sense intuitively that it's a long and mysterious journey.

The artist in us lives comfortably with the fact that a straight line is not just a straight line, a curve is not just a curve. These are inner qualities as well, just as numbers are. Two, for example, is not just a quantity, it is also a quality. Sometimes one has the quality of two. Sometimes eight people in a room have a quality of three. It makes a difference what colors we wear or paint our walls. There is this hidden or occult resonance in all things, and the artist in us knows it intuitively. Magic, mystery, are part of the whole. But these are wayward powers as well, and for this reason we must know the difference between one quality and another.

The odyssey of man is a long trip. Think of Homer's Odysseus, and his ordeals,

150

finally or not quite finally, cast into the sea, naked, then washed ashore, found by Nausicaa, taken to the king to tell his story. Still far from home, but one step closer. It is thrilling to tell the stories and to hear over and over again the tales of man's quest for his own place and his own soul. The palace at Ithaca and Penelope. We start with our longing to find our way; we undergo many trials and inner changes. Life is heroic stuff. We should tell each other these stories over and over again: the stories of man. And act them out, dance them, model them, paint them, sing them. This should be central in our lives and therefore in our curriculum.

The hero's way is the way of initiation. Could education be thought of as initiation into stages of development, rites of passage, a sacred art? How do we do it? We are doing it. We ask how to do it and grow in answer.

Artistic practice is a step on the way. It helps us to picture our wholeness, to feel our relevance. Learning is an art which occurs both in schools and outside schools. Let us keep to the path, wherever it may lead: the Way

<div align="center">to the Wholeness</div>

<div align="right">of our Lives.</div>

Just one more thing: in early September I spent an afternoon on the beach in Maine, with half a dozen other artist-teachers, talking about serious matters: like Urban Renewal, Art Education, Decentralization of Universities, what we want to do. As we began to break up, one man suddenly said he wanted to end by saying a poem: "Blue Girls" by John Crowe Ransom.

<div align="center">

BLUE GIRLS

Twirling your blue skirts, travelling the sward
Under the towers of your seminary,
Go listen to your teachers old and contrary
Without believing a word.

Tie the white fillets then about your hair
And think no more of what will come to pass
Than bluebirds that go walking on the grass
And chattering on the air.

Practice your beauty, blue girls, before it fail;
And I will cry with my loud lips and publish
Beauty which all our power shall never establish,
It is so frail.

</div>

For I could tell you a story which is true;
I know a lady with a terrible tongue,
Blear eyes fallen from blue,
All her perfections tarnished — yet it is not long
Since she was lovelier than any of you.

"Again! Say it again!" I cried, stunned by my thirst. He said it again, and two of his own, standing on the rocks by the sea. I wept with relief, with the relevance. Another kind of consciousness and body feeling. How parched we are in our earnest talk. Come, cross over, at last, into the double realm.

In this talk I have wanted most to bring the spirit of poetry, the mystery of art, into our ears. I don't know how to do it, but I want to learn how to do it. I think of Mac Hammond standing on that granite boulder in the Atlantic Ocean saying poems: one about Blue Girls and one about a still-life painting and one about American Indians. How can I share with you this essential truth, not how to use colored pencils in our math lessons, but

how to hear   the day   the sea   the person   THE POEM.

# X

During the academic year 1969–1970, I was artist-in-residence at the University of Lethbridge in Alberta, Canada. My appointment was cross-discipline, shared by the Art Department and the English Department, which seemed custom-built for me. I was also, I thought, to be connected in some vital way with an experimental college within the University. I had been away from university teaching since 1961, and this was an opportunity for me to see whether we might work fruitfully together again. I had changed, and, as I understood it, the universities were wanting to change too. It proved otherwise, and my lecture on "Non-Toxic Education" came from this experience. Also, my decision, as I phrased it to myself, to temporize no longer with secularity or popular thinking.

I made a trip to Japan during the Christmas holidays, to cheer myself up by a visit to friends in Hiroshima. They were directors of the East Asia Center for Friends World College, a unique venture in international education under Quaker sponsorship. I had thought my lifeline might take me from western Canada to the Orient, and this trip was a kind of probe. Unexpectedly, the trip clarified my view of the resources in my life at home and made me eager to return to Pennsylvania to fire the kilns I had helped to build and to tend my garden. Also it clarified for me the need to work diligently against the model of "Economic Man" which is eating souls all over the earth.

During the winter term of my stay in Lethbridge, the Philosophy Department sponsored a symposium on the Philosophy of Education, which I attended. The theme of the symposium was a critique of university education, prompted in large part by the dissatisfaction and rioting on college campuses. When I became openly distressed at what the faculty speakers were saying and at the students' frustration, I was invited to contribute a paper. The presiding professor said he was unable to make any sense out of the students' plea for "self-fulfillment," and suggested that I might like to try to do so. I accepted the challenge, and presented my lecture on March 17, 1970.

This was an important inner step for me: to decide to participate in academic conflict with gusto and goodwill rather than to flee in fear and disgust. My thanks to those worthy adversaries who drew my fire and respected it.

I began my remarks with a reading of William Stafford's poem "A Ritual to Read to Each Other," which will be found in the present volume on page 137 and so is not printed below. A long introduction of myself then follows. I was almost totally unknown to my audience, and was making my offering to the symposium in terms of personal values. Because it repeats information given in other talks, I have misgivings about including it here. But the tone and form of the piece as a whole are given partly by its beginning. I beg the reader's patience.

# Wholeness in Learning:
## or
## Non-Toxic Education

As those of you know who heard me speak here last year or who have happened across some of my writings, I took my leave of the conventional university approach to education many years ago. I had taken my doctorate in English at the University of California in Berkeley, had taught as a graduate student, then as a member of faculty; I had taught three terms at Central Washington College of Education, and three terms at the University of Chicago. There in 1945 I first *consciously* questioned the assumptions upon which higher education is based.

All my life I had been a good student, had loved school, loved my teachers, had done well in everything except, as a child, deportment and application, writing and art. At the undergraduate level, I was interested in poetry, sports, religion, dancing, grammar, history, philosophy, theater, sex, foreign languages, plants and animals and the sea, money, booze, science, cars — my major it turned out was to be literature and languages. My first two years I had attended an Episcopal junior college for girls in Portland, Oregon; then I got a scholarship to Reed College. My English teacher at St. Helen's Hall gave me an anthology of Oriental poetry, as a gift for good work, and I fell in love with Arthur Waley's translations from Chinese. I determined to devote my life to making more of these lyrics available in my own tongue, and so decided, at seventeen, to be a sinologist, a student of ancient Chinese history and language. There was no department of Oriental studies at Reed College, but there was an independent studies program, so I wrote my bachelor's thesis on Western Imagism in Special Relation to Chinese Poetry of the T'ang Dynasty.

After graduation, I gave a rummage sale to get money to go to Berkeley, to enroll as a graduate student in the department of Oriental studies. I got a job as a waitress and as a "reader," as they were called, in the English department. Readers read all the bluebooks, or exams: midterms and finals. The professors never read the exams, we hired readers did. It seemed strange to me at the time, but, as I said, I always loved and respected my teachers, especially the men, as superior beings, and supposed they knew

what they were doing. There were a whole raft of us graduate students deciding the fates of undergraduates, on the basis of exam grades.

After a term of study of Chinese, with an Austrian professor whose specialty was linguistics, I decided I should reconsider my path. After great anguish, I decided to return into the English department, where I could get a teaching assistantship (I had been fired from my job as a waitress) and deepen my joys in reading and writing with others. I could see that the study I had wanted to make of Chinese was not possible at Berkeley.

So I wrote my doctoral dissertation on Irony in Thomas Hardy, and pressed on. I had not consciously planned to be a teacher. In fact, as I say, the only thing I had ever clearly meant to do was to bring more beautiful poems into the world, via China. But my graduate teaching of remedial English was thoroughly enjoyable, and instructive. I found in myself a kind of fervor for dangling participles and misplaced modifiers, for the vagaries of coherence. In teaching I was learning, it was fun. And I was earning my living by doing what I would be doing anyway by choice, namely, reading and writing and talking about them in fellowship.

Also I found I was more interested in exploring what education was than in advancing in the ranks of the university, as is customary. I took a job at Central Washington when an emergency request came, because I would get to teach a greater variety of courses than are given to a young instructor in the usual English department. And I would also find out what a college of education was. I didn't get on with the president there, as it turned out. I lived in the small college town as I had lived in Berkeley, in a ménage à deux with my lover. It did not occur to me to suspect my colleagues of hypocrisy and double standards. Their language was certainly sophisticated, as were their bibliographies. But apparently a love affair in real life was more than an institution of higher learning could absorb.

So on I went, to Santa Fe, to get married, work on the newspaper, drive a taxi, get divorced, and on to Chicago, where I was offered a job teaching English in the four-year college started by Robert Hutchins and based on what he called "the intellectual virtues." I had taught Hutchins' writings in my comp classes at Cal, and felt honored to be appointed to carry on the mission of higher education in what I supposed to be their spirit. Well, it was soon apparent to me that, if these were the intellectual virtues at work, I would be better off damned. The atmosphere of the University was characterized by duplicity, sneers, sarcasm, oneupmanship, ambition, greed, joyless intellectual gluttony, and behind-the-scenes heartbreak. The students would not allow me to spend time in class on material which did not prepare them for their comprehensive

examinations. Talk about tunnel vision, ech. Nobody looked healthy or happy. It was a drag. The pay was good, the status was good, but the work and the life were juiceless and joyless.

I applied for a job at Black Mountain College, an experimental venture in North Carolina. I wanted to find out whether there was hope at the other end of the stick, before I left higher education as a profession. I had heard about Black Mountain from a student at Reed years before, and had carried the vision like a seed in my heart. It was a great place for my own growth, as it turned out: a college without money or prestige, at that time, though it has gained some prestige in recent years — or its legend has, for Black Mountain adjourned in 1956. The college was owned and operated and governed by students and faculty. Salaries were minute ($25 a month and board and room and medical insurance for every member of the family when I went there), no rank, no tenure, no grades (except for transfer purposes), flexible curriculum, arts at the center, no separate administration, no trustees, nobody to make the decisions and take the consequences but ourselves. No advantage to be there except to be *there*. No degree, no accreditation. But a stiff graduation program for the few candidates, which commanded the respect of every graduate school we sent a student to. We built buildings together, ran a farm, did the physical maintenance, and provided most of our own cultural events. A really ideal set-up, for angels. One chastening thing I learned at Black Mountain College was that university education had not equipped its faculty for self-government nor for cooperation nor with social imagination. The Black Mountain community of artists, scholars, and scientists was torn apart time and again by schism, secession, mutinies, expulsions. Power politics, empire building, territorial combat existed there as elsewhere. Changing procedures and structures in education is not enough in itself, the persons must also be transformed.

When I left Black Mountain, I went through a deep crisis of disillusionment and self-examination. Wrestling with the question: Why is it, if we are all so well-educated and brilliant and gifted and artistic and idealistic and distinguished in scholarship, that we are so selfish and scheming and dishonest and begrudging and impatient and arrogant and disrespectful of others?

I turned to arts of transformation: pottery, alchemy, spiritual self-development. It seems to me that it is not the structure of an institution that makes the difference, nor curriculum nor grades nor degree nor intellect nor arts nor sciences, but the values and behavior of persons.

I left Black Mountain in something like despair and did not teach for five years. I virtually forswore reading and writing and "mentation," and sought to awaken in my-

self other capacities for perceiving and responding. My second marriage had broken up: a professor of ethics and logic married to a professor of poetry and composition, both with the emotional development of infants. Plenty of ethical talk, plenty of·demands for clarity, plenty of Milton and T. S. Eliot, plenty of creative writing, but no marriage. And no college. So what price the trained intellect?

I turned for companionship to a nonverbal musician, began the study of Zen Buddhism, esoteric Christianity, translated *The Theater and Its Double* which launched the Living Theater into its postliterature phase, continued my work in clay and fire, spent a year reading *Finnegans Wake* aloud with two friends . . . lived in New York with artists, started a community outside Manhattan with a few former Black Mountaineers, built a shop with two other potters, made a garden, made a house, and began to teach again as a substitute in the local schools, everything from kindergarten to high school. I needed the money, I was still curious about this thing called education which is supposed to do so much for us, and my wounds had healed enough to allow me to re-enter the classroom with reasonable calm.

I began again to teach English, this time at City College in New York — part-time in the evening session in order to have time for my work in clay and my country life. Eventually I was taking pots to my English classes and to my chairman, and home-baked bread, sharing my life with students as they shared theirs through writing with me. But the time came when it wasn't enough. Still the fragmentation, the callousness of teachers, the cynicism of students, the hopes deferred. I felt a new integration for myself seeking to be born, and I asked for a leave of absence, not knowing what would come. I suggested to my colleagues that the schools close for two years and everybody go fishing — and only reopen if there was living motivation. Within six months, my book *Centering* had been unexpectedly commissioned. It was to be, in the publisher's jargon, an "interdisciplinary study"; my search for my own wholeness was found useful by others. It is a book about the arts of transformation: pottery, poetry, pedagogy, evolution of person through the ordeals of life.

Since its publication in 1964, I have earned my living as a free-lance teacher, writer, craftsman, workshopper, consultant, in the U.S. and abroad. All the time whittling away at my own growth and learning. Distributing my efforts across the division between verbal and nonverbal, outer and inner, intellectual/emotional/artistic; intuitive/imaginative/inspirational; body/soul/spirit. Seeking balance. Seeking clear perception, the new clairvoyance of our age: a "seeing" which is as disciplined as science, but which is fed from the inside by the ever evolving capacities of our wholeness.

Here I and the officers of this university part company. Our *intentions* are differ-

157

ent. I am interested in Persons, the University is interested in knowledge, intellectual development, cultural skills. In this symposium, we have heard paper after paper reiterate the functions of the University. Each of the last three, which I have heard, has forcefully disclaimed any interest in personal fulfillment.

On the first evening I was present, Professor A—— declared that he was unable to make sense of the students' desire for something they call "fulfillment." The same evening Dr. B—— referred contemptuously to the "whining" of students for love. The next week Mr. C—— sketched the faculty as a priesthood regarding itself as above question. His cynicism about human beings, whom he refers to as "a race of lemmings," allows him to accept the function of a university at a minimum level, as a system for tooling minds into social passivity and as a vocational filter. Last week Professor D—— found comical the attempt to read into the proper functioning of a university any concern for emotional feedback, or any concern for what I think he would call "entertainment," namely pleasure warmth enjoyment, celebrations and ceremonies.

Professor A—— has asked me to try to make clear to him what these whining and muddleheaded students might be referring to. I am aware, I hope, of his irony and friendly malice. Surely (a) the idea of self-fulfillment is not esoteric nor unfamiliar to the disciplines of philosophy; and (b) if it has eluded Mr. A——'s grasp so far, I think it unlikely that *I* shall be the one to make clear to him what his own studies and life experience have not. So I surmise that he has used this device to hustle me into a position which he and his colleagues have already struck out as absurd.

So be it. It is ever thus in debate with feudal authority. Barons *define* the petitions as irrelevant and the grievances as unfounded. Why this strategy is considered a mark of intelligence, I don't know. For what is created is ill-will, polarization, frustration, underground revolution, resentful fantasies of tit for tat, "You guys think I am irrelevant?: babies, I got news for you, YOU iz irrelevant, BAM ZAP etc." Dr. B—— insisted that love has no place in a university education. Since there is nothing in intellect itself to guide its use toward the welfare of persons, it may serve one end as easily as another.

I tire quickly of this kind of combat since it is circular and unresolvable. The lords will still be congratulating themselves on their definitions when the walls come crumbling down. They may never notice that no one is around, since as Dr. B—— said, it has never been the teacher's duty to take any notice of people. Teachers appear in classrooms . . . it is not their business to make their teaching fruitful. Of course he quickly saw the agitation and despair which would arise in the souls of students (and teachers!) at being so abused, and proposed an extensive counseling service to take care of

the depression and anxiety. Great solution: thinkers this way, feelers that. But wait, thinkers also have feelings, and feelers thoughts, so who should go where? Academic jargon separates "cognitive" and "affective" development though they are known to be reciprocal. There have been studies enough to tell us that we do not learn to think without sense experience, motor activity, emotional warmth, and imagination. The brain without human feeling is monstrous: we have been through that one. And the tender heart preyed upon by superstition is in trouble too. Why pretend that we don't know that our brilliance and sensitivity are as easily sick as sound, that we quote scripture devilishly, that our agile minds and panicky hearts can rationalize and justify our behavior till the cows come home. In this connection I am reminded of the end of the movie *On the Beach:* the nuclear cloud is approaching, the end of man is near: one fellow who considers himself on the winning side exclaims just before going under: *"We showed 'em!"* Showed 'em? Showed whom? Showed 'em *what?*

The world, it seems to me, is large enough to contain us all. I would like to see forms of higher education which would awaken and develop all the capacities of the human being. I see the world as a totality, and the forms of education as a totality, and learning as lifelong — in rhythms of learning, unlearning, relearning. The authority of the university is dimming, as is all authority vested in institutions. Authority is being transformed, it is being internalized and reborn in the individual conscience of persons. Person as author, as actor, as participant. Knowledge is being tested against practice. Wisdom against relationships.

I say it is all well and good, there is a time for everything under the sun. Consciousness evolves, values change and mature and wither and bear fruit, institutions rise and fall as the times require for the evolution of man, the spiritual continuum plays through the changing forms. We can learn to govern our appetites, our egocentricity, our loneliness and rage, to relinquish the familiar for the unfamiliar, to feel our personal history digested into the tissues of new perspectives, as in the seed point there concentrate the forces of the withering plant, the new life sowed by the old, the mystery of metamorphosis and reincarnation.

We can see how contemporary man is fighting for his life, and for his right to live. We can feel the center shifting from mastery of subject to mastery of self. We can feel new territory open; some of us are at its edge, homeless, sensing new points of contact, new streams of learning around the planet, wandering scholars, troubadours, migrant workers, consultants, tourists, grouping and regrouping, trying to find out how to be human beings, how to do the world's work in integrity. Many students (and teachers!) in universities are in a dilemma: they want their lives and their wholeness, they want

to grow in human being and in balance, they also want good jobs and they want to make a contribution to society. So they ask the university if it could find a way to help them, toward self-fulfillment and wholeness in learning so that whatever task they perform they could bring the wholeness of themselves and their learning to it.

Self-fulfillment is not a word that fits my mouth comfortably, but I think I do understand the direction it is pointing.

I have heard here two kinds of rebuttal, which I will answer along the way. One is: "Where did you ever get the idea that the university exists to bring you self-fulfillment?"; and the other is: "The role of university has always been and is, by definition, to transmit culture and to train the intellect."

Let us begin with the Self and its Fulfillment.

Self points to a dimension of being which is inclusive. It is the territory of the psyche: awake, asleep, and dreaming. Consciousness awake is part of a larger consciousness. This larger consciousness is called the unconscious, the superconscious, the psyche, or the spiritual worlds. What is pointed to is a dimension of awareness which is not ordinarily awake in daily doing, but which is nevertheless active as source and guide. The disciplines of consciousness expansion and inner development apply to this territory of the Self or psyche. There is evidence that the matrix of the universe is psyche, and that matter is its precipitate. There is evidence that the territory of the psyche is objective and can be researched (cf. the works of C. G. Jung, Rudolf Steiner, P. W. Martin, E. Graham Howe, R. Assagioli, Erich Neumann), that the distinction formerly made between subject and object is undergoing revision, that *all* experience is inner: that into all calculations must be read the calculator, into all measurements the measurer, into all scientific observations the observer. During the course of human history, the human eye has seen nature quite differently. What the eye sees depends upon the see-er. And the see-er may be understood largely in the light of the evolution of consciousness. For example, we do not have Galileo seeing the stars through a telescope until human consciousness has differentiated itself from its spiritual surroundings. This is a different stage from primitive *participation mystique* or medieval union with God. We do not get modern theater until it is possible for the individual to feel the form of his own ego as separate from the collective and as potentially free in its moral choices. Differentiation and integration of forms characterize the evolution of earth and earthlings.

Self then is both very big and very small. In each of us lives the history of man; in each, an awakening individual being. When we ask for self-fulfillment, we are asking for two kinds of experience. One is the experience of what it is to be a human being,

i.e. an experience of our origins and history, our culture; and the other is the experience of myself, the mystery of myself, co-creator of history and culture. Who am I? Who are you? Who are we?

We long to be recognized, and yet we are cautious. The psyche resists intrusion, fears being overwhelmed. It is understandable, but it is hard to know what to do when some are ready for the marriage feast and others are not. The tradition of the Bodhisattva is to wait and to work until all are ready. Until all are individuals whose self is filled out so that in it may be born the living experience of the Other Person. This is what love may turn out to be. The awakening in one's self of the Being of Another. A discipline of Active Listening may lead us toward this distant fulfillment: to listen to one another, with more than our ears; with our intuition, our imagination, our warmth, and, even, our prudence.

One of the exercises we do in my workshop here is to explore the use of transparencies in the fulfilling of an image. Separate layers of clear plastic, separate images on each layer, the light shines through all layers simultaneously, the wholeness shines through all the parts. Words, colors, drawings, symbols, light. A wholeness of separatenesses. It's got to be a paradox, we have both to know what we are doing and to not know. Be both on solid ground and at sea.

Having our cake and eating it too. It's the way. I have not forsworn my rational capabilities in order to develop my postlogical prerational intuitive capacities. I have not relinquished my ability to analyze, parse, generalize, speculate, draw distinctions, and reason deductively or inductively. But I have relinquished any superstition I might have had as to the superiority of that function, *or of its reliability without the cooperation of the rest of myself*. Man is a threefold creature of thinkingfeelingwilling, bodysoulspirit — interpenetrating spheres — every cell in the body has its intelligence, its warmth, its metabolism, they are continuously interdependent and interacting. Values are the way we feel about things: whether they are important, desirable, illuminating, healing, or dangerous and lethal. If we do not care about something, it has no value for us. Thinking, then, *is* an art of *love*.

Man is a mystery, an occult being, hidden from himself. He is much more than rational. The task is to discover what man is. We may learn that we are in the process of creation still, and that we are agents in creation. It is this discovery which may be at work in the archetypal field at present, and which may account for the enormous thrust of energy into the widespread desire for participation. There may be a new revelation slowly waking to consciousness, that our lives depend upon us as actors, and that we are walking nuclear powerhouses, every cell containing a solar system. You

don't have to contemplate the proliferation of stellar galaxies to have your mind blown, just consider what goes on in the mystery of your own body.

History as symptomatology: a script of inner forces at work. What we need to develop are new organs of insight into those forces, a new clairvoyance suitable for our age. We may come then to see with dispassion our resistances to change, our terrors of failure and loss, our needs and vulnerability, our stubbornness: to see how they work for us and how they work against us.

Self-fulfillment. It has to do with learning and unlearning, with feeling and self-mastery, with courage to be different from others, courage to be common clay; it has a lot to do with innocence. Innocence, not of babies, but of grown-ups, committed to what is whole and holy and healing.

Where did I ever get the idea that the university existed to bring me to self-fulfill-ment? Don't think I haven't asked myself that question a hundred times, in the past — with a heart furious and bitter. "You betrayed me," I raved at the ghosts of my teachers; "I trusted you. I thought you were teaching me what I needed to know. I thought the Good Life meant success and children and a husband and a home and having every-thing come out happily, and here I am in the middle of my life in despair disillusion-ment impotence isolation, in Hell. So I have a Ph.D., what good is it, I don't know up from down, dark from light, my life is in ruins, the girl next door never finished high school has five kids a husband a shoestore and looks juicy as a peach." Where did I get the idea? I, like others, had been brainwashed since infancy, by parents, schools, church, the American mystique which says if you do well in school, you will be "equipped for life." You will have done your duty and be suitably rewarded, by personal fulfillment supposedly — what else would it be? But what the university means by fulfillment is INTELLECT, POWER, and MONEY. It is a misunderstanding, but that's how it happens. With the help, as Professor A—— admitted recently, of the hypocrisy of college catalogues.

So my intuition about myself as a growing and learning creature was always con-nected with schools. It has taken all of my life up to now to work free.

My intuition about myself is that I have a future, that this future exists not only in time as history to be acted out, but also in essence as the unfolding of capacities and the experience of my personal destiny. This intuition belongs to mankind. We are told the stories of the human pilgrimage to the Grail Castle, tales of creation of world / man and woman, tales of the hero and his initiation into his manhood with his own name, the taking of one's own name is a way of speaking about self-fulfillment.

The difficulties of weaning ourselves from infantile dependency on the nourishing

mother, the alma mater, are well known to all of us who have suffered them through. We live like children in the dark of our needs and their gratification, largely unconscious, attached to the mothering breast of earth family school spouse society collective standards. We grow toward becoming adults, who are in the light, more aware of how the light shines in the darkness, less dependent upon collective approval, more individualized, more self-fulfilled, seeking our wholeness in freedom and union with others in a lifetime of labor on our inner path. An inner path which we walk on the earth, and which is therefore also an outer path. We look for the forms of education, aids to our growth, which will lead us and help us to grow true to ourselves. One of the things we need is respect. One of the things we need to learn is *how* to respect others. To respect is *to behold the invisible being present.* Lo and behold! To work free of spasms of re-action, free of blinding sympathy or antipathy, free to hear through the words the person speaking. These spiritual sense organs have to be slowly awakened. I am reminded of that passage in *Prince Caspian,* one of the Narnia tales by C. S. Lewis. Lucy sees the lion Aslan in the forest. Aslan tells her to wake the other children and bring them through the woods. But, he says, they will not be able to see me at first. And so it is: It takes awhile, and then first Edmund begins to notice something that looks like a ruff and whisking tail. Later Peter sees. Last, Susan. And yet he was visible to Lucy all the time.

The researches of psychologist Carl Jung led him to distinguish certain psychological types of people. And also to acknowledge the great difficulties of communication between the types. For example, a person who tends to lead with his intuition will be impatient with the workaday practicality of the sensation-oriented person. The thinking type will have trouble with the feeling type, and vice versa. But all these functions, in their degrees of extraversion and introversion, exist within every human being. One tends to be more pronounced in our temperament, and to be more developed. Schooling tends to strengthen the patterns of thinking response, at the expense of feeling, intuition, and sensation. Schooling also tends to reward verbal thinking types over non-verbal and other types. This often causes serious displacement of the natural search for balance, and causes serious undervaluing of basic human gifts. Persons who aspire to self-fulfillment often become ill when they are cut off from the flow toward total being. There seem to be basic tropisms in the human being, toward balance, toward health and wholeness: a natural centering process. People who repress their energy at their growing tips often get into trouble with alienation, depression, schizophrenia. We tamper with the built-in disposition of our organisms toward health at our peril.

As one gains in self-knowledge, there comes a time when one moves toward one's

less developed functions, consciously. This becomes the discipline of our ongoing adult education. To know that our characters are dynamic, that we grow and change throughout our lives, that in our growing tip there is the possibility of developing toward wholeness and self-fulfillment, the filling out of our personal self, the dwelling in ever fuller conscious relation to the transpersonal Self. "In my father's house are many mansions, if it were not so I would have told you."

And now to reply to the other rebuttal: that the function of the university has always been to transmit culture and to train the intellect, to prepare people for social roles.

So long as students and teachers identify with the values of their society, they are content with their education. As soon as they begin to question the values, they begin to question the education which is assuming them. We are at such a moment now. It does not, therefore, speak to the point of the unrest to justify the present by the past. Insights are changing; when insights change, behavior changes. As new goals swim into the inner eye, man's imagination envisions new paths. I myself think it is unfortunate that the dynamic of change is regarded as threatening, rather than a great adventure which needs the best wit and agility and steadiness of us all. I wish that our education could help us to develop the courage and resiliency and capacity for sacrifice, the insight into transformation as a principle of growth, which we need to have if we are to help our human work to go forward. Violence erupts when elements of our wholeness are repressed or abused. Violence may be either cold or hot, silent or explosive, withdrawn or aggressive. Violence against oneself tends to develop when we are estranged from our own deepest being. It is then that we begin to grow hard, resistant, fearful, competitive, hostile: these are projections of our self-alienation. Our unwillingness to imagine change is a projection of the distance we are keeping from our own inner fires. Once the barriers are down, we may stampede. We have kept the reins in tension for so long, we have no muscle in our thighs to ride and guide the pulsing energy of libido. We sense how shallow our skills are, and fear we may run amok. And for good reason. University education surely does not keep us from running amok: there is plenty of evidence for that in our educated societies. There must be, then, something else to learn.

My feeling is that this something else is beginning to creep in at elementary school levels now: a feeling for the whole child, for the whole teacher as well, for the whole school, the whole community, the whole planet, the whole universe: a translocalism at every level. All kinds of unschool things are happening even in schools. Many teach-

ers are willing to take in-service workshops, learning new values, new ways, courageously beginning to explore with the children the questions that are real to them. These are a possible new generation, who will perhaps ask for change in high schools, then in colleges. Maybe by the end of the century, there will be planetary networks of educational centers or learning environments which express our longings for inspiration, for experience, for understanding, for information, for relatedness, for practice, for belonging to something larger than ourself as part of ourselves.

The question about self-fulfillment is a question not of history but of a crossing point between past and future. Something deep is stirring within the psyche of man. We are entering a new age. The Aquarian Age, some call it. The Micha-el Age, some call it. An age of spiritual awakening in the individual, and of community. What in fact is being questioned is the authority of history. Nature makes leaps. Can man make a leap, into a new quality of being, uncoerced by the past, either his own or society's? Can we begin at a new point and proceed toward a new end? Can we make new karma? Or are we caught in the works, helpless to help ourselves?

The intuition of wholeness is justified not by history, but by a perception of what is happening now; by what is growing in us toward the future: a new birth, a new human consciousness and social order.

If you see the signs of new birth in the spiritual world of man, you will be able to make sense of current symptoms. For example, why does competition seem increasingly repugnant, where formerly it seemed stimulating? Because we feel a shift in our goals and purposing from Competitive Achievement to Quality of Being and Relationship. Not toward "victory," but toward human insight and a loving will. It is happening, whether we want it or not. It is happening in the depths.

Perhaps it is the philosophical question of secondary qualities, rearing its lovely head. Perhaps Newton did not settle our hash forever, and perhaps neither did Kant. Perhaps the secondary qualities are not so secondary now. Perhaps the categorical imperative is not imperative, perhaps the categories are transforming into a larger field now open to human perception which has been awakened to it.

Insights during our century have taken our perspectives another step. The relativity theory, breakthroughs in occult science and extrasensory perception, depth psychology, electronics, genetics, conservation and ecology, the dialogue between political self-determinism and world government, world design by visionary architects and poet-statesmen, a biodynamic agriculture which is not toxic, a medicine which is preventive. Poetry in space, poetry in sound, composition by field, an ensemble of soloists, an early warning system of man's imagination in touch with prophetic impulses stir-

ring in the creative unconscious, church drop-outs into new religious fellowships, metalinguistics, an archeology of cosmos. Why should we fight with one another about getting in tune with it? We can't do what needs to be done without one another's help. That's the fact. To do one's own thing is to come into one's own free awareness of how much in love with one another we deeply are: how we work to free that love, that interdependency, that sun at the center, that warmth and mutual beholding.

I cannot answer big questions of what's to be done. I can only try to find the way that is right and fruitful for myself, where I can feel that all of myself is relevant to the situation. I am interested in developing a consciousness which integrates religious intuition/artistic intuition/social imagination/knowledge of materials/intellectual aliveness. I am interested in working with others who want to find the new forms for the new consciousness and social order. I am inclined to take small steps: to design a home I can carry on my back, a three-pound, 30-foot circular impermeable tent, with plug-in sanitation, light, and heat; to design some clothes which change from one temperature zone to another; to grow nontoxic food and bake nutritious bread; to pray unceasingly; to receive gifts; to wait and to keep the faith; to fire my wood-burning kiln in Pennsylvania; to spread good tidings of the new man who is asking to get born in us.

In what kind of workshops do we fulfill ourselves: as man, and as individual? I hope the polarization into encounter groups, art workshops, communes, research, is temporary. I would like to see classes operate consciously on several levels: emotional learning, artistic learning, thinking, community, practice, perception, information.

I have developed one kind of format for a program which I call Cross-Over: Toward a New View of Language, Verbal and Nonverbal. I will be doing something in this spirit for a month this summer at Eastern Washington State College. I will be working with a group of thirty students and four or five faculty. Or rather we will all be working together as a group. We will have no other commitments during the period. The head of the Art Department, the head of the women's Phys Ed Health and Recreation Department, a writer, a dancer, a naturalist, myself and students. We will set ourselves in motion, change roles in leading and following, share what we know and want to find out, develop an organic life-line in our activities, meet daily to decide what we want to do, to feed back reactions, to talk philosophy — and stop at any moment to give our attention to each other's feelings. When you work this close to yourself, there are bound to be tears and anxiety and anger; as trust develops, we learn to communicate with each other through a broad spectrum. In the life-line of our learning, we experience the continuum of human knowledge and creativity: theater and architecture and mathematics and movement and health and recreation and dance and poetry and nature as

source, these all seem quite naturally and of themselves to weave into a pattern which reveals its unity to us.

Later on in the summer I may go to England to a craft conference of the Society for Education Through Art. The late Sir Herbert Read was its founder and philosopher. This year there is to be paper-making, and I want to learn. In 1968 at the farm in Pennsylvania where my base camp is now, we had a kiln-building and pottery-making festival, and we are planning a festival of paper-making, vegetable-dyeing, writing, and paper weaving. I am very interested in writing as a handcraft, in reawakening the art of the scribe, of involving writers in the physical materials of their craft. When you begin to see what writing really is, how we take the grasses of the earth and make them into extended planes, and take juices of roots and barks and leaves, and carbon from the fire, for color and ink, and draw contours of our inner life on this plane and send it floating around the globe, a message stick, for others to touch and gaze at and look up from and say, "It's good to hear!": Hear? Talk about mixed media! Who needs light shows?

The way for me is the middle path, through the organic center, the heart, the hinge, what all hinges on. The blood and breath center, the center of rhythmic life. The dangers are at the extremes: of expansion, of contraction. Dissolving, congealing. Conceit of the spirit; conceit of the body. Ruling the world by individual fantasy, ruling the world by technological models. Neither is the human path. True to our unfolding wholeness, we must mediate the bias of head or feet through the heart center. This is something to grow toward. A new dawn. We may not know what wholeness is, or self-fulfillment. But we know there is something in the wind, we sense ourselves in frontier territory, we feel excited and confused and earnest. The New Nomads, extending the love for roots into a love for the wholeness of the spreading vine in its seasons.

Centering: to feel the whole in every part. Distributing equilibrium: liberty and justice for all, in an even grain throughout the body of our clay.

When you undertake to do things out of a personal center, you are in for more work than before, and work of a different order. You need new arts of initiative and of judgment and of making agreements. It cannot be done any longer by fiat, or by an appeal to protocol or procedures. We are not used to asking ourselves what we need and want as a step toward social responsibility. We are not used to relating to each other free of role. The danger in letting things go their own way is that they follow the inertia of old habits, and acute conflicts develop between the self-justifying impulses of history and the prophetic impulses of growth. We have to pay attention and suffer through the

167

changes in attitude that are called for. Otherwise people get discouraged and drop out, or decide that collaborative learning is unrealistic and resort to formalisms they had discarded. It seems to me better to keep the faith, stick to the question, and grow to the answers. What students and teachers want is an open situation, not a tyranny of frustration either by rule or by formlessness. New forms should be consciously developed within the learning fellowship. They need to be continually relinquished as other forms are asked for; this is education in evolution, revolution. This is where imagination has to be active, and the practice constant. When we can do what we want to do, what do we do? This question is a doorway into the unknown, into a new way of working, into self-creation. For we find that we get in our own way if we are not careful. At Black Mountain College, did we want to make a mess of the whole blessed opportunity? No, we wanted to flourish. But egocentricity and sloth got in the way. There is someone in us who wants to be both free and connected: why shouldn't that someone be awakened and strengthened at centers of learning, and given creative leadership in the realm of the self? This is the royal Self, the King, the Babe. Without it, we are not fulfilled.

What is the advantage of deriving curriculum and university process from a concept of the evolving Self?

1. We do not sell ourselves short as being less than we are.
2. We release energy which is no longer trapped by compensating fantasy and withdrawal.
3. And most important, we find that our various fields of focus constitute a unity. Culture is the inner life of man: it is an organically unfolding continuum. Substance and understanding are the same word: *sub:* under; *stance:* standing. That's why I asked Professor D—— last week what *he* thought Aristotle meant when he said that man wanted *to know*. To know is to become substance. Who said that? Wasn't it Plato? To know the Good is to become the Good? *Love, know, become:* these mighty verbs have to do all with an awareness that lives in our substance, in our practice, an awareness that lights up the world of knowledge from within. Well, then, philosophy, or *philo sophia,* the love of wisdom, is not different from the impulse toward self-fulfillment.

*Gnothi seauton:* Know thyself. This was the maxim inscribed on the temple of Apollo at Delphi. To know thyself is to love thyself is to become thyself.

Since this is a philosophy symposium, it seems appropriate to acknowledge that when we speak of Self, Knowing, Becoming, Loving, we are pointing to Eidos, Living Ideas, Living Forms of Being in the Archetypal World, the spiritual world; we are pointing to the deep and basic mysteries of man. The oracle at Delphi, the mystery

school at Eleusis, the sacraments and sacrifices at different thresholds of our growth: These are our language: the Sun: Apollo/Mithras/Christ/Aion/the Self: rising within us, coming to consciousness as the center which holds us all, and which streams in the light of each individual vocabulary. When we live awake in this center, in this mystery, we are undivided yet separate, and perception is a function of love. Thus is the breach healed between intellect and feeling, intuition and sensation. Man need not be estranged from himself, but may be fulfilled in wholeness. This is the path, I think, which students are asking the university to embrace. It would be a powerful witness on the part of its doctors of *philo sophia* to undertake the discipline of suffering through their own transformation as models for the young of what it is to be an adult person.

For myself, after this year back in the land of University, I suspect that my direction is outside schools exploring resources for learning. I see a place for educational research which is connected with the heart of learning, but which has worked free of identification with the alma mater. Certainly the deep center holds us all, and the task is, isn't it, to find our own destiny within it.

I can visualize encampments on our Endless Mountains Farm north of Scranton: where we might come together from planting time to harvest time, to gather food, make celebrations, study, do research, practice, build, perform, worship together to plot each other's advantage, sharing costs, work, and opportunities — and then adjourn, like seed sown in the autumn, blown about the world to grow and bear fruit.

Perhaps the universities will adopt us as an outpost.

# XI

On February 14, 1971, at the invitation of Professor James Carpenter, I gave a public lecture at Colby College, Waterville, Maine, as part of an Arts Festival, in which I also gave a poetry reading, a showing of poem prints and of pots, and a pottery class. As often happens, I was asked to talk about "whatever I wanted." What did I want to say? I would be back in the land of "higher education." What could I bring? It was a question I wanted to try to answer. I did so with this talk entitled "Connections."

I had prepared a long and wide paper banner which was stretched twenty feet across the front of the auditorium. On it I had drawn with colored chalk four symbols which I had used in my meditations upon the themes of the talk. The sun-man originated in 1966 when I was preparing my first Cross-Over program. The rainbow had also been activated as a focal image during Cross-Over work with my friend and associate Remy Charlip. We went early to Penland to paint rainbows on paper banners which we hung full length in the entrance doorways of our meeting rooms. The fountain was newly inspired by the theme of connections. And the spiral sequence had gradually developed out of an attempt to envision the feel of centering: widening, narrowing, widening, narrowing, changing direction, unfolding levels; the movement, rather than the concept. Two colors indicated the double movement from periphery inward to infinite center and outward from a point to an infinite periphery.

I had also placed one of my pottery vases (a "kiva" pot, with a ladder inside) near the lectern. It seemed urgent to transform, however modestly, the environment of the lecture hall in the spirit of an arts festival. Indeed it is maddening to talk about art and connections, and not to make them. I recall how, when I was first given charge of the Curriculum Lab in London, I rushed out to buy flowers for the room we met in, and colored chalk for the blackboards.

# Connections

THE title I have given my talk is "Connections," and I want to begin with a poem by Dylan Thomas:

> The force that through the green fuse drives the flower
> Drives my green age; that blasts the roots of trees
> Is my destroyer.

And I am dumb to tell the crooked rose
My youth is bent by the same wintry fever.

The force that drives the water through the rocks
Drives my red blood; that dries the mouthing streams
Turns mine to wax.
And I am dumb to mouth unto my veins
How at the mountain spring the same mouth sucks.

The hand that whirls the water in the pool
Stirs the quicksand; that ropes the blowing wind
Hauls my shroud sail.
And I am dumb to tell the hanging man
How of my clay is made the hangman's lime.

The lips of time leech to the fountain head;
Love drips and gathers, but the fallen blood
Shall calm her sores.
And I am dumb to tell a weather's wind
How time has ticked a heaven round the stars.

And I am dumb to tell the lover's tomb
How at my sheet goes the same crooked worm.

The connections which I want particularly to celebrate here today are those between the inner invisible realm of the "force" and the outer visible realm of the "flower," the inner realm of nature and the inner realm of man, connections between the invisible life of man and the invisible life of the universe, invisible that is to ordinary eyesight. Connections between human beings, between fields of study and work, the fabric of a common spiritual community. Artists are sometimes particularly attuned to these connections, scientists too, mystics too, soul-brothers too. It seems meaningful to take this occasion of an arts festival to think together about a feeling for inner formative forces, a sense of connections.

Here I have made for us a few symbols which have been fruitful in my own meditations upon this theme. One is a Fountain. One is a Rainbow. One is a Star Man with a Sun at the Center radiating into all the Vocabularies of his Deeds. One is a Spiral Continuum, infolding-outfolding.

All the separate drops of the fountain come from the one source. The one spring.

In the French language, *la source* means *spring,* in the sense of a freshet of water, a *springing up and out* of the ground. It is interesting that our word "spring," for the season that follows winter, should be the same, and have in it that inner gesture of unfolding upward and outward, like a fountain. If you look at the drops separately you do not see their connection. Look, for example, at this area, where there would appear to be a random scattering of points in space, as the drops of water shoot here and there. But not if you see how they are positioned by their mutual relation to the force and movement of the fountain. They are an integral part of its form, and are deeply organically connected to the trajectories of its rising and falling movement.

Here in the rainbow we have a wholeness of the spectrum, one color turning into the next, no hard edges, all developing between the poles of light and dark.

In the next drawing we have man, shaped like a five-pointed star, the arch of his cranium a rainbow, at his center a sun, sun-center, solar plexus, sun life being, radiating out into all the vocabularies of his living; eating sleeping walking dreaming drawing dancing telling stories listening, into his works whether geology or painting or farming or philosophy or theater or anthropology or physical education or teacher training or architecture or handcrafts. All connected through a common source and common qualities of being.

And last is the spiral form in a series. The spiral draws inward in something almost like a suction, and at a certain moment it makes a complete turnabout and the new spiral takes its path outward and inward, connected with the one before, with the one that will spin in turn out of it.

These are a few pictures to start with, as we come to our subject.

My theme is Connections. Yet what I have written here seems to range from horticulture to alchemy to the history of consciousness, with a few poems sprinkled in, and relying heavily on paradox. The central image seems to be a cabbage. Well, so be it. There may be a message in this way of working. Maybe that's what a subject is, a gathering of ideas as set in motion by a central impulse. Like a magnetic field. Start the field going, and elements begin to swarm. By what logic? By attraction. By resonance. Maybe that's what relevance is: the feeling of attraction and resonance between ideas and people. I'll risk it.

Now for Mr. Cabbage. He grows a big heart. Out of this heart come leaves. As the leaves grow, the heart grows. The cabbage gets its leaves from the inside, where there aren't any. Cabbages grow from the inside, from the heart. And by growing they create their hearts.

A neurophysiologist from Yale says that brains too are created in this way: from

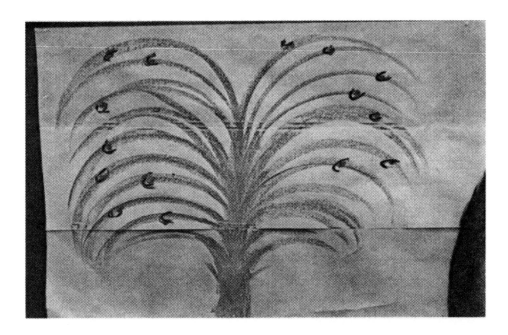

Fountain; Rainbow

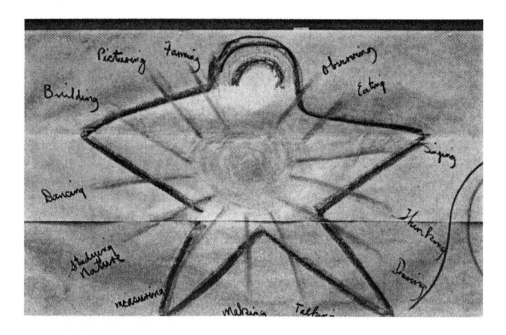

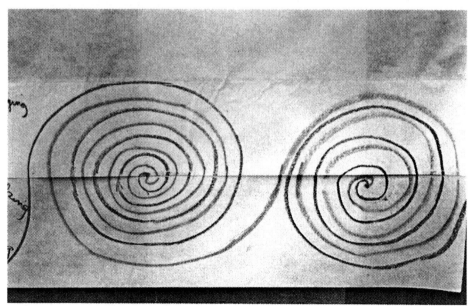

Star Man; Spiral Continuum

un-brain forces. He says that the human brain is created by thinking, that ideas and values create chemical reactions in tissue. Like a cabbage, somehow the physical form grows from an invisible realm.

This invisible realm must be a powerfully creative region. It furnishes us not only with cabbages and brains, but with our scientific hypotheses, religious experiences, and works of art.

In his letter to me, inviting me to speak at this festival, Jim Carpenter said, "It is a time when we bring to a head some of the enthusiasm about the arts here on campus."

I would like to say something about what underlies this enthusiasm, and how this enthusiasm is connected with the inner spirit of curriculum as a whole.

College curriculum is a funny sort of a thing, the way it is all divided up, into art and other things which are supposedly not arts, and yet they are called "liberal arts," aren't they. A college of liberal arts is a college where you study not art, but science and philosophy and history and mathematics and languages and literature and psychology and sociology and political science and anthropology and education. But even though they are called liberal arts colleges, they are often not very liberal about what they offer in art. Art as distinct from liberal arts seems to be when you are painting a picture or making a sculpture. Art tends to be thought of as visual. Courses in art don't usually include music or poetry or theater or dance. Although now there seems to be a push in our consciousness toward seeing these things as connected, these arts as part of a larger art form. Actually there seems to be a growing impulse in our consciousness to see that the visual arts, the verbal arts, the nonverbal arts, the liberal arts, are all interconnected, and even connected with non-art subjects like perception and linguistics and biology, physics and religion and mythology, with numbers and ratios, with rationality, in ways that we haven't thoroughly sorted out yet, but we are beginning to think about the interconnections between things, and to experience them, to experience relationships, now that we have already for a long time been thinking about and experiencing things as separate and different from each other.

This change suggests that consciousness is an unfolding being in us, that there is psychic development in the history of human beings, just as there has been physical development. An evolution of consciousness as well as an evolution of natural forms.

When you begin to notice this developmental process or order in the forming of human consciousness, you begin to feel very interested in where you stand at this moment in relation to what has happened before and what can happen in the future.

It is as if we are points on a continuum. It makes us uncompetitive with the past, and interested in it as a human story of how things come to be as they are, what stages of growth are, and how we can cooperate with the growth forces which are emerging at any given moment. Now it is a very complicated and challenging picture, because of course growth is not altogether a matter of bulk or quantity. We know that when we grow up, we mean not that we increase in size indefinitely, for actually we get our full physical growth fairly early in our youth. But the growth which we continue to experience is more like an inner ripening, it is an experience of quality. Qualities for example like meaningfulness, relationship, courage, insight, humility, perseverance, humor, friendliness, confidence, caution, a sense for the welfare of others, a sense for the part of yourself that is decreasing as it were with age, and the part of yourself that is increasing. There seems to be this kind of interplay between natural energy which builds up the mineral components of the body, and the psychic or spiritual energy which deepens and extends and contains a feeling for what life really is, "a sense," as Wordsworth wrote:

> Of something far more deeply interfused,
> Whose dwelling is the light of setting suns,
> And the round ocean and the living air,
> And the blue sky, and in the mind of man;
> A motion and a spirit, that impels
> All thinking things, all objects of all thought,
> And rolls through all things.

This is part of a poem called "Lines Composed a Few Miles Above Tintern Abbey," which is one of the beautiful and wise poems which Wordsworth wrote out of his experiences of the stages of development of his own life, from boyhood to manhood, from brilliant physical identification with nature to, as he says, "something far more deeply interfused" . . . that "rolls through all things."

So you see he came in his life to be able to distinguish between spirit which moves and dwells, and the successive forms in which its moving and dwelling are manifest. Certain forms seem to take more than ordinary eyes to see them: for example, "the round ocean" and "the living air." These images are visual, but they require the inner eye as well as the outer. The outer eye will see no round ocean. The inner eye, which is the eye of perception, of insight, may get an inkling of why round. The interesting thing about this inner eye is that it functions not in the organ eye, but actually it functions

174

more out of the heart, a feeling for things, a feeling which is a way of knowing about things, a feel for a kind of inner or spiritual form. There is a warmth, a recognition of something revealed, insight seems to come from a kind of sun-eye which shines, as it were, from the center of our roundness. Except, of course, with sun-eyes, as with suns, the light is everywhere, at the periphery as well as at the center. The sun-eye-light shines through the tips of our fingers when we are making a pot or brushing paint on a canvas or weaving fibers together or making love — the sun-eye-light shines through our feet as we walk, or dance, or kick a football, or a potter's wheel, or work the pedals on a drum or piano or organ, or drive a car. The sun-eye-light is in our hands as we greet one another, in our eyes as we make room on the earth for one another, in our tongues as we greet the food we take into our mouths, in our ears, all over our skin, in our viscera and muscles and bones and hair follicles and genitals and blood vessels and cells and nuclei, and the whole thing is one big sun-eye sense-organ of insight, that sees and hears and tastes and touches and smells and creates things which are beyond the powers of the sense-organs to experience, but within the power of these supersensible organs. Sense-organs turn on when we pour our soul forces into them. The body as we ordinarily use it is full of experiences which its mineral components could never of themselves get into. The living body is a lot more than the physical residue left at death, the so-called corpse. When the life goes out of a body, the body is still there, but it doesn't work any more now that the inner being has left. It isn't even asleep. It's uninhabited. And it soon decays back into the earth in a way that a living body can't do. A living body can't decay because it is alive with forces which don't decay. The scientists sometimes call this non-dying aspect of the body "negative entropy." It really means that the energy is "holding back" — going in the opposite direction from decay. An older name for it is "ether body," which bears the life-formative-forces, as well as memory and habit, and which detaches from the physical body at death.

What I want to do here is to give you a picture of life and of human beings in their physical nature and their supersensible nature which will affirm how full of motion and spirit and unfolding forms our world is. How full of connections.

It is helpful, I think, to ponder upon the fact of these inner processes. For this way that life works is the way that art works. This is why we tend to call any undertaking an art when it seems to be drawing upon the fullness of inner feeling and upon careful regard for physical expression. To live and to work in the world mindful of the processes which are necessary to infuse matter with soul forces, to use techniques on behalf of living forms, is a great art.

That one's life is a continuum of an unfolding form, whose beginnings we do not

know and whose endings we do not know, makes it also like creating a work of art. We are working out of sources which are intuitive, our ideas come to us from somewhere, often right out the ends of our fingers rather than out of our thoughts, and we work with the process, sensing a form which is taking shape. We finally agree to call it finished, but who knows . . .

What I want to say to you is that life is best understood and practiced as an art, the way that art is understood and practiced. We rely on inspiration, feeling for materials, knowledge of how to put things together well, patience, physical strength and awareness that we are part of a process which we don't know much about yet but which we live within and are sustained by.

The verbal arts we practice, or visual arts, or graphic arts, or theater arts, or musical arts, or liberal arts, are *part* of something. They are not the whole story. And they are interconnected at the center with all the other parts.

Why all the fuss about art? What is art? Why do people sacrifice their time money family reputations life everything to stand for hours years in front of a piece of linen stretched on four boards with a brush full of paint, dipping the brush again and again into color, obsessed with getting something on the canvas? What? A bunch of paint. A picture of something. So what. Big deal. The Metropolitan Museum pays two million dollars for two hundred square feet of a picture of something.

Shouldn't we be out feeding the hungry instead of sitting at our easels or typewriters trying to bring a painting or poem through its birth into the world of consciousness? What are we bringing into the world with these smudges and stammerings?

Do other experiences have the same compelling power? Yes I think so. Total concentration, total focus, enjoyment, discovery, inner effort, creating something, feeling secure in the process yet not knowing or demanding to know how it will come out. Many of the things we do may have this quality. Take gardening, for example, or making lab experiments, or working out a new equation, or cooking supper, or having a child, or teaching a class, or running a college, or praying, or going for a walk, or getting married, or dying.

Here I am already making connections, seeing art as a fundamental component of life activity, a quality of our nature. When the artistic component is consciously affirmed and nurtured in the total spectrum of our lives, it tends to release both energy and light-heartedness, and at the same time seriousness and devotion to the materials at hand.

My studies and experiences have led me to a conception of man and universe, of

education, which is undivisive. The whole planet is a school. The center is everywhere.

One way to picture this is to think of the process of centering clay on a potter's wheel. Possibly some of you know that I have given a lot of thought to this experience of centering and its curiously compelling magic, and have indeed written a book about it. In it I speak of how centering the clay on the potter's wheel can be experienced as an expression of a very deep inner law, with deep implications. It is a law by which one comes into such a relation with the world and with oneself that one feels the whole in every part. The potter takes a ball of clay, puts it in the middle of the wheel head. He spins the wheel and the clay revolves. Before he can make a pot, he must bring the clay into a perfect equilibrium so that it will be an unwobbling pivot, and so that when touched at any one point, the whole body of the clay will take form. The wholeness of the form is involved wherever you touch it. The potter wets his hands and moves the spinning clay upwards into a cone, pressing it together and lifting it up, and downwards into a plane, stretching it and compressing it — moving it, up and down, in and out, until the whole ball of clay moves into center, that is, moves into equilibrium. Centering is the giving of a certain quality to the clay, so that centeredness is distributed throughout it in an even grain. No difference between inside and outside. The center is everywhere, the center being this quality of equilibrium and equalness of texture, of balance.

In the same way one may think of the whole planet as a body in equilibrium, in which the center is everywhere, the spirit of the earth, the spirit of the sun-eye, the spirit of the beloved is everywhere, the plastic body of our clay, ready to be formed into living vessels, when touched at any point by a hand which is firm and gentle and attuned. Or ready to collapse. The discipline of centering is the discipline of bringing all the clay into center, rather than of leaving it out. That is, there are no non-members in our planetary school. Nowhere that isn't campus and learning territory. The word "school" means "the leisure to learn." Its root means "a holding back": wait, there is something here to pay attention to, to be mindful of. Whenever we learn something we change, we are new. Mobility is intrinsic to life, fertility, pressing on. When it is mindless it is cancer, when it is mindful it is learning. Cancer is the mindless rage of cells to reproduce, oblivious of consequences to their environment — mindless growth, mindless creativity. Wait, be aware. This is the paradox, to risk *and* to take care. We walk a tightrope on the inner path.

This too is the paradox: wholeness is diversity. Every sphere has its opposite poles, is made up of differences, uniquenesses, in a tissue of relationships, interactions, interpenetrations.

One of the inner laws appears to be that as human beings develop individuality, working for wholeness in themselves, taking responsibility for themselves, befriending themselves, embracing the dark and light in themselves, they tend to become awakened as well to the invisible being in others. The impulse in human growth toward individual freedom and its opposite impulse toward relationship, are counterparts. Without freedom, union may be a mindless sleep or hysteria which is called "identification." Without union or relationship, there may be no freedom, only isolation and tyranny. The paradox is built in. Freedom and union are reciprocal. Wholeness and differentiation are reciprocal. It takes a long time for a cabbage to grow all its leaves and its big heart.

It is for this reason that conflict is a built-in resource of life. Conflict is the experience of differences. Conflict never goes away. It is like anxiety and hunger. And fear. It's not supposed to go away. It has its work to do. It tells us we are not the only creatures on earth, our wills are not the only wills, our ways are not the only ways. It helps us to hold back and learn something. It may tell us also that within ourselves we are conflicted. Part of us wants to be a member of the gang, part wants to be a loner. Part of us wants to build the blocks into a tower, part wants to knock it over. That's the name of the game, building up and falling away, relatedness and autonomy, at the same time, no winner no loser. Once we begin to regard conflict as a friend, as a resource, rather than as an enemy, we lose our fear of it. Wars are waged to get rid of conflicts and differences. They will never end until we learn to respect conflict, to love the enemy.

How do we do that? *There's* a research project for the next generation! Peace is an *art* of war. It is not a bland static condition in which everyone agrees to agree, it is a dynamic condition in which diversity and conflict are centered in the body of our growth.

Who is the enemy? We have two enemies: the one who wants to own us and enslave us and from whom we must gain our freedom, and the one who is separate from us and has no feeling for us. The enemy from whom we must separate and the enemy with whom we must join. We stand between two necessities, to be separate and to be connected. In Chinese, the ideogram for enemy is a picture of two friends side by side. The enemy is the friend. Oh thank God for the subtlety and ancient wisdom of the mysterious East. The enemy is the friend. It is he who makes our growth possible. It is he whom we must honor and work with toward a wholeness which contains us both. He is our negative space, to speak graphically. He completes the picture of ourselves.

Questions like these: how do we love the enemy, who is the enemy, what is art, what is school, what is leisure, these are paths. They lead not to answers but to gradu-

ally unfolding awareness, one step at a time. The question itself becomes the seedbed of an answering which is like a responding, the way a body answers to love by rising and opening.

I am reminded of a dream which my friend Tom Beers had recently. He told me about it. He said he was on a path in the dream, and a young lady kept urging him on, urging him to stay on it, because, she said, he would eventually come to the eggs, the path would lead to the eggs. He was puzzled, because he kept thinking that the eggs should have come first. No, that's not the way it works in the inner world. The path leads to the eggs. Ask the question and grow to the living seedbed.

The inner path seems to have this self-renewing, self-correcting, self-completing quality. What the psychologist Jung called "the creative purposeful." As we walk the path, we make careful observations and testings, mapping the territory, and this becomes our science. The science of any period is the map of its reality. It lies always between the last insight and the next. When the reality is one-sided as ours has recently been, closed off from the inner world, its science will naturally grow toward the new questions.

A science of the whole man is undivisive, and takes in all the evidence of man as a being of body, soul, and spirit, who not only has eyes and ears but is a see-er and a hearer, and whose experiences through the body bespeak another realm.

Art is the most physical of our sciences. It is the consequence of our passion to make our inner life visible and sense-perceptible, to embody it. We are continually making things, making things, what to do with them all — continually giving material expression to something, to an idea, to a feeling, to a nothing to a something, doing we know not what. Led by an inner compulsion as decisive, fully as decisive as the sexual urge or as hunger, fully as decisive as the commitment to any ideal. Sitting in front of a typewriter hour after hour, pecking away, gazing into the inner distance. Sitting in clay up to our eyebrows and beyond, up all night firing the kilns, flaked out with the heavy work of bronze casting, preoccupied with the inner score of song or poem, hocking the family silver to buy paint and canvas, doing without food to have the free time to compose or write — in order that something from that inner realm may find expression in substance that we can recognize with our ordinary senses. Even so the quality of what we have done rests uneasily in the material, for the flow of inner experience is mobile, filled with resonance, flowing color, thoughts that move like swimmers in the depths, a music of language which plays through the personal histories of words, hopscotch, and scampers and dances and radiates its light alive in a diamond

rainbow a far cry from that black type on that white page. So that when we look at what we have made or what others have made, we need to look *from the inside,* from where it has come, feeling what kinds of living inner impulses have formed it. It is like looking at a person. You see the physical image, you try to sense the invisible being, to hear *who* is speaking. Not coming in too fast with esthetic demands or psychological demands or assumptions, but delicately, as if in the presence of an unknown god, listening to hear not what is said but what is meant. Not coming in too fast with a reply or reaction, but listening, asking, awakening in oneself the sense of the other person and his source. Creating and experiencing art may have this kind of solemnity and sacredness and intimacy — not to make it too heavy a matter, but not too light either.

Again we walk a tightrope. For the urge to create may be mindlessly self-perpetuating, engulfing the personality. Part of us wants to drown, or to burn up in the sacred flame. There is a time of learning for the artist as well — a time of waiting, of holding back, coming into balance with the other parts of life, in consciousness.

Art then is a process of transmutation, awakening an inner realm within the countenance of matter.

This was the old alchemists' art in the middle ages: to awaken the gold that lay in the depths of dung and red earth. This was not worldly gold, as they so often explained, but a gold of the spirit, warm radiant and incorruptible. The elements transforming in the crucible were agencies of transformation in the men themselves. The goal was the sacred marriage of the elements, and the birth of a new being, the homunculus, the new man.

I feel very connected with the alchemical tradition, through the arts, particularly clay and the art of the fire and the transformations of person and of society. Theater is another connection out of this common center. For theater, like alchemy, is a virtual art: it does not have its end in itself, its true happening is upon an inward plane. This plane is made available to the imagination of the spectator through theatrical space poetry. Its ultimate purpose, like alchemy, is the creation of spiritual gold, the gold of the spiritsuneyeheartbody.

"Virtual" is a funny word, we don't use it very often. But I think it is important to stay with it a moment here. Let's see if we can get a feeling of its flavor. "Virtual" is connected with "virtue," but not in the way you would expect, unless you are an English major and have done some textual studies of Shakespeare! Both words, "virtue" and "virtual," originally mean having supernatural power or influence. The virtues are orig-

inally one of the celestial hierarchies. That is, one of the orders of spiritual Beings who have shared in the evolution of the world. "Virtue," the word, became secularized, even as consciousness became secularized, and now means a moral practice or action, whereas originally it meant the supersensible Being who behaved morally. Likewise, "virtual." Both words come from the root *vir*, man. Virile, manly. To be manly means to be connected with supernatural Beings. "Virtual" then means having the power to be felt without being physically present. It means "of the essence." When we experience through our imaginations, we are experiencing virtually. Hamlet does not die in physical fact upon the stage, but he does so in our imaginations. The imagination is a way of knowing.

Meditate on a seed, for example. Take a morning glory seed and instead of eating it, put it in the palm of your hand and picture what it really is. What is it essentially? Not what it looks like, a speck of dry tissue. In it lives a whole plant, roots, seedling leaves, vine, flowers — yards of vine, dozens of flowers, green pink white blue, fantastic. The living plant is virtually present in the seed. It takes a double eye to see this way.

When we say that life is an art, that life can only be understood if it is approached as an artistic process, we mean that, as in theater or alchemy, something is deeply interfused through its physical forms. And to understand the physical forms accurately, it is necessary to see them with a double eye. This way of seeing is a need in all disciplines. It is for this reason that I urge everyone to practice an art, and to regard whatever his work is as an art.

Popular knowledge about the surfaces of things, and skills in manipulating these surfaces, are insufficient to constitute an education for reality.

Likewise, when we live in the spirit of science, we live in a quality of inquiry, of wonder. We put one foot in front of the other, standing firmly balanced on the earth, finding our way on. Each step is both an answer and a question. We both know and don't know what we are doing. We are a mixture of light and darkness, an interplay of color, rainbows. We learn to sit loose in our positive space, knowing that the other part of the total picture is the opposite, the negative space is the opposite. I think therefore that we need to learn to hear the *yes* in the *no;* the *no* in the *yes.* To hear what is not said. To see what is not visible. To receive what is not given. Into the heart of the spiral we go, and at the center we make a complete turn and retrace steps, going in the opposite direction.

It's a long long way to Tipperary, but we have to walk that road if we want to get where we're going. We have to gradually learn to stand in an awareness that is both us and more than us, in which we are sustained by warmth even when we are cold with fear.

The sun shines on everybody. It makes no difference to Mister Sun whether we are good or bad, pink or blue, rich or poor, sick or well. The sun makes no demands. It offers itself in warmth to us all. If we lose our shirts, we will be warmed by the sun. Do you hear what I am trying to say? We fear to lose what we have gained and worked hard for and depend on for our security because we think that without it we will be nothing. We will have nothing but our fear and our loneliness and our nakedness and shame. And no one will like us or respect us. We think that affection and regard are based on achievement and responsibility and approval. This is the part of us that is dark, that is not yet awakened to the light and comfort and warmth of the sun. Oh ye of little faith. It is true, the sages tell us so, that there is this time of fear and woe and horror and nakedness and helplessness and emptiness, as one gives all that one has in order to enter into another quality of being, of substance, to awaken within the sun-eye-heart-body, to feel the presence of the invisible Beloved who never quits. If we try to get the power for ourselves, we will always be cold no matter how many coats we have, always hungry no matter how many feasts.

Now how come we have to learn this all over again? How come we don't just get things straight once and for all and live happily ever after? Well, let's change the question: How come if science is so smart, it has led us so far astray in our planetary health? If science is so hard-headed about facts, why doesn't it produce a few that are true for more than five minutes? The turn-over in truth in science is greater than the turn-over in fashions. Our world is mobile and dynamic, and in motion inside and out. Or take centering the clay on the potter's wheel. How come you can't just center it and press on without any fuss or problems? Like, there, that's done. Now we're in the clear. No, that's not the way it works, apparently. Over and over again, rhythmically, after every strain put on the clay, back into center we have to bring it, continually bringing it into center at different stages of the work, with different risks and different forms sought.

When something is born for the first time, it comes out of a creative darkness which is fertile and unconscious. So far as we know, for example, the arts and hand-crafts have come out of deep sources which have to do with religious ceremony, with the need to hunt and to eat and to drink and to gather, to dance and to sacrifice, to plant and store and make shelter for body, make nests, all part of a religious ritual — the gods are in the earth air water fire — the gods are in the animals plants stones, in the living and the dead.

The practical need was part of an essential need: to survive physically was to sur-

vive as a spiritual being related to one's own soul, to one's ancestors, and to the gods. All we know about prehistory attests to this.

The question of survival has been increasingly secularized, made a matter of physical survival only. In school we are rarely advised how to help ourselves to survive emotionally or spiritually; actually we may feel endangered by the brittleness and aridity of so-called knowledge and civilization.

And now everywhere there is a turning again to inner sources, a hunger for inner survival, for softness, looseness, fluidity, a hunger for personal respect and identity, for relatedness. Only this time we are consciously asking for it. It's not a given. Each person is free to ask his own question out of his own abyss and walk the path to his own sources of renewal. We do not suck at the breast of the great mother goddess any more. On the contrary, we have been cut off from the inner worlds for five hundred years, when we left the spiritual authority of medievalism and began to explore the planet, and to settle in a new land.

The spirit of America has come from all over the earth: settlers from all the countries, inspired by a spirit of frontier, of do-it-yourself, of independence, of hacking a conscious life out of the wilderness, far from being in religious harmony with wilderness as were the natives. Oh no, destroy the wilderness, destroy the Indians, make way for the rugged individual: black white brown yellow, Irish English Welsh German French Italian Slav Swedish Jewish Russian Chinese Mexican African Arab, some force bringing millions of souls across the great water, to take a new name, American.

"Leaving home" may mean turning away from fertile guidance — as in adolescence we turn against family to find our own way. We must do this, for our own ultimate health.

In order for modern man to find his way, to explore the physical universe, to develop the scientific intellect, to strengthen the individual ego in freedom, to come to a new free awareness, there had to be a darkening of contact with spiritual sources, a sacrifice, a twilight of the gods, until, as Nietzsche announced, God was dead.

The old gods were dead. The ones who did it all for us whether we wanted it or not.

When individuals develop who can choose for themselves, the new god rises in the inner realm, beaming through the tissues of our bodies and our minds. The Beloved. This is why the old authority game won't work any more. The sun-god is rising in the men of earth, centering, distributed throughout all peoples, everybody has some, so let's talk it over. The earth itself is beginning again to speak. And the wisdom of our early brothers, the Indians, is rising again.

This way of reading the story of mankind from the inside helps, I think, to create

a steadiness of mind: seeing our mighty journey, with a task to perform special to men on earth. Wisdom is already in nature. Divinity is well established. But human beings are an art in process; human love and human freedom, human community are the future arts of our inner schooling. We work against tremendous odds, handicapped beyond reason, vulnerable to influences which would turn us to stone or dissolve us in thin air.

Easy does it. Easy . . . easy . . .

So we look for the teachers who can help us; we pass around helpful hints. Trying to get on with it. Free to change direction, free to hew to the line, in harmony with something in us that feels juicy no matter what age we are, in touch with our growing tips, ready to stumble, ready to live, ready to forbear and to forgive. There's something in the air, we're on the track, we humans, always have been, and if we're true to ourselves we won't be talked out of it just because we haven't got there yet.

For such a journey we need a firm orientation. Feet on the ground. Spirit well rooted in stories of early man, legends, fairy tales, myths, stories of initiation. Each time we change direction, we slowly integrate the old and the new. We find our way on, using all our resources on behalf of each new question, each new art.

Folktales and creation myths in our human heritage help us to follow the inner law which says to change direction if you want to stay on course. Let me just remind you of this one, of the African Bushman, as it is told by Laurens van der Post in a selection called *Patterns of Renewal*.

The great Creator Spirit of the Bushman is the Praying Mantis. The Praying Mantis has a big family. His wife Kauru the rock rabbit. His adopted daughter Porcupine and her husband the rainbow. Their two sons, the gentle and the angry. Mongoose. Young Mantis. And the father of Porcupine, the great All-Devourer. The last of the stories of renewal is that of rebirth, of transformation through entering into one's early beginnings, and assimilating them into one's future in a new way.

Mantis gets sick. He can't swallow his meat. For the Bushman, sickness of the body was spiritual sickness. The food he could not swallow was zebra meat. The Bushman sees the zebra as the animal of flight and evasion. Mantis is saying, I can't swallow any more flight, any more evasion. He tells Porcupine to call her father the All-Devourer to come and eat a sheep with him. The sheep is the meat of acceptance.

Porcupine is horrified. The All-Devourer is her father and she knows what he is like. He will eat not only the sheep, but everything else. But Mantis insists. Porcupine then submits, and very sadly takes a little bit of her own food and hides it so that when the All-Devourer comes he shall not have access to it. She, the intuitive soul, hides this

little bit of nourishment for the future. Then she calls the All-Devourer to come.

He comes. The sky grows black. He sits down to eat with Mantis. Soon the sheep have gone, the shelters have gone, the utensils have gone, Kauru goes, the rainbow, the mongoose, Young Mantis, finally Mantis himself vanishes into All-Devourer's stomach. Porcupine is protected because she, the soul, is the daughter of the All-Devouring Source. She stands with her father and her sons. She weeps bitterly to see the world as she has known it vanish into the All-Devourer.

But, the story goes, she does not weep long. She has her own heroic intuition and her own future aspect in her two sons. She tests each one of them with a hot spear in the ear for gentleness and for fierceness. Then with the fierce man on the right of All-Devourer, and the gentle one on the left, they cut the belly of All-Devourer open.

Out comes the vanished world: Kauru the rock rabbit, Kwammanga-a the rainbow, Mantis, the mongoose, the sheep — all that have been devoured. Porcupine gives them some of the nourishment she has preserved. Then to show that they have been altered and renewed, the story says, "Porcupine led them far away from the scene to a new country." She led them, that is, to a new element of being which they could not have accomplished before this descent into the All-Devourer.

Each step is on the path.

I have tried in this talk to evoke a spirit of interdisciplinary interplay and undivisive imagination. Guided by an intuition of wholeness, we may work to bring our inner vision into earthly practice, into forms of living and working, like the good practical visionaries that we are. Artists, craftsmen, homemakers, teachers, farmers, acrobats, pilgrims, merchants, designers, historians, seers, students of nature.

It is helpful to know that life unfolds from the center like a good cabbage, that it never quits, that we are into something that lives even when it dies, pulled ahead by the rhythms of withering and ripening, full of dangers, an adventure that is real and solemn and on which a great deal besides our personal welfare depends.

I would like to end with a poem that wrote itself for this occasion:

> Sieberling, can you find me,
>     the old lute gone down,
>     the old apparatus in tatters,
>     doors undone,
>         sands in, time out?

185

Who's there, standing?
it's me o lord —
who, me? who else?
Sandusky, are you there? where?
Will you wilt now that it's ended?
the berries all canned, the hands down?
Done, undone, all done,
what's left, what's there under,
tickling and tickled, a catch
in the throat? in the net?
what's catching and who's caught?
I tell you, elm, I'm in your heartwood,
your blight. Old elm, I'll
always remember. Help me
to say it all begins
here
and branches out, singing.

# XII

In August, 1970, Molly Francis had come from England to celebrate her birthday on our farm. I drove her into the Catskills to visit her dear Quaker friends, Virginia and Bainbridge Davis. Virginia Davis later said it was "fate" since she had just gotten my book *Centering* and was thinking to propose at an autumn meeting of the executive committee that I be invited to speak at the Friends Conference on Religion and Psychology at Haverford College, June 4, 1971.

The theme was to be "Positive Dynamics of Evil." All winter I made notes in my journal. In February, at a planning session, the subject was slightly reset as "Wrestling with the Daimonic." It seemed an opportunity to share with Friends some of my wrestling. Quakerism and Jungian depth psychology made a congenial context.

The subject had been chosen by the Conference Planning Committee, and owed much to their interest in the chapter on the "Daimonic" in Rollo May's book *Love and Will*. It was announced as follows:

> Our concern this year will be to explore together the dimensions of the daimonic, the realm of inner impulse which is the source of creativity as well as destructiveness. We are too often afraid of the instinctual drives of sex, aggression, and lust for power, which if unchecked can take over and deform the personality, and thus we fail to recognize that they are the *source* of our creativity. Our cultural and especially our religious ideals have tended to instill in us a *static* ideal of goodness which strangles and impoverishes life and has left us with a fear of contending with the daimonic realm. We will therefore wrestle with the problem of redefining good and evil, to free ourselves of the stereotypes that bind us to apathy and blandness, that we may be in touch again with the creative source that allows us to live out our potentialities. We will explore the lives of artists, particularly William Blake, which help to bring alive the inner process whereby contact with the daimonic becomes a transforming experience. The relationship of the spiritual life to the daimonic will be our concern also. Resources will be drawn from primitive wisdom and myths as well as from contemporary depth psychology. As one of our speakers has said: "I live in the heart of paradox. What has nearly ruined me has blessed me."

This talk was subsequently printed — in a shortened form with several "Bouts" omitted — in the Friends' journal *Inward Light*, Vol. XXXIV, Nos. 79–80, Spring–Fall 1971. In this book it is published in full length, from the original typescript.

# Wrestling with the Daimonic

(dedicated to a drawing "The Devil as Horse," by Carlo Pietzner:

*spell-binding grace and haunted inwardness /*
*exquisite leap of pride into the ecstasies of matter /*
*silken and alert / a golden darkness /*
*self-suffering of the daimon, caught, arched,*
*unbroken-out / your dark fires may carry us*
*to light — MCR)*

My dear Friends, we are embarking upon a hazardous journey, wrestling with the Daimonic. I think we should acknowledge that people have come back from these encounters, limping. Think of the Old Testament story of Jacob, who wrestled all night with an unnamed Being. He would not let it go until it gave him its blessing — which it did — but he had been maimed in the process. Let us have a moment of silence together before we set out.

I would like what follows to have the flavor of a poetry reading rather than a lecture. These will not be poems in the usual literary sense, but rather poems of living and wrestling. I have enjoyed composing them, they have engaged me deeply. There are too many (this is the way with daimons: they tend to be mulish and unable to budge, or overly spirited and unable to be still). You may find yourself wrestling not only with your daimonic but with mine!

It doesn't feel right for me to talk abstractly about the daimonic. Others would be better prepared than I to give the theory of these dark encounters. I say "dark" not as a value, not as evil or foreboding, but as "not-light," that is, not conscious in an ordinary sense, though deeply conscious in an unordinary sense. I would rather share with you the wrestling itself. And so I call my presentation "Bouts with the Daimonic." I hope it will be a true witness to creative process and Person. If we want creative forces to play, we have to open doors and live at risk, consciously.

BOUT 1.

Scene one: I am rushing to the mailbox, surrendering to a sharp ir-
rational desire for the beloved. There will be no mail
for me, why am I hurrying and hoping and desiring? What
force carries me out to the road, while another voice says,
"There is nothing"? The desire is real, the hope is real,
the empty box is real.

Aroused by the cold spring wind, I burst out, singing:

It is cold

and life is cold

and life is cold

and life is cold

and life is cold

cold

COLD

COLDDDDDDD

I let my voice out of the song into a kind of gasp and
scream. I am not in anguish. I am wrestling. My voice
sounds full.

Scene two: I sing it again, and add a line:

I CAN FEEL THE ANGER BEGINNING TO RISE

Warmth. Concern for myself implicit. *Who* is cold?

*Who* is angry?

*Who* is singing about it, making a song, spontaneously, in the living mo-
ment? The voice is very connected with release of energy, release of feeling,
very connected with the daimonic, with sexuality and aggression and
power, physiologically I'm sure, as well as psychologically and spiritually.

It is the Wrestler singing.

A BEGINNING: I was born near Hell's Canyon,
in Idaho, near where the Snake River
digs the deepest chasm in America.
Maybe that's why I seem to have had such a
lifelong running contact with breakthroughs from the

189

> depths. (And it's from these depths, they say, that
> the starlights of heaven are most visible, even by day.)

Isn't it remarkable the help we get from coming to know what a word means! This *daimon, daimonic*, gets us into the heavens and the underground, both more-than-human, less-than-human realms. Divine, that's agreed. Little else seems clear. That figures, since we're in the land, not of brain, but of stars and chasms. Dark in any case, as outer space seems to be, starward. Some say daimons are earth spirits; others say angels.

But best is tracing of *daimon* to its root, which brings us into meanings of *destiny* and of *knowing*. The root image is *to stand*. Something about the daimonic stands within, unfolds as fate; something about knowing stands likewise within, perceiving things and beings, their posture, their stance, their gesture, from the inside. Knowing is not from the head, not smartness nor intellect. Too much evidence to make that a controversy. Knowing is direct perception . . . intuitive? Let's wait to decide all that; in any case it is direct sense of what something is, who someone is, which is never the rigid outside of appearances as the organ-eye sees, but finer, much finer knowing, what makes something tick, how things stand. The one who knows has special powers. Attracts special trust, special awe. Knowledge abused makes bad magic, bad medicine. Glorious to find the root of *daimon* in both destiny and epistemology, our lives' character and our ways of knowing.

Here is a poem of mine, wrestling with daimonic knowing. It is called "Dream: Pentecost." Pentecost, you will recall, is the occasion fifty days after Easter when the Holy Spirit appears to Christ's disciples in tongues of flame above their heads, and the men begin to speak in languages they did not formerly know.

### DREAM: PENTECOST

The dark red hollow of my mouth:
a room, a black tenebrous room, a hellish tryst, the dead
of night, infernal aura burning within the walls,
drapes sinks rugs tables chairs curtains,
and toward each other we step, my teacher and I,
into the center of this distance:

I am in a dark chamber with my teacher

190

who is short and Semitic and in tweeds and his hair is dark and curly
and close to his head, his nose is arched and in the grottoes of his eyes
flash golden fires, his face is all acurl with flame
and force and smiles, and life-lines folding into flesh,
and the ruddy dark look of his blackness and his gloom
and the fiery essence of his dark power and the wreaths
of his wrinkling features fathomless where they start,

I am in a dark chamber with my beloved teacher as never before.
He kisses me full upon my mouth
a full kiss that has no passion in it,
and in between my lips his absolute black tongue passes
like the deft head of a snake lifted by muscle
slipping and stealing dark and purposefully
between my lips.

             I was astounded. The dark
chamber, my teacher, my lips, the dark gliding
penetration of the tongue, the contact —
a picture and a sensation and a portent
I cannot be rid of.

What speech presses he into me?
What illumination gestates behind those walls?

The gliding mind and the womb of the throat,
the stealthy assured pressure, knowledge
enters the dark cave where self is rooted in the bite of the teeth,
is spread through the skull in branching aisles. The clean
unpsychological unpassional entrance of my teacher's
speech into my mouth portends. By Lucifer's light
knowledge finds its orifice,
the female organ awaits by destiny the tongue
that speaks in it.
All parables of love and genesis:
the word sounds
                down the forming scale
and spirit flutters up from the ground.

BOUT 2.

We have somehow to listen to IT speak, what is IT saying? Not to substitute feelings *about* it or thoughts *about* it or reactions *to* it for the real contact, THE FIRE THE ICE, surrender, *knowing by the feel of it.*

We can tune in sometimes, in meditation, in quiet, the stillness, the empty mind. What does sexuality say when left to speak for itself? I WANT YOU, I DON'T KNOW WHY, I AM UNCONSCIOUS, I WANT SOMEONE MORE THAN MYSELF, I WANT TO BE KNOWN? There is this way forward, to One Another. Sexuality, not obsessively genital, but distributed throughout the body of our clay: love-making, making love, creating love, as we speak to one another, look in one another's eyes, touch, say hello and good-bye, eat, walk, sleep, come together, part, making love as if it were something real that could be made, like a cake or a painting or a garden or a poem or a cup. I sometimes have this sensation acutely, that I have spent a day making love, offering myself to be known, making myself visible, drinking in the presence of my friend, finding him, knowing him. Or her. Or them.

What does aggression say? I'VE GOT TO MOVE, TO MOVE OUTWARD, I'VE GOT TO EXPERIENCE MYSELF MOVING AND POWERFUL, I'VE GOT TO WAKE UP OUT OF THIS SLEEP AND THIS IMPOTENCE, I'VE GOT TO BLOOM AND SHOW MYSELF AND GUN THIS MOTOR AND SEE WHAT IT CAN DO, I'VE GOT TO FEEL MYSELF DOING AS MUCH AS I CAN DO, FULL STEAM AHEAD, GET OUT OF MY WAY, I'M SOMEBODY! ?

Rage? I'M TIRED OF BEING COLD AND TURNING AWAY, TURNING IN ON MYSELF, COLD. I WANT TO FLARE OUT, BURST INTO FLAME, CONSUME WHAT RESTRAINS ME, I REFUSE TO TAKE ON ANOTHER'S FORM, I REFUSE TO BE PROGRAMMED, I REFUSE TO BANK MY FIRES! ?

Impulses which may in human beings generate love and will are inherent in these uncanny voices. They cannot do it alone. We cannot do it without them.

BOUT 3.

The path then may also be to *awaken* the daimonic, as resource, to hear its voice,

*to know it.*

Does an encounter with lust, hostility, anger have to be acted out in order for awakening to take place? I'm not sure about this. It seems to me there is enough acting out in our lives, through childhood and youth and the middle years, to draw on when we are ready to begin.

I myself work with these sources very often by means of living inner

pictures, "an acting out" in living inner experience, like an inner theater or stage. Theater, aye there's the rub: this word too bears a clue: same root as *theory, theoria,* a seeing into, a vision — for what can be seen "into" is not the object, but the idea, the *eidos,* the *form,* which, invisibly, is its reality, keeps it together, makes it what it is. True seeing is not by the physical organ-eye, but by the inner eye of imagination and insight. All the world's a stage, in that all the world's an inner vision, all the world takes place upon an inner stage as well as an outer one. The outer boards decay and are renewed; the inner spectacle is like a vasty seedbed for our daily doings, the scene.

An example from theater may be helpful here. Consumed in jealousy, Othello strangles Desdemona before our eyes, but not physically. The experience is enacted in another realm. Wrestling with the daimonic in the imagination permits us to work with the essential form of the unearthly fire. By suffering it through in imaginations, insight may come.

We make contact, feel the strength of the adversary, rest, digest, and feel ourselves different for the next encounter. And each night we dip back into sleep for refreshment and reworking. And in daily worldly practice we see how far we have come. Sitting loose, keeping it loose, not tiring ourselves out, not trying to win, keeping the contact, feeling the mutuality of our encounter. Again, holding before our awareness the meaning of the word "adversary," the one toward whom we may turn, the one who stands beside us, the one without whom we are not whole.

Inner development may help us to work for transforming contact in the inner realm, through meditation and inner dialogue, through prayer and worship.

Encounters with the daimonic are meaningful in terms of personal destiny, personal biography. They are not random thrusts from impersonal instincts. They are meaningfully connected with where we are in our lives, with our karma. Karma is the complex and subtle fabric of our inner forming, its causes and purposing. In my own life and study I have found that one does not go very far into one's deep wrestling with the daimonic without developing a sense of journey which is bound neither by birth nor death.

But wait — let me tell you what I dreamed recently, my dream will witness as my words may not. *I had heard that there would be a storm. I*

*was in a kind of little village near the sea, though not within sight of the water. I was worried, though no one else seemed to be. I went out to where I thought the sea was, by a house, but there was only a puddle. I had to go over a high dune to get a view of the waves. I walked up to the top, and to be sure the sky over the water was an ominous gray. More remarkably, a kind of black machine, with insect legs, was flying over the sea, dropping lightning bolts out of its belly. An amazing sight, the lightning zigzagging in bright jabs, like deformed sun's rays, high over the water, while the black box with its open underside flew steadily toward the land where I was standing. I went back to the village and told what I had seen. Again my agitation seemed disproportionate. Harmless lightning, far out to sea, nothing amiss, not hitting anything. Then suddenly the attack began. From somewhere (was it overhead?) came pointed assaults, not a random scattering of darts, but each one directed personally at some one particular individual in the group, not lightning but long tubes with heads ejecting in our midst, the head the face of a particular person, a person's head showing at the end of a gigantic long tube, like the arm or leg of an octopus, a penis, a snake, a cannon, a mouth, a windpipe, a gorge, a jack-in-the-box (jack-in-the-pulpit?). The many cables from the one omphalos, each one carrying a special relevance for some one of us?*

<div align="right">

(*pulpit*, Latin *pulpitum*, a scaffold, a stage)

</div>

BOUT 4.

How about making masks of daimonic forces: anger, lust, power, and wearing them, feeling the Being? Then how would I move to the next mask? What is the gradient? From anger to . . . what? More anger? Forgiveness? By means of what? What is the resource for change? Is it built in? The meristem? The child in man? When I was younger, people used to tell me I ought to grow up. I always replied that I hoped to, though I wasn't sure how it was to be done. How does one grow up?

*Who* is growing up in me? *Who* is wrestling? *Who* is dreaming my dreams?

What do we do when we don't know what to do, when we have no resources, are undone? Do we ask for help? sit still? press on? into the dark? take a bath?

Who is the person within me who is receiving the attack of lust or ambition or hostility, or *inspiration*? Yes, inspiration without human judgment is daimonic, potentially destructive, hazardous.

What is judgment, and where does it come from? Is it a sense of proportion? of measure? "How much and when?" Proportions in time? Rhythms? Growth and change *at the right time*? Meditation is "a measuring." Comes from an ancient Iranian root meaning "a grain measure!"

Remember the story of the Zen priest who asked his disciple ten questions, heard the answers, and told him to go away and come back in twenty years. In twenty years, the disciple returned. The master asked the same questions, he gave the same answers. "Excellent!" exclaimed the master. "You pass!"

Always remember the double nature of the daimonic: creative/destructive, depending . . . Doesn't always have to be "creative" in order to be creative, if you know what I mean.

BOUT 5.

What keeps one from falling into one extreme or another, losing oneself in daimonic possession, congealing at the wrong time, exploding at the wrong time? What is the inner gesture of balance? It is the center point, the fulcrum. The ridgepole. Something different from ordinary consciousness or unconsciousness. Jung speaks of the transcendent function, which mediates the relationship between unconscious and conscious. His wonderful lecture by that title, "The Transcendent Function," was published by the Student Association in Zurich, 1957. I recommend that you look at this if you don't already know it.

However, another kind of picture is personally more helpful to me. It is the picture of man, free in his inner spiritual activity to transform what Jung acknowledges to be "mechanical" procedures in the unconscious and conscious. Man working on himself, to free his initiative, to begin to free that inner fountain, which can create future actions free of past patterning.

Another great researcher and teacher of our epoch, Rudolf Steiner, carved out of wood a remarkable sculpture, which he called "Representative of Man." In this sculpture, the figure of man stands between two daimonic figures. His left arm is raised, his brow is noble, his mouth compassionate, his torso steady. Lucifer above, intense,

winged, and falling; Ahriman below, the gesture of his body the beautiful tensions of roots, claws, vines, gnarled earthly forms and earthly entanglements. They are, as it were, man's right and left hands, polarized forces. Man needs them both. But he stands, a pivot, a fulcrum, a Human Being, the weaver who holds the threads in his own hands. It is a mystery, to be contemplated in this great artistic work.

Let me conclude this BOUT with a poem written by Alfred Barnes, an American who has lived for many years in Dornach, Switzerland, where this great sculpture stands. The poem is called "Triune."

Two partners on the way, I have to take —
With them as partners, then, you see me whole
And fitted to the task and claim I make
To work the mines of Solomon and soul.

The partners are to me both day and night —
Between them, I could never singly choose,
As they augment each other, dark and light
And turning to the one, myself I lose.

They are like pillars, to the right and left,
On which an arch is raised and this am I,
A Key-stone, without which, these two were cleft
And separate, alone, I, too, must die.

My "I" is like a rainbow of one piece,
A meeting place, my claim on life, my lease.

## BEGINNING AGAIN

In early February, at Pendle Hill, there was a planning session for this Conference. I was asked to explain my approach to our topic, which at that time was phrased as "Positive Dynamics of Evil." First I passed around paper and colored crayons and asked each person to make, without thinking about it first, marks on the paper which would contain for him the feeling of evil. They were for ourselves, not for the group. I wanted two things: first, to help people get in touch with themselves and their own relation to the subject, intuitively, before they started listening to me. So that they would have a base in themselves, a fulcrum, a point of balance to help them weigh my words. Second, to touch with their *feeling* the inner gesture, the motion of the energy;

196

what kind of energy does evil have for you, faint? passive? aggressive? circular? dispersed? pressing hard? skittery? what kind of color — black? pink? violet? red? white? puke?

I didn't say all this then, not wanting to organize the approach too much. Some people made symbols, like dragons, conceptual rather than kinetic. And that was valuable for self-knowledge too. Finding out what we are starting from in ourselves, our assumptions, our spontaneous bias, what we *bring* to a topic, the shape of our inner ears. All this needs to be mapped eventually, slowly, gradually, frankly, unemotionally in the sense that we do not totally identify with our emotional reaction, though we may indeed gnash our teeth or ache with unshed tears or gasp with wonder. There needs to be that "place" free of thinking, free of emotion, free of purpose, that Creator Being in us who flows from source, in dialogue with the past, with patterning, affectionate toward bias but free of it, or growing free through conscious inner activity. The creation of this new form in ourselves, this new man, this bud at the end of the branch, this head at the tip of the phallus, this inner sculpture and genesis is deeply connected in my knowing it, with the Christ mystery, the Christ impulse. It has something to do with the mysteries of initiative and the higher Ego of Man, something to do with loving the adversary, something to do with incarnation and resurrection, a new kind of spirit-knowledge which connects spirit in Man with spirit in universe.

The mystery of the ego, the fulcrum, the ridgepole, the center, the free initiative, love and will, is connected with the Formative Acting of the Christ Being in the double realm of earth and spirit. He was born on earth. He descended into hell. He rose from the dead. He spent time in the desert. He was betrayed. He was crucified. He wrestled with the daimonic. He was tempted by spiritual power as well as by earthly. Should he be a magician? A worldly regent? Should he save himself? . . . My dear Friends Conference on Religion and Psychology, I sense such a deep and important truth here, I must give it this emphasis. So be it.

I want to tell you of one moment that this "knowing" befell me. As you know, I work in the arts, with clay and with poetry, am associated with theater and the movement arts, and go about the world claiming that life itself is the greatest art. The dialogue between my life of work and my personal life has been continuous and deeply engaging, often severe and hazardous. First I wanted to be a boy devoted to brightness and athleticism, then I wanted to be a woman loved by a man, then I wanted to be an artist outreaching my trained intellect, then I wanted to be a whole person, and What Was That? My work in the arts has reflected my explorations, and my relationship to form.

197

At first I was afraid of form, and felt that I couldn't make form unless the lines were clearly marked. Then I became experimental, though full of self-mistrust and secret envy of people who seemed to know what they were doing and had uncluttered walls and tidy houses. Then I began to affirm *all* forms as language, as communicative, attuned to the suchness of the merest breath upon glass. Ah, a marvel! Any stain, mark, or mood, pure enchantment: say Yes Yes to what we behold!

The unfolding of my question this year is: "What is form?" That has been my stance. Not held in consciousness, but somewhere as it were behind the brain, deeply gestating in all my blood and being. On Palm Sunday weekend I was at the Camphill Village for Mentally Handicapped Children at Beaver Run, near Pottstown. I had taken pots from my most recent firing to show my friends there. Dance/Pots and ritual pots inspired by the book *Black Elk Speaks*. On the wall of the room where my pots stood, there hung a new painting by my friend Carlo Pietzner, who has been director of the Camphill Movement in America. The painting is of St. Paul. It is called "Paul Waking," and it shows two faces. One is the manly face of Saul/Paul as he might have looked on his way to Damascus. To his left (our right) shines a face of raying light, eyes deep in the abyss. The left eye of Paul and the right eye of the Christ Being merge in the center. Paul's hand is raised, as if he were both shielding his gaze and looking into some new distance. A powerful painting for me, quite amazingly free of its pigments.

I sat together with these pots and the painting, in deep listening and moved by some unknown, unexpected force to "look" with Paul's awakened "double" eye. After hours of wrestling with roused negative feelings, and picking my inner way among pit-falls everywhere, struggling still to see the face of the being with whom I was wrestling, I cried out stormily, "I know that the answer to my question, What is Form? has something to do with that painting, with Paul Waking."*

The forming of ourselves to live and work in the world, whatever we do, has something in it that is called forth and clarified by this unfolding of Inner Form toward the Pivotal Figure of Man, the marriage of Heaven and Hell, the keystone in the arch, rainbow man, all the colors of the spectrum, destined to stand thus, to know thus, a double realm. A form within.

This last bout has taken quite a different direction than I expected or wanted. I

---

* It turns out that the actual title of this painting is "Peter Waking," and it depicts a similar, though different "waking" by Peter after a dimming of his consciousness during the events on Golgotha. Because Paul's experience bears such potency for one who like myself must be sometimes "taken by storm" across the abyss, "taken" into the new, I leave my mistake to make its contribution, with Carlo Pietzner's consent.

feel some anxiety when I talk about these things. I would rather avoid it. But instead someone in me decided to wrestle.

What I meant to do was to tell you the stories and jokes that I told the planning committee, after they had done their crayon exercise.

INTERRUPTION! *Last night a neighbor's barn burned down, all the cows trapped in their stanchions, burned alive, the farmer's shock . . . I can't stand it . . . It's too much.* I HAVE TO STAND IT. IT'S HERE. IT'S HAPPENED. I HAVE TO STAND IT.

*But it's not human, it's not fair, it makes no sense, those helpless beasts.* Exactly, it is not human. The daimonic is not human. Injustice is not human. The world is not human yet. That's why we have to wrestle. And recognize the daimonic forces at work in Life. WE HAVE TO STAND IT. WE HAVE TO STAND FIRM, AND WEEP, AND GNASH OUR TEETH, AND BEAR THE PARADOXES OF GOD. AND WORK TO FORM THE WORLD FROM WITHIN. THE CENTER ALSO EVOLVES. WHAT EACH ONE OF US DOES MOVES THE GREAT SEA, HELPS IN THE GREAT INNER ECOLOGY OF UNFOLDING WORLDS. WE HAVE TO DEVELOP RESOLUTE HEARTS, AND EYES THAT SEE THROUGH THE VEILS. THAT'S WHAT I THINK. A CLAIRVOYANCE SUITABLE TO THE "KNOWING" OF OUR MODERN AGE.

THE STORIES

These stories help me to live my life. I chew on them, like spiritual cud. They help to attune me to the Daimonic. I share them with you here. Briefly:

1    A Jewish rabbi was traveling by foot from one Polish town to another. It was a long way. Darkness fell and a storm blew up. The rabbi lost his way, struggled on knee-deep in mud, until, quite utterly exhausted and mired in the black impenetrable glue, he fell down, beard and all into the muck. Hopeless, helpless, he raised his eyes to heaven and cried out, "Praised be the Lord, the Devil is on earth and doing his work beautifully!"

2    There is a wonderful legend in Jewish Hasidism that in the beginning when God poured out his grace, man was not able to stand firm before the fullness, and the vessels broke and sparks fell out of them into all things. And shells formed around them. By our hallowing, we may help to free these sparks. They lie everywhere, in our tools, in our food, in our clothes. In ALL the deeds of earth.

199

3   This one is a joke, about the
    one-legged whore who charges *extra*.

4       This story comes from Laurens van der Post's book *The Seed and the Sower*. It
    is a scene near the end of the title story. The hero, handsome blond and gifted, is
    suffering guilt and woe because he has betrayed his dark handicapped brother. He
    stops in Palestine on his way to the war in Burma, and visits the place near Emmaus
    where Christ appeared to His disciples after the Resurrection. He has a vision of
    Christ appearing, and the disciples come toward Him. ". . . but," Christ says, "one of
    you is missing — Judas, where is Judas?" "Here I am, Lord," cries the hero in an-
    guish and horror, and he comes forward out of the shadows and falls at Christ's feet,
    covered with shame. Christ lifts him up and kisses him and says, "Beloved Judas, I
    could never have done it without you!"

5       In a time of personal ruin, I was lying in the bathtub, wrestling tearfully . . . in
    the midst of total inner disorder, wrestling with the Lord's injunction TO BE PERFECT
    EVEN AS YOUR FATHER IN HEAVEN IS PERFECT. I would never make it. Perfect? How
    was I to understand the word? Perfect and pure of heart? What means pure? Pure,
    pure . . . PURE APPLE JUICE! I began to sense a clue. PURE APPLE JUICE IS MADE
    FROM THE WHOLE APPLE, BRUISES, BLEMISHES, SKIN, CORE, THE WHOLE IMPERFECT
    WORKS. PURE APPLE JUICE IS NOT PASTEURIZED, REFINED, FILTERED, NONENTITY!
    BRUISES BLEMISHES WORMS AND ALL. TO BE PERFECT IS TO BE WHOLE, A PARADOX,
    EVEN AS OUR FATHER IN HEAVEN. BEHEMOTH AND LEVIATHAN, CHRIST AND SATAN.
    THANK YOU DEAR ANGEL, DEAR DAIMON, FOR SWEATING IT OUT WITH ME HERE.

Isn't this story connected with our Conference theme? our common concern over a
bland goodness that is estranged from vital connection with the creative-destructive
sources of our inner darkness, our unconscious life and will?

Our psyche feels unrest. It is hungry for life, for danger and magic, for creative
communications. We search for something that feels real; in our search we turn to sex,
to drugs, to war, to violence, searching for contact, for release.

In our compulsion to think of ourselves as good, we rationalize and justify all our
behavior; or we are self-accusing. Evil is unacceptable to us. Evil is "the unacceptable."
How do we come into dialogue or relationship of some kind with what we regard as un-
acceptable? This is the first step in wrestling: to stop calling things good or evil. Stop
judging. Stop saying war is bad, violence is bad, lust is bad, anger greed gluttony envy
are bad. Stop saying they are good. Stop identifying with them. Stop accusing and
justifying. Let be. Let some distance develop between oneself and these experiences.

Some emptiness. Then perhaps the next step will be to make the relationship human and personal. War in me, lust in me, anger in me. What do they want? What are they saying? Do I want to hear what they are saying? Can I bear anxiety, hunger, pain? Can I bear uncertainty, without an irritable reaching after fact and reason: a negative capability, as the English poet John Keats called it?

I would like to ask you now to do a short exercise in unacceptability. To put our hands into the sea. To begin to wrestle.

Please take this moment to make contact with yourself in some experience that seems unacceptable. Do something, think something, feel something, shout something, picture something shameful, nasty, evil.

Let's all close our eyes and do it.

Okay. That's done. The devil is in our midst, part of our meeting for worship.

BOUT 6 (from my Journal)

Note, in *New York Times*, March 21, 1971, from an article on African Christianity: "Africans do not view the problem of existence of evil in the same way as do westerners. There's no dualism, no concept of the devil as a force in opposition to God. . . . Even the evil spirits are ministers of the Supreme Being."

I have a strong self-negating daimon in me. Face it. Get the feel of it. Who is it? Who is sabotaging my positive acts? Let me see your face! Tell me your name!

. . . apologizing, dragging its feet, a strong negative counterpart to my positive prayers. It throws up roadblocks, broods, becomes discouraged, loses its nerve, is weakened by self-doubt. Aha, so this is part of it too: oh my negative self. You are abhorrent to me, unacceptable!

But so are my bright gifts abhorrent and unacceptable to it! A joyful impulse crumples in self-reproach.

Sometimes it has the face of a witch, who keeps going yakety yak, big mouth, saying how it all is, how it all should be, lecturing me and everybody else, she is both-

ering me right now, and I don't like her or her tone. Arrogant and presumptuous and intrusive is what I feel like calling her. "Stop telling me what to do!" Yak yak, ugly teeth, like a cartoon of the nagging wife. A black witch in touch with the spirits.

Invite her in. Sit with me at table, oh my horror, my despair. It's no sin to be a black witch. Invite her in. Ahhh, she begins to relax, to breathe, to ease off the strain in her face muscles, her mask peels away like dry onion skins, flakes off. We appear to be sitting in the kitchen of DT's and my old sixth-floor walk-up apartment in New York City. Sitting. I'm nice to her. She weeps angrily — coughs — curses — like in a convulsion — stamps her feet — a pool on the floor, tears? reflecting the sky? God help her! Kiss her and love her; like the hideous bride in Chaucer's *Wife of Bath's Tale*, she will transform.

There's a lot of my mother karma in this witch: sarcastic, critical, demanding; perceptive, warm, hilarious, doing for others. A lot of my father karma in the fear, sense of isolation, shyness; seriousness and good faith, passivity — doesn't like to quarrel with this witch — prefers to let her rule the day.

But that's not fair to *her!* She can't help herself. She needs *me* to help her now. I will talk with her, risk her tantrums, hold her, give her something to eat. We will try to get on together. I think this evil witch has possibilities. She needs a friend, that's for sure, whether *she* knows it or not.

. . . Then there's the white witch too, in her flowing robes and stars in her crown: harrassing me with visions and ideals. Always pressuring in some high-minded way, never satisfied. I salute you, oh goddess, but you are not me. You are not the way.

Are these like double shadows? one dark? one light?

Help me to sit at table with my fears of the dark side and my fears of the light. My negative soul is sorry for its black-heartedness and coldness. My light daimon is heartily sorry for its fervor and greediness for good.

Help me to be healed of one-sidedness. That's what the word *sin* means: to one side, missing the bull's eye, the center where dark and light are suffered through.

Perhaps when I am on friendlier terms with these daimons working in me, I will be better able to cope with them in others, hopefully.

OH BLESS THIS DAY OF THE NEGATIVE TRUTH
THE DEVIL IS ON EARTH AND DOING HIS WORK BEAUTIFULLY

I feel curiously relieved, as if a burden has been taken off my back . . . a big sack, a garbage Mr. Glad Bag, full of deformed critters, off my back, set on the ground, out

they come, cursing and stretching and drooling and capering. A lot of sass in that bunch. A lot to carry around all tied up. Let them out. They may change their ways in the open air and a more wholesome environment. Better keep my eye on them.

> *My yoke is easy and my burden light, Jesus said.*
> *Stretched in the four directions, the cross . . .*
> *embracing depths and heights. Its crossing*
> *point is His wounded heart, pressing on.*

P.S. There is help to be gained from the little creatures: mouse, worm, cricket, all the littlenesses of Life bringing their valentines of whiskers and slithering and whistling, to the worried realm.

The little daimons — elves, fairies, dwarfs, gnomes, trolls, and salamanders: they're part of it too, but be careful, their moods are changeable.

BOUT 7.

"If we can't love our failings, what shall we love?" (said to me by Charity James, in conversation).

BOUT 8.

An incident from a dark time in my own life, when I was in the daimonic waves, and determined to get the good of them; lonely to the core, Thanksgiving Day homeless and in crisis, out of my head with woe and desperation, sick, abandoned, awake. I walked like a crazy woman through the back roads of the country, babbling to the night and the stars, at wit's end singing to the future as if I were its court fool: "Come in, baby, come on in," I called. I had chosen to surrender, to go all the way, to the bottom of the lost demented night. And when I thought I would faint with tension and inner chill, suddenly there opened at the bottom of the long cold shaft a kind of dawning space and place, and *there were people!* O my dear Christ, I said to myself, here everybody is. Loneliness turns out to be the place where everybody is. The place of greeting. The great Grand Central Station and Central Park. The waiting room. The intersection. The abyss. The fountainhead. Everybody was there, all the people from the midnight cafeterias and cheap hotels where I had been wandering earlier, the bus terminal waiting rooms, the streets and kitchens. It was a moment of dreadful ecstasy,

it changed everything. . . . I could not any longer live as if I were alone, because I knew now that I was not. The common rooms are inside. I could not be intimidated by the contemporary jargon that describes reality in terms of ordinary physical appearance. I knew now in conscious inner experience what my intuition had hinted to me all along: that we are present to each other and connected in the deep realms of our being, and when we deny it, we crucify each other. . . . To love is to consent heart-feelingly to this interdependence, to make of ourselves apt vessels for its expression, to let this truth be lived through us, to stand out of the way.

## AN ENDING

We choose to wrestle with the daimonic because it will increase our self-knowledge, it will help our growth and creativity, and it will enrich our lives and capacity for "good." Our picture of life will change. Wholeness will become a suffering-through of both dark and light. And the meaning of "Judge not!" will become clearer. Truth will include not only the shadow, but the dark "unknowing" out of which consciousness and creativity come. The dark in both senses is source: dark as "the unacceptable" and dark as intuitive. Our sense of fact will enlarge to include all the facts of our destiny, dark and light. As our sense of fact expands, our epistemology will develop to include consciously the realms of "spirit knowing": imagination, inspiration, intuition. In tune with this, life is asking us to develop a language true to the facts. This means that we may sacrifice our one-sidedly intellectual language for a language more adequate to the resonances of the double realm. This is a subject in itself. I wish only to touch here upon some implications which arise when we acknowledge the daimonic as source. Most important is the concept of "the wrestler." An inner Man stands as an arch between the polarities of being, and transforms them, integrates them. He rides and guides the fires. "The Devil as Horse" may carry us, but the reins are in our hands.

It is very important that we grow toward being able to surrender to the dark, not to be overwhelmed, but to contain it, like a vessel, to give it the shape of our awareness and our warmth. The vessel is alive, a living vessel, a living form, a living intentionality (to use Rollo May's word), a living person/form, a living person/heart/form, a living person/heart/warmth/sense-revelation/da-sein/thought/divining/presence/form.

Daimonic beings change by being invited to circulate and breathe in dialogue with us. And we come closer to source through them. We seek to fill the earth spirits, Ahriman, *physis*, with consciousness and caring. The fallen angel Lucifer, addicted to ever expanding possibilities, we seek to rescue by filling consciousness with the Form of Man's Being.

Sufficient unto the day is the evil thereof. Wrestling relevant to the day. Not solutions for all time, but for this time. We must wrestle with the temptation to become absolute; we must learn to live in the mystery of time and unfolding.

Within the individual a moral source may wake. It is a birth in the depths. Powerful forces work against it. And so we wrestle.

And isn't it remarkable that we do so, continue to do so, by some flow of courage and love of life? This is how I find our human sweetness, our saltiness, neighborliness, pluck, and good cheer. They are all part of our depths of being, our divine source, our daimonic if you will.

A few scenes I cherish:    Christ eating fish with his buddies
              on the beach.
                   Christ drying his feet in Mary Magdalene's
              hair.
                   Christ having a favorite disciple,
              "the disciple whom Jesus loved."
                   Christ impatient with his mother and
              brothers when they disturbed him at his work.
                   Christ gentle with the exhausted disciples
              who were too tired to keep the watch in the
              garden before his arrest.

        The fallen
        The criminal
        The unfaithful
        The foolish
        The barren
        The blind, ill, demented, violent: *these* are the Christ
        in each of us. If we do not love them, we do not love Him.
        "I was a stranger," He said, "and ye knew me not." The
        stranger within, who is unacceptable; the unknown god.
        "I was the stranger, and ye knew me not." Must we not
        take this counsel seriously, and reach out our hand to
        the one whom we fear?

To see in the dark takes new spirit/eyes.

It is difficult work to contain reality, and not to falsify it. We need to be both vul-

nerable and unwobbling if we are to be open to contacts with the spirit world both dark and light. But when we can do this, each "receiving" and "offering" helps to befriend the realm. To be able to say Yes and No to it. And we ourselves are befriended.

I had a dream in which a tremendous fire was raging clear across the full width of the horizon. It was burning steadily toward the house where I lived. A woman neighbor and I packed our suitcases and ran away. One person remained behind, he did not run away. He was a friend, the director of a craft school where I sometimes teach in real life. This friend remained, and the fire swept through the landscape, through the house, through the pottery vessels, through the man. I could see the flames coursing through everything, but nothing was being consumed. After the fire had swept through, I returned and the director said, "Everything is still here. Only the color is deepened." And it was so. He was intact, and the pots were richer deeper more lustrous in their colors.

It seems right somehow to set ourselves in motion this June 1971 Conference of Friends

> with an inner picture of The Friend,
> who stands in the House of Self, and
> ripens through the flames. He is there
> for us even when the fire is too strong and
> we have to run away.

# XIII

This piece wrote itself "out of the blue" one morning in the early summer of 1971. I considered sending it to *Saturday Review* in response to the Illich article which helped to set it off, but my impulse was fragile and didn't survive. It is published here for the first time.

During this year I was preoccupied with my relationship to the Camphill Movement for the mentally handicapped, which has "villages" in this country. I had very nearly joined the movement in 1964, and its spirit has companioned me during the seven-year period which this book covers. Much of the work I did in 1971, in clay and poetry and thinking, took its life from my connection with the Beaver Run Village for Mentally Handicapped Children, where I went often to share the life and work, and where I set up a pottery studio. We share an interest in learning community, in handcrafts and artistic expression, a love of the earth and its seasons, biodynamic farming, a new consciousness and social impulse religiously based, an integrated society that includes not only the colors and races of man but the old and the handicapped in need of special care. Camphill is based on the work of Rudolf Steiner.

As early as 1963, in my review of Paul Goodman's *Community of Scholars* for *Liberation Magazine*, I mention Camphill Village for Mentally Handicapped Young Adults near Copake, New York, as

> the purest example I know of a "village" movement, where young adults and their teachers live together in deepest life-commitment to work, mutual service, artistic fulfillment and spiritual festival. . . . I do not mean that the hope of the world lies in mental illness. I mean that if we teachers are serious about serving an idea of community, we should realize that there may be handicaps even normal intelligent people have to overcome. Intellect itself may act as a handicap to humane endeavor. There may be a competitive and unyielding pride. There may be a static obsession with the right to think as one pleases, the right to illusion and prejudice. They must dissolve, must they not, in order that we may be free enough in ourselves to execute the purposes of others? Must we not examine our assumptions about the nature of man, and study best how to foster values of material simplicity and spiritual union?

The next year the same magazine printed another piece of mine, again responding to statements by Paul Goodman. It is about Community and Art as New Impulses in Education. It ends, "Out of community and art will grow our curriculum and our pedagogy. Within them will grow our way of knowing and perceiving. Handicaps and imbalances will be understood and acknowledged, and education will become an art of healing."

The theme of understanding and healing our mental handicaps recurs throughout this volume. I have felt for many years, through the experience of my professional and community life, that a concept of "mental handicap" could be fruitfully applied to those of us who are undiagnosed, if we could look at it with objectivity and imagination. There may well be some-

thing destined for me here: to find a way to live and work with the mutual resources of handicapped and normal individuals, and with our mutual needs in learning and living. It expresses my passionate concern for "total community" and for working with the artistic capacities of both handicapped and normal people.

The final lecture in this collection, for Michaelmas 1971, also owes much to the spirit of Camphill, where I have sometimes celebrated the autumn festival.

# Mental Handicap and Human Learning

Today I received the current announcement of a Growth Center. It says that they are hoping

> to provide Ph.D. students facilities and instruction while they work on the creation of the new profession of Humanologist, or one who aids people to attain their full human potential (true maturity). The new profession of Humanology would limit itself to working with "normal" persons, rather than pathology which has been the primary concern of Medicine and Clinical Psychology. Obviously, much research and experimentation will be required to establish the long overdue profession and we believe the awarding of the Ph.D. degree in the field will do much to establish the profession.

When I read this, I had a number of thoughts which I would like to offer here. At the same time I had been reading Ivan Illich's piece on "deschooling culture" in the *Saturday Review* of June 19, 1971, and a new edition of Rudolf Steiner's *Roots of Education*.

Obviously there is widespread concern now for getting the human being in his wholeness into the picture of man, society, and education. There is also concern for the health of the earth, the planet as a whole, to get *that* into the picture. There is an awakening perception not only that everything in life is connected, but that things are connected in particular specific ways, many of which are invisible and may not show themselves for a long time. For example, we know that the deadly effects of poisonous sprays and fertilizers are invisible, that actually things may look better for awhile, bigger fruit, cleaner gardens, and then one day the piper appears and asks to be paid: children die, animals die, lakes die, eggs don't hatch.

So here we are in a world that is growing into new perceptions: Ecology. Wholeness of Person. Invisible Reality. Mutuality of Earth and Man. Mutuality of Person and Person. And Time Organisms.

I have a Ph.D., but it's not in humanology. It's in English, from the University of California. I got my Ph.D. when I was twenty-five years old. I am now nearly fifty-five years old, and I have wrestled hard for a long time with the values of my education and with the questions it raised.

One question is about what a teacher is and what a student is. Or rather, *who* a teacher is and *who* a student is. Or rather, *who this teacher is* and *who this student is*. Not by definition, but by asking how one person thinks of another person, what does he include in his conception of that person. What does he base his picture of himself on?

Another question is about what intelligence is, and why is it if we are so intelligent and well-educated and *normal*, everything is such a mess? Not only "in the world," but in our personal lives. Brightness does not endow us with good judgment nor keep us from hurting ourselves and others. Being gifted does not help us to listen to what life is telling us. On the contrary, we tell it what it is and expect it to rally to our exhortations. Nor does cleverness keep us from duplicity and secret inner lives, which we deny in our public image.

Another question is about what institutions are, what forms are, how they come into being, how they develop a hardening process, how people get caught in them, what some of the problems are of continually working free. We live in forms, we "give to airy nothings a local habitation and a name," and yet we are always changing and growing in our human forms. We change in size, in appearance; we grow a first set of teeth and lose them, grow a second set and lose them too; we grow hair, and lose it or it changes color. Compare a baby picture with a death mask, and you'll be reminded of how we keep taking on one form and relinquishing it for the next, and how this is true for the forms of our feelings and our deeds as well as our bodies. At death the change of form is as drastic as it was from Unborn to Born — or from a flowering mustard plant bursting yellow and green into that little black flyspeck called a seed where the plant somehow *is* but who ever would think so if he went only by what his senses told him. The death of the plant creates the seed for the next cycle. It is something to think about, to meditate on, the simultaneous forces of growth outward and growth inward, which express themselves so differently to sense perception. In order to know what a seed really is, what it contains, one needs to behold it in the imagination. The imagination is a way of knowing about invisible reality, "supersensible" reality.

Well, I didn't get taught *that* in school. Actually I was taught just the opposite:

209

that there was something called knowledge which made it possible to pass tests and get jobs; and then there was something called imagining, which was a kind of luxury for children and artists, and which made up things that weren't true. It was confusing. For there I was taking my degree in literature, which was created by imagination and which I was supposed to know about. Was literature untrue? Was it hogwash, a luxury for children and artists? There were various opinions about this, but nothing sure.

The thing that helped me most to keep afloat in all this flotsam and jetsam that called itself University Knowledge was a phrase I came upon in an essay by T. S. Eliot, the American poet from St. Louis who became English. He said that the most important qualification for a critic of literature was "a sense of fact." Or was it for a poet? It doesn't matter, since I was both: and heard the statement with both ears.

A sense of fact! What a glorious commitment, what a devotion, what a spiritual discipline! Yes, I agreed, we must devote ourselves to honoring the facts.

One of the first facts that I was called upon by life and my "discipline" to recognize was that I and my bright associates were idiots in some extraordinary way — moral idiots, at least, unable to find our path into the good life which we had expected to be ours. Didn't the advertising say that a college education, especially a higher education, would lead to the good life? And here we were, falling upon each other with violence, resenting and betraying and fawning, filled with righteous despair.

(Later I was to come across Rudolf Steiner's book *Knowledge of the Higher Worlds and its Attainment* and read, ruefully, "When you undertake a single step forward in the knowledge of spiritual realities, take at the same time three steps forward in the development of your character toward the good.")

At first I blamed my teachers for having neglected to teach me a) anything useful about human relationships or how to handle human crisis, b) anything about how *I was part of* a real outer world and a real inner world, and c) inner resources for change. I was furiously angry with my education because I felt that it had betrayed my trust. It was supposed to prepare me for life. I had gone into it like a lamb and had been unprepared for the slaughter that followed. Somehow I had supposed that I would be immune from anguish and the death of hopes because of my advanced degree.

But what were the facts? I kept coming back to that question, willing to relinquish my personal grievance for my sterner obligation, as I saw it. The facts were that my teachers were mortal creatures like myself, sincere and reasonably hard-working, who had been hired to teach the Eighteenth Century or Chaucer or Shakespeare or Contemporary Poetry. There was silence on other matters, or at best a coquettishness. I began to see that I was demanding of them something they were not prepared to do,

certainly no one had done it for them. I was projecting on my teachers an image of "the teacher" who would lead me like the Good Shepherd to green pastures, still waters, and the restoration of my soul.

Many people are now demanding that schools and society "do it right," so we can all be in heaven, where we want to be, instead of on earth, where we are. They suggest that society should be free of problems, individuals free of anxiety, marriage free of conflict, all heads of government should be enlightened saints. There is this formidable zeal for making things good beautiful and true in our own image. It now seems to me not surprising, this touching combination of self-love and abstract thinking: the demand that oneself should be above reproach and that the world should be one's dream of the world.

What it leaves out is a sense of fact. A reality sense. Even if we go to encounter therapy every day, even if we are saints, there's a lot more to it than that. If you have read the lives of saints, you will know the facts of inner conflict, of suffering and disease and hard kinds of death. Being a saint seems to mean being willing to suffer through lovingly both the dark and the light sides of life, the cruel facts about oneself as well as the pleasing ones — lovingly to embrace them all, without favoritism, without bias toward a self-willed model.

I don't say these things from any superior stance. God knows I've been through the thick and the thin of it. But I want to bear witness here to an alternative we can struggle through to.

There is one fact that I want to emphasize because it is one of our biggest segregation biases. And that has to do with "normal" and "not normal" intelligence. As I said, I began to ask, at first with bitterness and self-reproach, why it was that I couldn't maintain a marriage or wisely administer a campus if I was so smart and creative. I began to be interested in "mental handicap," "emotional disturbance," "retardation," deafness, blindness, autism, cerebral palsy, mongolism, epilepsy, brain damage, and the rest.

That part of our humanity or "humanology" doesn't get into the "normal" picture of what wholeness is. I mean not only the dark facts of the psyche, the shadow figures whom the psychologist Jung has taught us so fruitfully about, but the mysterious connections of body-soul-spirit which are expressed in the "handicapped" — what one might call the "faulty incarnation." For the person is there, we learned that certainly from the remarkable example of Helen Keller, blind deaf and dumb, animal, unregenerate, who was awakened through her teacher's help to become visible as the great spirit she was, against the great odds of a crippled sensory system. Her sensory system

was a shambles. If one had gone by the testimony of ordinary measurement, the child would have been stashed away in an asylum for the hopeless. What a fact to have revealed: that in this almost total sensory blackout, "The Person" was intact.

During the past ten years I have been associated informally with the Camphill Movement for the Mentally Handicapped and its communities. This connection surfaced, so to speak, at a time when my questions about normal human beings and liberal intellectuals were particularly acute. Why, I kept asking, don't the humanities rub off on the humanists? I was searching for insight into the handicaps from which we intelligent people suffer. I had a strong intuition that there was a "teacher" here for me. A "teacher" is a kind of "spark" that leaps across when an experience coming toward one and an experience in oneself touch. Or when a fact of life speaks and is heard.

Recently I spent some weeks at the Camphill Village for Mentally Handicapped Children near Pottstown, living the life, living and working with the children and their friends and teachers.

What *struck* me was how "objective" the difficulties are with which the children have to wrestle. I saw myself, I saw human nature, acting itself out right there. "So that's what we are," I whispered to myself under my breath. Those children know it, their teachers know it — but *we* don't know it. God help us to get acquainted more fully with the wholeness of person, to develop a sense of fact for what that really is. Wholeness. It's not a basket of flowers. It may be that fulfillment is the coming into human relationship with our handicaps, living with them realistically, asking for the help we need, not giving ourselves a snow job about how since we're normal we must be okay and out of danger. I'll have something more to say about where that help can come from.

But let me tell you about Becky. In Becky, and in the other children, I perceived exaggerations of human characteristics, like messages writ large, like HUMAN TRUTHS for us to take in.

Becky is seven years old, and she is crazy with greed and impatience. If she were allowed, she would eat forty cookies for dessert. She cannot wait to be served at mealtime, but screams and tears her hair and bites and kicks and tries to snatch the food off the serving platters. When she first came to school, she was literally beside herself. Fat and unappeasable. Violent. I observed how her housemother gradually was teaching her how to wait, an instant, five seconds, a minute, for the gratification she was howling for. I saw her bite the hand that fed her, stamp brutally on her teacher's foot with hatred and misery. I saw how her teacher and her friends never abandoned her to herself, she could not do for herself, helped her gradually to find some tiny sliver of self-

mastery. I saw her first worried smiling, her first quiet listening as her teacher held her hand and told the day's fairy tale. What a lesson for me to behold, unflinchingly, since I too know well the dreadful possession of "appetite," the abrasive defeatism of impatience. Appetite and impatience are not personal, they are forces that work in us as "objectively" as cell division. It does no good to defend them or deplore them. They are facts, like weather. Meaningful facts that are connected with growth. They become personal by their part in the karma of each of us. Each has his appetite and his impatience to wrestle with. The "handicapped" tend to acknowledge how weak their powers of wrestling are, how they need their teacher/friend to companion them, to be there, always, supporting, guiding, feeding, responding humanly, teaching them how to do these things for themselves some day.

Abbie has two responses: one totally negative, one totally conformist. Fascinating. Abbie cannot bear to be spoken to directly. If a stranger calls her by name, she makes frantic gestures of pushing away, shields her face, says No No No. She cannot bear to be accused of being Abbie. With someone whom she trusts, however, her response is just the opposite. Her housemother says, "Abbie, pass the cabbage," and Abbie repeats in a kind of panic "Abbie, pass the cabbage." She totally identifies with the beloved other one. What a lesson: how we say No to the world, frantically, when it calls our name. Who, me? No, no — get away. I am not here. There is no one here. I am afraid to be that person who is separate from all other persons. I hate the world who wishes to be separate from me. I hate you all. No, no. I will do as my beloved does. I will say the same things, by rote. Mindlessly. Frantically. Now, let us all say together "Abbie, pass the cabbage." That's fine. Class dismissed.

(I am reminded of the cartoon of the lemmings rushing to their compulsive mass suicide. One has hopped on a rock and is saying, "I may be a lemming, but I'm not going.")

Andy, on the other hand, when he first came to school was so sensitive to the presence of others that he shrieked when anyone came close. He sat alone at the end of the table, not because he was withdrawn, but because he couldn't stand the nearness, he was too sensitive to it. He could only find himself in empty space, without others. He is much better now, a fine chap, though tending to be overly severe with himself. He usually says, before he has even completed a task, "I'm doing it wrong."

Why are we so sure we are doing it wrong? Or so sure we are doing it right? Why can't we bear the touch of others? It seems to me helpful to think of these as handicaps, not personal, but built in: to think of our greed for money, privilege, territory, power, as handicap as well as advantage.

213

David is a nine-year-old glossy-eyed child. He doesn't speak, though he sometimes makes sounds. A nimble body, fleet as a deer, if he ever gets "out." All his "mind" seems to be "feeling." No common sense. If he goes out by himself, he disappears in a wild abandon of spontaneous directionless movement away, into the woods, into the creek, who knows. Pure feeling. Pure spontaneity. Pure nuts. He gobbles his food in the same spirit. Pure abandonment. He has been gradually taught to make a gesture of asking for bread instead of greedily devouring the plateful before you can say "don't," mashing it into his mouth, crumbs in piles around his chair, crazy with gusto.

Robert is afflicted with body spasms which cause his limbs and his head to flail wildly. He seems about to fly apart in a dozen directions. His teacher holds him against her body, holds his arms quiet, holds his head still on his neck, or tries to, until in the next spasm an arm or leg gets free. I sat at table with them and was deeply moved to see how the two of them sat, enfolded together, the teacher firmly gently guiding the dizzy spoon into the wildly distorting mouth. She was holding him together. Talking to him gently firmly, trying to help him to overcome the force that was tearing him apart. His eyes were sweet and unshattered.

Isn't it interesting how these "normal" things like appetite and impatience, the ability to say No and to say Yes, the need for distance, the ability to give ourselves to feeling and to movement, can be wasters of our human substance and work against our welfare?

It is the presence of the teacher and the friend that makes the difference. The children learn to befriend each other, to acknowledge their illnesses unjudgingly, to be helpful, to be unsentimental. And we teachers and friends learn from the children to see ourselves more clearly, to be less emotional about our handicaps, and hopeful of learning to change them as we can.

It may well be that handicaps, vulnerability, weakness, illness, wounds, and short-comings are the very source of community. Living into the riddles of existence with gladness — a gladness that isn't different from awareness, which isn't different from pain, which isn't different from letting go and forming again in better balance from the inside the next bit of life-line.

Perception has its time-life, and if it is true to a sense of this fact, it learns to give up its claims when new perception is born. Institutions, whether they are marriage or a school, when they begin are lively and infused with a loving perception that is true and shared. In time the perception is at a different focus, another perspective. If the institution is to stay alive, it will relinquish the joys of one perspective for the joys of the next, which has evolved in its growth. It is not possible to be everything at once, we

have our seasons, and forms evolve. One foot in front of the other. Patience. Revelation. The Good Friday law of death to worldly power, if the enlightened body is to rise from the corpse-seed.

Ivan Illich, in his *Saturday Review* article "The Alternative to Schooling," says:

> A revolution against those forms of privilege and power, which are based on claims to professional knowledge, must start with a transformation of consciousness about the nature of learning. This means, above all, a shift of responsibility for teaching and learning. Knowledge can be defined as a commodity only as long as it is viewed as the result of institutional enterprise or as the fulfillment of institutional objectives. Only when a man recovers the sense of personal responsibility for what he learns and teaches can this spell be broken and the alienation of learning from living be overcome.
>
> The recovery of the power to learn or to teach means that the teacher who takes the risk of interfering in somebody else's private affairs also assumes responsibility for the results. Similarly, the student who exposes himself to the influence of a teacher must take responsibility for his own education.

These are interesting and forceful statements. They are a needed perspective on the consumerism which handicaps education. I would like to add another perspective, of insights and educational practice in our time.

The perspective I wish to call attention to here is "anthroposophy," rather than "humanology." Anthropos Sophia, rather than Human Logos. *Sophia* is the feminine aspect of the spirit; that is to say, it is that aspect which like a vessel in all individuals *receives* the light, knows that it receives the light, even when the light quickens in the vessel, and the vessel itself, alive, creates light and bears it forth out of the darkness into the world. Anthropos Sophia brings to our current research a perspective which would look at people and things and institutions *from the inside,* seeing substance as spiritual, forms as inwardly sourced (as from the invisible "content" of a seed), all forms together working in learning and teaching in mutuality, spirit in man a part of spirit in universe, an ecology of human spirit and cosmic spirit, earth and the stars. An anthroposophical conception of man acknowledges his polarities, his need to grow, his need to affirm each form as it comes, his need to cast off the old form so that the new one can emerge, like a bud, breaking the seal, always sealing over, always breaking out anew, in a continuity. Man *imagines* facts as well as perceiving them with his senses. Man has *insight* as well as organ eyes. We live in a double realm. Primitives, children, artists, and the secret lives of middle-class Americans attest to this. Anthroposophy is a science of man suitable to our time because it wishes to include all the facts, of nat-

ural science, of art, of religion. It sees that man is a threefold being of body, soul, and spirit — thinking, feeling, willing — a spiritual being whose life between birth and death is part of a reincarnating individuality. Connections do not end with death, nor begin with birth. The ecology is cosmic. And the forms are as specific as the invisible forms of "matter" photographed by special instruments. The development of perception can only occur when human capacities are sufficiently developed.

The word *anthroposophy* is not mine. I learned it from Rudolf Steiner, who applied it to express the study of man. Steiner has a prodigious ability to probe for facts in places where they were never looked for in my education. He knows full well that knowledge does not belong to people or their brains. Sources are available to everyone who develops in himself the organs of knowing. Everyone must test facts for himself. Nothing is prepackaged. This is a good kind of teacher, I think. Imagine what the effect might be if teachers learned that they are "spiritual beings" who have the ability to develop insight, that they will be teaching other individualities who likewise are spiritual beings who may develop insight, and that the tissue of responsibility (or karma) is woven mutually. Human learning is a living inner path, along which we move.

This kind of learner/teacher is different from the model found in the University, where you are paid for what you have already done, not what you are growing toward. Authorities are paid to reiterate. No wonder there is such despair among young college graduates and teachers. They long to be inwardly active, and yet find themselves everywhere programed.

The biggest step I have taken during my post-university learning is to realize that in Man are united the polarities of spirit and matter, and that to understand myself and others I must develop a sense of fact that reads both ways. The best term I know for this so far is Spiritual Science, a translation of Steiner's *Geisteswissenschaft*. That seems to indicate the direction human perception is moving. The words are clumsy. I hope we will find better ones.

University truth is losing ground because the ground of knowledge is changing. And university members are handicapped by attachment to intellect, money, status, materialistic knowledge, and role playing. Heart and soul and spirit are blowing their trumpets around the walls. The inner life is asking to be taken seriously as a fact, connected with the physical body of man and earth and stars, and connected with our capacity for knowledge.

Truth does not live at the surface, not yet. We are not transparent yet. Truth is occult. It lives in the depths, and materializes in a double realm, visible and invisible, like the seed. That's why we need an education that will help us to develop our powers

216

of knowledge of the double realm. And that's why our great teachers ask us to experience paradox, to experience the opposites, to awaken in ourselves a soul-filled awareness, and an imagination, inspiration, intuition which are paths of knowledge between man and universe.

Human consciousness takes leaps. When Copernicus discovered that the earth goes round the sun, rather than the sun round the earth, there was a tremendous suffering of change. For the new truth contradicts the old one. How can it be? The movement within the consciousness of man that he is not the universe, but is part of the universe, is like the movement in a child's consciousness when he learns to stand apart and see the world as separate from himself. First to be part of your mother, and then separate from her, are contradictory truths. They appear in a certain "ratio" in our time-organism if all goes well.

When Galileo discovered the mathematical principles of the heavens, there was a tremendous suffering as spiritual insights were sacrificed. When Newton discovered the principle of gravity, again there was the downward pull of man into matter.

Then when Einstein discovered relativity, again the insights changed. We are now suffering acutely as the organism of society in the depths tries to change against the resistance of obsolete habits of thinking. The facts of relativity are that truth is a function of relationships. Truth cannot be owned, for then it would be partial, and truth is inclusive, like a sphere. And like a sphere, in order to see it, you need to come from different directions, different perspectives. To know what something is, we have to take into account who or what is looking at it. The see-er is part of the seen. The inner world of Person is part of the facts. This means yielding a lot of ground, from a philosophy of information to a philosophy of living being. The new science has united with the facts of the poet and the priest.

More recent discoveries — the immaterial nature of matter, the connection between body chemistry and states of consciousness — these indicate a change of direction from the movement down into our bodies, gravity, measuring, individual property, knowledge as property, individual as owner — to the individual now in relationship, body not only as gravity but as levity, measure as not only material but musical and mystical, the measure of detachment and caring.

New insights contradict old ones. That way of stating the fact sounds harsh, and frightening. If we say that the new insight is a metamorphosis, in the way that a seed is a metamorphosis of the plant, our concept becomes an imaginative picture, and an inviting one. If we know that we are on a path of metamorphosis, we will not expect one way of thinking to last forever, nor want it to.

Truth does not move in programable steps. The spirit of truth is free, and outside the logic of our "causality" theory. There is this "outside," this "negative space," which cannot be figured into our methodical calculations. There will always be surprises. That's why, when truth changes direction, we have to be ready to do the same, as a bee does, to stay on course. Spirit in persons, likewise, is incalculable.

The new ground of knowledge is insight into an objective world which is both inner and outer: a spiritual world, a spiritual substance. Since this world is common to all men, all men can work it in their vocation. But we have only just begun to imagine what kind of education we will need for this new insight of our epoch. Surely it will need a science to discover how our physical life and our inner growth are connected. Rudolf Steiner says in *The Roots of Education:*

> Man must be *educated* because he has to be brought to his full humanity. And if you have the right idea of how we must lead man in body, soul and spirit, to become a true man, then you will see that this must be done according to the same laws by which an abnormal human being is brought back into the right path. To heal a man who has not a full humanity in himself, but whose humanity has been harmed, is a task similar to education. It is only when we again come to recognize the natural and spiritual relationship between these two activities that we shall be able to fructify our education in the right way by an ethical physiology.

I wish to suggest here that we consider deeply the questions: What is the knowledge of man suitable for our epoch? And how can we as individuals make it the basis of our teaching and our learning? How can we use ourselves and our insight on the behalf of a common question? It is like being in on the creation of a new world: as if we are all now potential pioneers, potential builders of the new community, potential researchers and celebrants, at the beginning of the new impulse. Life is exciting when you think how much each person can do to help in the common work, to know ourselves and to transform ourselves.

# XIV

This talk was given on September 16, 1971, in Farmington, Michigan, at the invitation of Robert Piepenberg, for the Michigan Potters' Guild and Oakland Community College, where Piepenberg teaches and where the talk took place. In it for the first time I made an extensive showing of new work in clay and talked around it, letting this dialogue give the form of my presentation. And, more explicitly than in "Nine Easter Letters," I integrated into the talk a feeling for the Michaelmas festival which comes in late September.

I drove to Detroit in order to bring nine cartons of work. Indeed this decision to witness to the importance of personal initiative in sharing our work and its meanings has informed the way I was to "lecture" during the following seasons. It fits with my taste for immediacy and "suchness": a relish for intrinsic worth, "that particular what." And for what Paulus Berensohn in his new book *Finding One's Way with Clay* calls an Aesthetic of Humanness. Some work may be self-evident: a mug, a bowl, a casserole, pitcher, platter, ceramic shoe or handbag, hanging planters, though these may have special secrets for their makers, to be shared. Other work, symbolic, sculptural, may offer a still more secret script. We are used, in the study of art and culture, to inquire into sources of imagery in order to attune ourselves and indeed in order to be able to "see" what is there. In Africa, a few bumps on a high rounded surface, like a spiritual Braille, may signify the presence of gods.

Last spring (1972), a Conference of Women in the Visual Arts met at the Corcoran Gallery in Washington, D.C. How much anguish was expressed by women who felt frustrated by a lack of gallery recognition! I suggested that they might imagine, if they wished, other options: that we let our homes and studios be galleries informally; or take our work in person, a piece at a time if need be, into neighboring homes and community places, libraries hospitals schools. How free we are to be imaginative and to invent ways of sharing! I see myself as a kind of peddler, carrying sacred wares around the country, offering work in dialogue with people. I often include poemprints in addition to clay forms in these presentations.

The talk as printed here has been taken mainly off a tape made on the evening it was given, and for that reason mingles improvisation with some written material I had prepared. I also showed slides of earlier work in clay.

# Work and Source

You may think when you look at the front of this room and see all the things I have brought with me that I have misunderstood the invitation and that I thought I was invited to come to give a show rather than to give a talk. I didn't misunderstand, but I felt very much the need to bring work this time and to let the work do part of the speaking.

I'd like to begin as a kind of warm-up with a few poems inspired by clay and potters.

The first one is the first poem I ever wrote about pottery, and I wrote it a long time ago when I first began to work seriously with clay at Black Mountain College with Karen Karnes and David Weinrib, in 1952. I was so astonished, so full of joy and amazement at the experience of clay and fire, of centering and forming and trimming the ware — and having been identified in my own thoughts up to that time pretty much with the verbal arts rather than the non-verbal arts, it was natural that my wonder would find its way into a poem. My heart was overflowing, and I saw the truths of pottery everywhere. I call it "Homage to the Weinribs, Potters"; and still, though it is full of innocence and beginnings, I like it; I'd like to begin the evening with it.

HOMAGE TO THE WEINRIBS, POTTERS: BLACK MOUNTAIN COLLEGE

Sun-up /
over the valley's lip a running glaze,
lake, crazed and curdled.

Sun-down / and
the dense rim fires
nut-black, bone-brown.

Stoneware is the night,
its granite foot, aside, the hills,
trimmed sills and shallows. O bene,
bene,
blessed be the jars that
burn with day, turn smack
center on the whirring dark.

This next poem I wrote for Karen Karnes, on her thirty-seventh birthday. Karen and I shared a pottery shop at Stony Point, New York, for ten years. I hope you are familiar with her beautiful thrown forms, and her large coil-built fireplaces and garden furniture. I like to make poems for special occasions, pots too. A couple of the images at the beginning come from the fact that at this time Karen was making a lot of bird-feeders and soup tureens.

FOR KAREN KARNES, ON HER 37TH BIRTHDAY

clay
has a way, of making seed streets for vagrant birds,
soup saddles to hold us thirsty riders,
clay corned to a bitter red
and straddled and thinned down to blue,
I say, clay
has a way of being plastic
and without residue, we sing
to the one who works it so.
We sing: soul, and shaper.

    This is a birthday.
    This is Karen, devoted to the plainspeaking of clay
and its parables.
    This is our pleasure,
        To listen to her vessels' cuneiform,
        To respond with a verse
        and to love the speaking dust.

This next one is called "Concerts of Space." It's a poem that I wrote in London four years ago when I'd been to visit Lucy Rie, whose work you may know — a great Viennese potter, who has worked in England for many years. She is a tiny woman with a very large electric kiln which she climbs into, and out of. And makes very thin cups and saucers and bowls and uses primarily a palette of black and white glazes though now there's a new book called I think *The Art of the Modern Potter* in which she's represented and it shows her reaching out toward some other colors. But her work is some of the first stoneware I ever saw in those early days when Warren McKenzie came to visit Black Mountain, where I was living and teaching English, and brought a pack-sack full of beautiful pots and one of them a cup and saucer by Lucy Rie. It moved me

221

very much: so thin and delicate, yet strong; glazed in a ripe white glaze, and dark manganese. And so when I was in London I made a pilgrimage to this potter whom I very much admired, and wanted to buy a cup and saucer from her. And she wouldn't sell it to me but she gave it to me.

<div align="center">

"CONCERTS OF SPACE"
For Lucy Rie

</div>

I was looking at a friend's bookshelf
      this morning
and I thought I saw a book with the title:
    "CONCERTS OF SPACE"
and my heart leapt!: "What a poetic title!" I exclaimed,
    (hearing music of the spheres and heavenly harmonies!)
And then my gaze lengthened, and the words read:
    "CONCEPTS" OF SPACE. Never mind, I said to myself,
              (and perhaps aloud),
I shall write a poem and call it "Concerts of Space,"
and it shall be for Lucy Rie
    and the cup and saucer she made, and gave to me on Sunday.

Your pots are decisions, Lucy Rie,
    decisions, forms, and emblems: *mots*.
No, no, they are pots of clay,
timbres of darkness and light,
suffered through, come safely through.
Your hands, Lucy Rie, conduct them through the fire:
          "concerts of space."

The last poem that I want to read in this beginning is not by myself, but by William Stafford, a poet from my part of the country where I grew up, the Pacific Northwest. William Stafford actually was born in Kansas but he has lived in Portland, Oregon (my home town), for many years and teaches at Lewis and Clark College there. This year he has the poetry chair at the Library of Congress. This poem that I want to read to you is, I think, an important poem for us all to know. It's called "A Ritual to Read to Each Other" [see page 137; it ends "the signals we give — yes or no, or maybe — / should be clear; the darkness arounds us is deep"].

<div align="center">

222

</div>

I'll try to make my signals clear tonight, but be sure they won't be any more than signals.

This is the first stop for me in a kind of autumn pilgrimage of work. I live on a farm in Northeastern Pennsylvania, where I keep house, make pots, grow nontoxic carrots, write, and go out from there to work with different kinds of groups in religion, psychology, education, mental retardation, organic gardening, the arts, social change, interdisciplinary workshops, handcrafts, trying to learn to practice what I preach: how to bring the spirit of wholeness into ourselves and into our deeds. This is the discipline of Centering: to feel the whole in every part. It's difficult. I'm a student on the path. I need your help.

My first response to the invitation from Bob Piepenberg to come was, as it usually is, to think of what I might possibly be able to offer. And I thought that what I would really like to do would be to bring the work of this past year, to show it, and to speak about it. It seems to me interesting, and a new kind of work for myself, significant, from different kinds of source than formerly. And so I proposed to speak on the theme of *Work and Source*.

It seems to me that you could say that in a way a lot of our work comes as a response to the nature of our materials: to the plasticity of the clay, the color, the texture, ways of forming, the dialogue between our hands and the wheel, working with slabs, with coils, pinching; our response to different kinds of fire: raku, reduction fire, oxidation, oil, gas, coke, wood, electricity; primitive fires: cow manure, peat, sawdust, what do you want. All of these things which are full of feeling and excitement and to which we respond. Also, we may start from a personal relationship, the wish to make something for someone, to celebrate an occasion, a ceremony, for a use, to put food in, flowers, birdseed. Or begin with a concept, a design, a fantasy, a myth, an image from a dream, or spontaneously trusting our unconscious. These suggest a range of creative starting points. In each of these we engage actively out of our own experience. There is characteristically an urgency and an excitement. The sense of oneself as maker is very alive.

This year for me in my work there has been another kind of source I have felt. I want to speak about that and also to show examples from earlier work. The inspiration does not come from material in the same way, nor from ways of working. Also this theme has something to do with this time of year for me, the autumn time of year.

I don't know how much you are into Michaelmas and into the festivals of the seasons of our planet. I wrote my doctoral dissertation on "Irony in Thomas Hardy" — Thomas Hardy was an English novelist and poet and dramatist of the nineteenth cen-

tury. I got a big dose of Michaelmas through the novels of Thomas Hardy, which are full of the folk culture of southern England, in Wessex. So it has been a familiar concept to me as the harvest festival at the end of September under as it were the archangelic guidance or blessing of Michael, who was, as you know, known for his prowess with the flaming sword and his victory over the dragon — earlier in the history of religion he was also known as "the countenance of Jehovah" and as "the face of the Christos." Rudolf Steiner's lectures on the rhythm of the year have taught me more.

I feel very connected with seasons. I experience the earth as a living organism with an inner life. And the great cosmic festivals of the solstices (Christmas and Midsummer's Eve) and the equinoxes (Easter and Michaelmas) are very meaningful to me, not only to me of course, but here I am just speaking for myself and since I don't know how many of you share this relationship, I have to tell you about it. Because I'll tell you what it is with Michaelmas: It is a time when everything changes color, the leaves change color, die, drop; all nature seems to be going into a dying phase. And yet at the same time there is this tremendous aspect of seed-sowing, the contraction of the whole nature of the plant into the seed-point, so there's this countereffect of a kind of generative impulse that's in the air. I have a poem "Levity" which celebrates this season — it's in *Centering*. I may read it at the end of this talk if there's time.

But in any case there is at this time this one thing going on in the materials of nature as it were, and another thing going on in man as a kind of renewal of energy, a kind of feeling that he doesn't have to go along with the destructive season of nature but actually feels a kind of momentum in his own self-consciousness, a kind of independence in his own inwardness and freedom in his own nature. In some way it's like a second Easter; where the springtime Easter has to do with the death and resurrection of the god, Michaelmas is like the death of nature and the resurrection of man, not identified with nature. So this is a very congenial counterpart to my theme of "Work and Source": the spring and summer pleasures, as it were, of our sources in the materials with which we work, the techniques, the ways of firing, the forms of use given by these factors: roundness/hollowness/watertightness and so forth. Then the Michaelmas source, as it were, not in the materials nor in the technique but in something else, some different source, some almost objective inward source, as Michael is objective in His Being.

I've brought pots to show you, of this year's work and its sources, and slides. And now that I'm here, I have, I confess, a fear that this may not be enough: my need to show you my work in a kind of Michaelmas Festival. I have a feeling that I should have

perhaps some larger truth to give you. But this is my truth tonight: to witness to the importance of our need for each other as persons in a common work — and, however humbly, to The Real Thing, and to truth of being. I want to try to show how what I say comes from the clay, that I have learned it there. I want, earnestly, to indicate how individual work, though intensely personal, is more than personal. Our forms are fed from common ground. Common concerns speak through them. I want, by example, to say that though we may be mothers of what we make, our works may be real and separate from us: revelations of themselves, not exhibitions of us. I want to point to an offering that is both personally true and objectively true. It is our offering as artists.

Where may we look for source? It is a mystery and a call and a circle that contains; it is a meditation and an abyss, an unfolding tongue; it is a voice and a warmth and a word, it is a heart-form, a crystal form, a face, how can I say where it is: it irradiates the physical facts of matter, it is sun source streaming from the future inviting growth and healing. It is the Beloved. It is the Wellspring.

Wilhelm Reich, the psychologist, said something marvelous about it, I think: "The source from where the sap of truth is streaming is common to all living beings, far beyond the animal man. This must be so because all truth is a function of living Life, and living Life is basically the same in everything that moves by way of pulsation. Therefore, the basic truth in all teachings of mankind are alike and amount to only one common thing: *To find your way to the thing you feel when you love dearly, or when you create, or when you build your home, or when you give birth to your children or when you look at the stars at night.*"

There is at this time of year a special truth for us. In autumn, the leaves turn color and die and drop from the trees, and all of nature appears to go to sleep. A face shines then from the winged seeds, the meteoric showers of iron in the skies, the rise of energy in man who, not identifying with nature, offers his freedom of spirit and his individuality to the cosmos — no longer drowned in the blissful sleep of foliage and fruit.

It is the face of Michael: the spirit whom we honor in the autumn festival of Michaelmas. Let me read you my poem for this year's festival: recently composed, on seeing the first turned tree, a maple, on the edge of the field where I live in Pennsylvania. It is dedicated to a painter with whom I wished particularly to share this unexpected and stirring encounter with Color as Living Cosmic Being, in a simple tree. I was deeply struck and moved as I saw revealed in the tree, its green leaves now splashed with the complementary red, the mighty moods of iron, which in our pottery kilns likewise give us the IRON GREEN or CELADON and the IRON RED.

225

(for my friend the painter)

*Michael*
This first turned tree, a maple,
stands absolute for iron:
green of spring, red of autumn,
marry in deep fathoms' fire.

I see its face in surfaces of leaves,
in roots, in earth that feeds them,
in water, air, and sun. The face:
Dear Michael of the Autumn Colors,
Dear serious face, dear sword of consciousness,
With your flaming lance dance us awake!

We rouse from summer sleep at the tomb's edge,
this second Easter: this fall,
from foliage into color, from color into spirit,
from spirit into Man.

Our wintry resurrection already is preparing,
in these flags of leaves, its Festival of Color,
inward turning. Invisible to sight, new hues
are visible, risen light!

Oh Michael, your mighty countenance
quickens us into withering,
quickens the seed forth,
marries tomb and fountain
in mysteries of earth.

Oh Michael, in your countenance we trace
our new heart,
our new face.

226

Iron is particularly interesting to us as potters, is it not? In our clay it gives warmth of body color, in our glazes it turns amazingly to iron green, iron red, iron blue, iron brown, tenmoku, celadon — combines with other metals, and in derivative forms like rutile, makes honey hues. Where would we be without our red iron oxide, for brush work, inlay, and signature? Iron in a certain sense might be called the potter's gold.

In the old days the alchemists said all metals were potentially gold. With their art of fire, they hastened the process of transforming base metals into gold, with the help of what they called the philosopher's stone. This process had its counterpart in transformations of the inner man, whom they called "the living stone." Fire in the stone was their picture of spirit in physical man. I have a poem which brings potters and alchemists together: Daniel Rhodes asked me to write it for his book on kiln-building, where it appears.

AN ART OF FIRE
perfects
        the mystery,
completes
        the life-line of
        our common clay.

Potters transform
        like alchemists of old
        crude earth into *le pierre qui vive*
        FIRE  IN  THE  STONE.

They shape their kilns to tongues of flame,
        its food and rule,
pacing the flow of fuel, the hold of heat,
the cooling,
alert to tame the elemental blaze
                        into life-vessel for
                        Aquarian Man.
Self-creation is an art of fire:
                        each person
                        forms
                        his spirit's housing
                        and
                        celestial cistern.

"To know iron, and equally all other substances, not merely in terms of material value; let us learn to know them in their majestic spirit power!" So urges Rudolf Steiner.

How may we think of the spirit of iron? It is the spirit of Michael's sword which slays the devouring dragon and releases a person into inner freedom from nature's compulsions. It is expressed in our freedom to think thoughts uncoerced by past patterning, by temperament or heredity or environment. It is our openness to the Wellspring in our thinking and in our feeling and our doing. It is our individual ability to transcend group or nation or fashion. It is the iron in our blood which masters death in nature, it is an ability to perceive each other as sacred unique invisible beings. Why do I say invisible? Because we change so much from infancy to old age, it hardly seems possible to identify ourselves as a visible image. And yet we experience ourselves in an inner continuum, a sense of being WHO WE ARE, through all the changes of our body and character. We may perceive each other with *insight*.

And we may perceive the work of our hands in the same way. With insight. What is present, more than the eye-catching color, the texture quickening the fingers' touch, the ring of the high-fired pot to the ears, and so forth. Remember the story about the old Chinese potter: A nobleman is riding through the town and he passes the potter at work. He admires the pots the man is making, their grace and a kind of rude strength in them. He dismounts from his horse and speaks with the potter. "How are you able to form these vessels so that they possess such convincing beauty?" "Oh," answers the potter, "you are looking at the mere outward shape. What I am forming lies within. I am interested only in what remains after the pot has been broken." It is not only the pots we are forming, but ourselves as well.

To feel the Being of the pot, like a ritual vessel, as it were in meditation, each humble thing of earth an object of our devotion. Isn't this what the new religious impulse of our time intuits? That we are relinked, re-ligioned (that's what the word *religion* means, to be relinked, bound together again, not with epoxy but with human concern) — relinked, re-ligioned, through our devotion to all the everyday acts, the humble humanity of each person, the mugs and saucers and napkin rings, *the power of the small* as the Chinese Book of Changes, the *I Ching*, calls it. And yet through the small, as through the tiny mustard seed, the true power speaks, and flowers, and bears fruit.

We don't need to go to Japan in order to revere the spiritual entity of the Tea Bowl. Let us revere the spiritual entities of our own tea bowls. Nor do we need to go to India to find the mandala of the circle and the four directions: we have it in the hoop

of the earth which the American Indians worshiped and the four directions of their dances and their wisdoms. (Actually they had seven directions, which is even more sacred: east west north south up down and the midmost point.) We have the resurrection of spirit wisdom in our soil. From all over the planet, the peoples of many nations come to bring wisdom and to learn wisdom. Let us be quiet enough to hear these first things of the earth wherever we are. The ground of our planet is continuous. Let us feel the whole earth Being in every part. Centering.

This past year I spent much of the winter absorbed in the book *Black Elk Speaks,* the lifestory of a Holy Man of the Oglala Sioux tribe, as recorded by John Neihardt.

In this most remarkable and moving book, Black Elk tells the vision which he had as a child and which was the spiritual source of all his life as a holy man and healer. He recalls it in these words:

> . . . Then I was standing on the highest mountain of them all, and round about beneath me was the whole hoop of the world. And while I stood there I saw more than I can tell and I understood more than I saw: for I was seeing in a sacred manner the shapes of all things in the spirit, and the shape of all shapes as they must live together like one being. And I saw that the sacred hoop of my people was one of many hoops that made one circle, wide as daylight and as starlight, and in the center grew one mighty flowering tree to shelter all the children of one mother and one father. And I saw that it was holy.

I won't summarize Black Elk's great vision here. I want only to mention that in it he visits the flaming rainbow teepee, where the Six Grandfathers of the world — the four directions plus sky and earth — welcome him and give him presents and counsel. He recalls it later in these words:

> Then suddenly, as I sat looking at the cloud, I saw my vision yonder once again — the teepee built of cloud and sewed with lightening, the flaming rainbow door and, underneath, the Six Grandfathers sitting, and all the horses thronging in their quarters; and also there was I myself upon my bay before the teepee. I looked about me and could see that what we then were doing was like a shadow cast upon the earth from yonder vision in the heavens, so bright it was and clear. I knew the real was yonder and the darkened dream of it was here.

> I have made these Six Grandfathers and brought them for you to see.

> Black Elk did not tell anyone about his vision until he was seventeen years old.

Then he told a medicine man, friend of his, because he was becoming ill with fear, having carried the vision for so long in himself without using it. The medicine man said he would need to perform the vision for the people. He would have to make dances and ceremonies for the tribe to participate in. "A man who has a vision is not able to use the power of it until after he has performed the vision on earth for the people to see" — this is what Black Elk tells us.

One of the dances of the vision which the people did was called the Ceremony of the Elk, and in this dance there were four virgins who represented the life of the nation's hoop, which has four quarters. "The four virgins," Black Elk said, "wore scarlet dresses, and each had a single eagle feather in her braided hair; for out of the woman, the people grows, . . . The faces of the virgins were painted yellow, the color of the south, the source of life. One had a daybreak star in red upon her forehead. One had a crescent moon in blue, for the power of the woman grows with the moon and comes and goes with it. One had the sun upon her forehead; and around the mouth and eyebrows of the fourth a big blue circle was painted to mean the nation's hoop."

I have made the Four Virgins and I have brought those too.

Actually the first Being I made was a medicine man I call Hump. (He is with the Pietzner family in Pennsylvania at the present time.) But no, that isn't quite true either. I believe this rhythm of work began in August of last year. I had made an important personal decision and the work seemed to be connected with that. I had returned from a year as artist-in-residence at a university. It was a difficult year. I had tried to offer Person rather than Product as creative starting point. I didn't get very far. The materialistic bias of the institution was unyielding. But as they say, it was a very good year for growth! And by the time that I got home, I had made an important decision for myself. I realized that I mean to serve Living Being and Connectedness wherever I am. This is what I mean by the religious life: to connect with spirit in man and in universe, wherever I am, and to start from that source to engender forms of living and working and learning; to learn to sense the spirit and its modeling however it goes.

I found myself handling the clay in a new way: modeling from underneath or behind the slab or plane or surface, rather than applying clay to the face of it. It felt like the way the breath works, from the inside, swelling out the forms of torso and limbs. The one piece I have brought from that time is this one: I call it St. Michael-Shiva; it appears to be the figure of a Being in an aura of fire, or perhaps it is an aureole of wings!

When I made the Grandfathers, I threw the vessels on the potter's wheel, and then

modeled the faces, the braids, the symbolic gifts *from the inside*. This has the wonderful effect of making the inside-outside dissolve into a kind of transparency. The clay is like a membrane through which Beings are perceptible to our senses. Each Grandfather has his proper color on the inside. Each clay body is slightly different. Each has his symbolic gift. North, white, with the peace pipe. South, yellow, with the flowering branch. East, red, with the four-petaled herb of healing. West, thunder black, with the sacred cup for catching rain water. Sky, blue, with sun-spiral and flowering tree of life. Earth, brown, with the nation's hoop.

In the same kiln that I fired the Grandfathers and the Virgins, I fired copper-red wine cups and bowls, pinched tea bowls, and an Easter ritual piece: an open grave, a corpse, an angel sitting on the rim. It was a lot of work from many sources: clay-wise, color-wise, glaze-wise, dream-wise, worship-wise, personal-love-wise, use-wise.

Another piece of work of last year which is part of the mysterious working from Source came between the St. Michael-Shiva plaque and the Grandfathers. It is a piece which might be called Emerging Form. It is made up of seven individual parts. They are all hand-modeled or pinched. And fired in a wood-burning kiln, without glaze, only the deepening of color given by the atmosphere and a slight fall of ash from the hard wood I use. The form begins with a piece I call Root/Shoot, indicating the heaviness of the dense globe of root in the earth and the opening above ground of the shoot into what becomes ultimately the flower open to the sun and the planes of the leaves, a totally different harmonic from the gesture of the root. These gestures of the inwardly dense with the center inside itself, and the inwardly open with the center at the periphery, metamorphose through these pinched forms. You can see in Root/Shoot a figure-eight shape, a geometric figure of the lemniscate, the Moebus strip, gathering in here at a crossing point between the downward thrusting root and the opening throat. In the four parts that follow, you can see a gradual absorption of the root energies into open cup. In the fourth piece, the middle piece, you see a beginning asymmetry, a thickening of the tissue here, a thinning out there, as you can see, for example, in the spring, if you watch a skunk cabbage unfold: the wall of the pot thickens and infolds here in the place where the new leaves will come out of. In the last two movements, as it were, the open vessel begins to differentiate forms on the inside, until they come finally to something that suggests to me the human inner ear. These two last pieces are pinched so that both the inside and the outside have differentiated contours, like a continuously modeled and contoured plane. Not pots with bottoms to sit on. But beings who are alive with secrets all the way round. The last one shows an intensification of form: a vessel, indeed, a receiving form, like a pot, but differentiated on the inside, and

231

suggesting a listening chamber, with the tensions of cartilage or bony structure within the vessel like the parts of a lyre or a harp: the resonance of the bones and their marrow, the living membrane stretched between them, this central opening or core, an inner ear. As the plant calyx receives the light of the sun, the inner ear receives the light of consciousness. It is an organ of equilibrium, of balance, of an inner voice, an inward listening. There is something of Michaelmas here too, in the transformations from the nature being of root/shoot to the mysteries of the human inner ear.

Emerging Form was not a planned piece. It came out of my meditations on the metamorphosis of forms, especially plant forms — and my interest in the kind of leap which nature makes as between, say, a cabbage and us. I worked on several of the pieces simultaneously, over a period of days, and it was only after I had finished that I began to see what I had done. I felt that I had been spoken to, or through. How much there is for us to share with one another about what we hear through our hands.

Other series of pots came out of this winter's work. These are "Dance Pots" and two "Drawings."

The Dance Pots came partly out of my preoccupation with the Indian material, and began with two pots, one called The Dance of the Four Directions and one called Thunder Dance. The Dance of the Four Directions I no longer have. Thunder Dance is this one: a dark thunder glaze on the inside, five markings with lighter glaze in the corners and the center, made with a head of wheat.

I don't know whether these pieces will convey themselves to you. They were very interesting to do. I threw them, and then when they were right there fresh tender and wet, I danced with my hands in them on them around them, improvised — and sometimes it worked more to my satisfaction, sometimes less. Partly the impulse came from the Indian spirit, partly from the fact that a friend of mine, Carolyn Bilderback, was going to give a dance concert, a woman who is interested in clay and its relation to dance. I was thinking about her, and I was thinking about one dance that she does which I like very much, which is called "Leda." It is a dance which she does costumed only in a simple white slip. You know Leda and the swan . . . Zeus comes in the form of a swan and makes love to Leda . . . it's a beautiful quivering simple lyrical gorgeous dance, moves me very much. And I made this piece, and dressed it in a white slip, and made it for her for a present, and of course it was the only one of the dances that cracked in the firing!

The glazing of these Dances was a special question, like that of costuming the body in a dance. I didn't want them to turn into just some more glazed pots, funny-looking bowls with dents in them. I wanted them to be Dances, body in movement. So

I decided that for most of them they would be glazed only on the inside, leaving the body naked. This is Leda. It is one of four dances costumed in white, which go together. This one is called Racetrack. This one is called Lapwing. This one is called Pregnancy. Pregnancy Dance also has a real source in life: when I was at Black Mountain College there was a young woman student there named Wilma Fuerstenburg, who was a dancer and about to have a baby. And in the eighth-and-three-quarters month, she gave a dance program in honor of the approaching event. She was so moved with the solemnity and joyfulness of her pregnancy that she made a concert of dances in its spirit. She dressed herself in a long blue velvet soft gown, and all the dances were very slow, with special kinds of movements required by the weight of her body and its balance. It was an occasion of grace. I shall never forget it.

This dance, Waltz, is glazed inside and out with this deep copper mauve: a kind of heart shape. And this beautiful object, with a sunburst of color inside (I didn't do that, the fire did!), is called Square Dance.

This small rounded piece is called Baseball. I showed it to a friend, who liked it and its blue insides and ruffled edge, but when she heard its name, she said, "Oh how can you call it Baseball, it spoils the whole thing." She didn't understand about Baseball. You can't spoil Baseball — it's an ancient truth! Ballgames are part of the mysteries; people don't understand that ballgames are very archaic ritual dances. Don't fool around with baseball! So for her benefit I've changed the title to . . . "Spring Training"!

This one — this is a funny strange one — this one is called *Wholiness*. On it the glaze, the costume, did another kind of thing, and I like it, I don't know whether you will, but it seems to have its own kind of power, it doesn't seem decorative to me, it seems strong, like if you have ever seen Martha Graham's work in dance theater, the costuming sometimes is strong, not decorative, it's an element in the drama. That's what I want to suggest about the way the glaze on this piece appears in images over the edge — and when I speak about source of a different kind, it was not any pleasure in the glazing or any feeling of aesthetic quality or beauty, but rather a kind of an objective ingredient which I experienced differently. It was interesting to me, and I hope it is to you.

The last dance is the most difficult to accept — and therefore to me the most interesting. It is called Acrobat in the Labyrinth. Can you see the spiral curving up and around on the inside? The pot is a kind of spiraling sack, teetering firmly on its foot. It has rags of glaze color, that copper mauve, flying and swirling from its shoulders and sides. I spun the bisqued pot round on the wheel and poured glaze in a spiral, lip to

233

foot, to fetch a proper feel to the glaze, so that the dance would have a kind of whirl-ing quality to its costume. I wanted something like an acrobat, like some flying gauze, or gods — like the acrobats flying off the horns of the sacred bulls at Minos on ancient Crete. These bits of floating "silk" stuck to the turning form, and now they spin in turn. This strange misshapen pot has a beautiful ring, it seems close to a human poétry. Could we see ourselves as Acrobats in a Labyrinth?

The two "Black and White Drawings" are interesting too, I think. Each consists of three pots, like a sort of triptych. And though I think of each trio as a single piece, each pot, like each panel of a triptych, has its own character. I call them Drawings not be-cause they have drawings on them, but because I look at them and ask that they be looked at as if they were Drawings. Now you know how it is when you usually look at pots, you look at them with a sense of volume, a sense of grain and texture, color, sil-houette; you ordinarily look at a pot quite differently from the way you look at a draw-ing, I think you'll agree. With a drawing there is a greater activity of the eye in follow-ing lines and the negative spaces and the dark and light and the shadows. Drawings take an especially thorough kind of looking, a detailed kind of looking, and that's what I wanted for these.

This one is called Flower: the calyx, the body, the root. This one is called Black and White Line Drawing. Here is the "line." These express lines not only in the literal way. Feel how your eyes also create a visual line, coming to the rim, and then outlining this negative space, and up and around, and then this negative space and around. When you are in different positions with regard to these Pot/Drawings, you see not only the lines, as it were, of the throwing marks, but you may look at the whole surface noting their susceptibility to shifts in light and shadow and linear values, cross-hatch-ing. I've never worked in this way before, integrating the values of drawing and pots, of dance and pots, of meditation and pots. Also it is the first time I have created works in groups like this, families of pots, trios, ensembles. Oh yes, one does it with sets of table ware, in a sense. But that seems to be more a matter of quantity. This work feels to me more like music, one piece with several movements. Or a poem, one piece with several words. Or a community: one life with many beings.

What is it about art that works for us as source in these mysterious and yet quite tangible and concrete ways? Is it intuition in touch with Being at a level ordinary con-sciousness can be awakened to?

All the deeds of life are creative, and bear within them the inner lifelight, poten-tially. Artists need to see in this way. Lifting things and beings of the world into life-light, or offering ourselves to them so that they may catch light from our inner flame, is

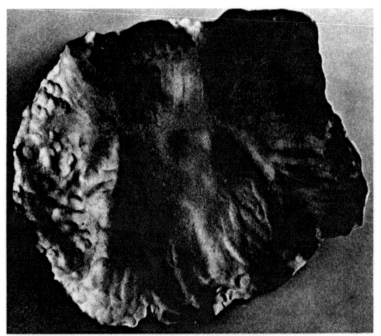

"St. Michael — Shiva." Pinched stoneware plaque.

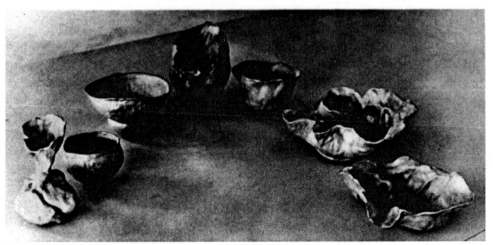

"Emerging Form." Pinched stoneware 7-part piece.

235

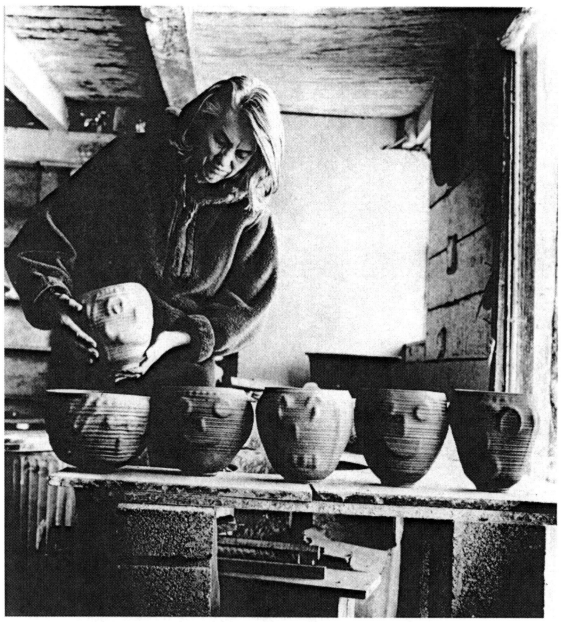

Author in her studio with "Six Grandfathers of the Flaming Rainbow Tepee," from Black Elk's vision.

236

 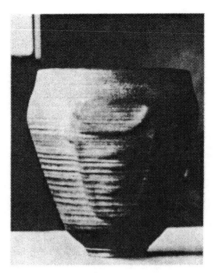 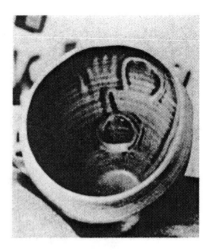

"Grandfather from the West," front view, back view, inside view.

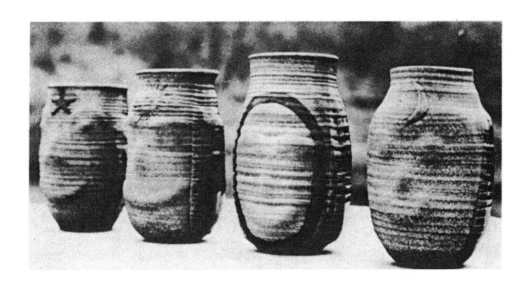

"Four Virgins of the Elk Dance," thrown stoneware.

237

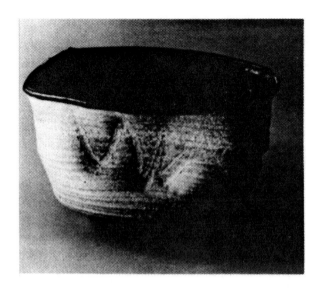
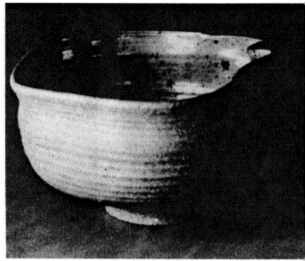
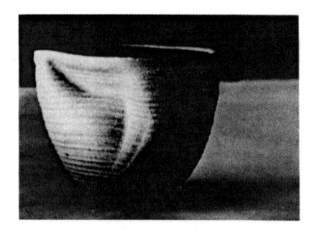
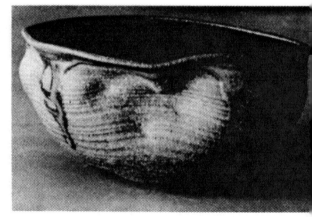

Dance Pots, thrown stoneware, hand-modeled, reduction fired in gas kiln: "Thunder Dance" (top left); "Leda" (top right); "Square Dance" (bottom left); "Wholiness" (bottom right).

238

Dance Pot, "Acrobat in the Labyrinth."

239

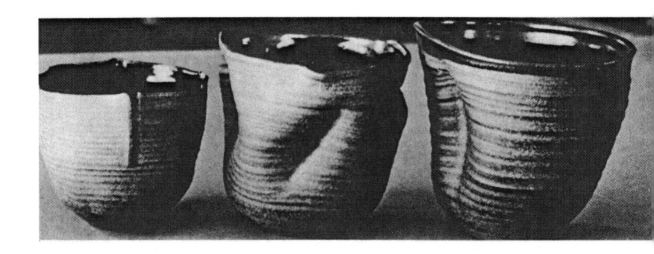

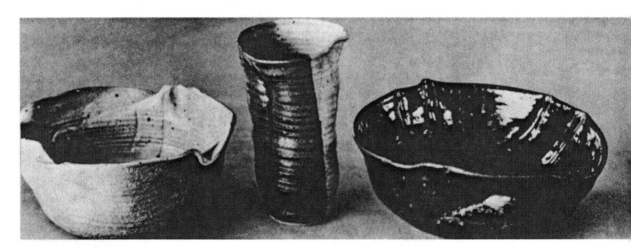

Pot Drawings: 'Flower, Calyx/Body/Root," thrown stoneware (top). "Black and White Line Drawing," thrown stoneware (bottom).

artistic activity, is human activity. To lift the tools of our work, the materials of our work, our gestures, into lifelight, and to show them irradiated with what is awakened also in ourselves, this is a way of knowing what things are, a human artistic religious scientific knowledge.

The ordinary things of life: a sponge, a mop, a vacuum cleaner, a table set for lunch, a bathtub, a car, a child playing — these may be beheld artistically in daily life. We see them shine from within. This is not to sell short the darkness, but to see how it shines from within.

For our craft includes the dark side of life as well, includes our unreal hopes as well as our maturity. Indeed, our needs may be our bond with others. It is important to keep the picture of wholeness alive in our understanding of ourselves: the center we live *within*, the life we live *within*, the love we live *within*, the connections we live *within*. All the Beings of dark and light are part of the center we live within. To feel ourselves in touch with the wholeness of life is, I believe, to be on center, to be *in* love. That's what love is, I think: the discipline of containing and keeping the faith, rather than excluding. Whatever lameness or weariness or confusion or handicap or deformity or weakness or desperation or unreadiness we feel is part of that source, part of that love. Anger is part of the embrace, when we continue to support one another and ourselves in the ordeals of life, not cutting ourselves off, feeling that a needed separation may occur as *a living form* within the differentiating life-line. We try to keep the faith with the Heart in Whom we live.

To work from source then, as I experience it, is to work from living being: whether it be juicy or arid. Deserts are real. Oases are real. On center, one may be off center as much as one is, for it will be inwardly supported and affirmed, and given form by the equilibrium one undertakes.

That's what I want to say about Source tonight: that it is a Living Reality.

To conclude: at this festival of Michaelmas, we may be aware of the sources of our work in natural materials, in pleasure and feeling, in use and beauty. And we may be aware of something else: a way of working that evolves not out of material, nor out of use, nor out of feeling for beauty; but a way of working in which the Living Realm of Being and Becoming speaks directly across the threshold of our bodies.

In primitive cultures, as we have seen in the case of Black Elk, spirit vision was an important part of the rituals of the hunt, of healing, of working the earth. The task for the artist/healer was to find the way to perform the vision on earth for the people to see.

In our contemporary time, we have the possibility of renewing the wholeness of our lives, and of reintegrating Source consciously into our living and working. We can try to perform a vision which will speak from a healing Source. Craftsmen have special opportunities to carry their visions into neighborhoods of real people. We may perform the dances of our crafts on the streets of villages, in empty theaters, in public parks. The relationship of handcraftsmen to social change has barely been explored.

Finally, I would like to show you five small objects of special portent. One is a stone rose. It is a natural stone form, a Barite rose, from Oklahoma, a stone that grows in the shape of a rose.

One is an ancient Egyptian potsherd, with this glorious Egyptian Blue.

One is this pre-Columbian clay deity, hollowed out, a thin plane of clay, modeled from behind.

These last two are clay mother goddesses: one is from a modern water cult in Nigeria, one is from an Amazon fertility cult in South America. See how this dark one carries her baby and nurses it. See her elaborate hair style. And see how the Amazon goddess is brushed with dark and red geometric stripes, and has a cornshuck belt wrapped around her hips.

They are among my treasured possessions, and I have brought them for you to see. I think they help us to keep in touch with Source.

# The New

Wᴇ begin now with this, how we are in a new time of ourselves. These past years have been a continuous unveiling, taking masks away, taking away familiar shapes, familiar structures, treasured truths, to reveal a living seedbed, flowing waters, interweaving colors, spiritual contours underneath/within/above: immanent/transcendent. Maxim: "Until our worst fear befalls us, we are not born."

We start from a different point, from a new heart, with a new face, to a new purpose: To see community wherever we are? Not to prescribe, but to feel it, in every part? Loneliness and estrangement, "the self-shaping of privacy," antipathy, the need to resist? To embrace? To discover? What luck, to dwell in the forms of difference and sympathy, as in one living form. When I am not in love with this much trust, I am terrified of it.

We begin with our real needs and try to ask our real questions. We respect the tenderness of our souls and our delicacy of feeling. We respect our toughness and imprudence, our generosity and abandon. Gifts cast shadows. We respect our fear and shame and anxiety, our hatred, and sourness.

We are not always able to give what we are asked for.

We want to start from a beginning, new in a new time. We take small steps. Each one feels real. What is money? What is food? What are dreams? What is home? What are clothes? What is sleep? What are stars? What is color? What is form?

What shall we do with our irritation, our hurt feelings, our self-doubt and pride, our over-give? How shall we adore, how hope? We listen, and learn to respond. This takes time. It is our work. This is learning to live.

"What shall I do with my life?" Feeling real to oneself is a new kind of work. And making sacred relationships with what is not oneself is a new kind of work.

The human soul can enter into life only through very small openings. When my therapist Erlo Van Waveren told me this, I immediately saw in my inner eye a mouse-

hole, in a baseboard, bright eyes and twitching whiskers and perky ears, a little mouse looking around, and coming in through a very small hole. I like this. It is in contrast to the cosmic vistas which the spirit tends to prefer, or the "no exit" temptations of the body. The human soul tends to get dizzy on cosmic heights. It feels more in balance with the girl next door, or the groaning child in our own breast.

One time when I was feeling heavy and depressed, I turned inward to ask what was wrong. Suddenly, in my psyche I felt a wee mouse. I was lying smack on top of her, no wonder she felt squashed and unable to move. I learned from Ms Mouse that she thought of me as King, so busy taking care of things, he's unaware of whom he's sitting on. And my mouse is so unused to feeling any worth in herself that it took my questioning to stir her up. Where was the Queen? And where was the Human Friend?

The King too, I notice, suffers attacks of woe. He is the King, so why does he weep? Ah, he is lonely, and hard pressed by many responsibilities. He asks much of himself in governing his realm. I suggest that he sit back for a moment and rest. And to the realm, I suggest that they bring forward their gifts and their love. Valentines and jigs, songs and presents, the cricket brings his knees and the beetle his nose and the cockroach his wit and the ant her grouch and the grasshopper his wings and the mouse her soft body and lovelit eyes, bringing their joy to the King. They didn't know he needed them, and neither did he. He weeps to feel the warmth and caring, takes off his crown, the realm has awakened, now all dance. The realm cannot, now, be governed by a king, but needs all creatures large and small. I have been meaning to make a great big mouse out of clay. And I have started to model a feminine mothering figure who is always accessible.

Spiritual opening, expanding consciousness, responsibility, are steps on a way. But they need to be reintegrated with simple humanness. Arthur Josephson used to tell me a story about a Chinese sage who was best loved for his simple soup: pilgrims lined up with their bowls far down the mountainside! . . . Spirit, awakened, needs the small openings of human reality. We who are concerned with inner development need to remember, I think, that growth is not to be understood in terms of indefinite expansion. It is helpful to notice in life and work how the motions of widening and narrowing follow rhythmically, as in centering clay on the potter's wheel, to produce a quality of being. In order to make the form, the clay must be brought into the compass of the hands.

The canopy of heaven is wide, and our two feet are its base. Let us feel the heavens circulating through our feet, our narrow base. And let us appreciate that what we do as we stand here, making soup for each other, flows into the heavens. Through the

crossing point the flow goes both ways: and there is that instant/point where we rest in the quiver of the double realm. This threshold quality may be experienced as a Door. We stand in its shadow and receive the Sun's Mysterious Light. We move through it in any direction and feel the form's flow.

Yesterday a child asked to play with the clay figures of a Christmas manger scene, which I bought in France many years ago, and which she had seen in my house during the Holy Nights. They are colorful and beautiful, and with them is a tiny clay angel which Michael Cohen once sent to me for Christmas. The child moves the figures around on a low table, talking to herself and to me, making up stories: here are the people in a circle around the baby, now they are walking aside in small groups, now two are coming back to take care of the baby who is crying, now they are whispering quietly. She calls them King, Husband, Woman, Baby, Angel, Sheep. One of the sheep, she says, wants a jewel from a King's box of gold. As I listen and enter in, I feel a "larger presence" like a poem fully sung: this child Ruth, the improvised play space, the Beings who form their stories in her thoughts — the primal quality of truth we human beings share — the way it finds us — how active the lifespirit is in each small person! I stand in awe of the millions who live the life of earth, doing its work, suffering its conflicts, manifesting its human destiny, imagining. The whole world is our religion. Blessed with an inner child, we may see it new.

CPSIA information can be obtained at www.ICGtesting.com
Printed in the USA
BVOW081103211011

274218BV00004B/19/A

9 780819 560292